THE
CALLIGRAPHERS'
DICTIONARY

THE CALLIGRAPHERS' DICTIONARY

ROSE FOLSOM

Introduction by Hermann Zapf

With 205 illustrations

Thames and Hudson

For Fred, who is the heart of this book, and for Sylvia, Ralph, Rose and Joe, who shared their love of words from the very beginning.

Acknowledgments My special thanks to Michael Gullick for keeping me on track by reading and making many valuable suggestions to early and later versions of the typescript; and to Hermann Zapf and Susan Buchholz for reading and giving valuable comments on the next-to-final draft. Any errors that have slipped in despite such superb help are mine alone.

I would also like to thank Barbara Greig for being the godmother of this book, and Wolf Von Eckardt for guidance in the early stages. Thanks to Sheila Waters for the use of her library. Thanks to my family, to Marta Legeckis, Jo Seymour, Judy Hoyle, Jerry Kelly, Linda and Meyer Katzper and Charles Hughes for moral and technical support. Thanks to librarians at the Library of Congress and elsewhere. Greatest thanks to my husband, Fred, for constant encouragement. And finally, thanks to the ladies and gentlemen at Thames and Hudson. Deo gratias.

Contents

Preface

IN February of 1984, a colleague called me up to ask if I knew what "bank script" was. She had run across it in her reading, and knew of nowhere to check its definition. This was not the first time someone had needed such information, in the same way as I had called others – sometimes on another continent – to help clarify something I'd read. Many hours had also been spent leafing through my library in the midst of a project to find one crucial bit of information.

I had to admit I'd never heard of "bank script," and lamented the lack of standard nomenclature in our field, not to mention the absence of an encyclopedic reference book. Upon brainstorming about what could be done to improve things, the idea of *The Calligraphers' Dictionary* was born.

The process of writing it has been a humbling one, beginning with the absurdity of trying to codify the liquid and subjective tool of language. Because terminology varies regionally and from century to century, we shall never be without some ambiguity. No amount of research can standardize completely the words we use, even if that were desirable. But much research and double-checking have gone into each entry, and the greatest pains have been taken to correct common fallacies and misunderstandings.

This book is meant to streamline the study, practice and appreciation of calligraphy by offering definitions and explanations of words that appear insufficiently explained in other contexts. We trust that an increased knowledge of calligraphic terms will help open the way to joy in the making and studying of letters.

A comprehensive system of cross-referencing (in SMALL CAPITALS) is found throughout the text to help the reader use this book most effectively. You are invited to let the "word trail" of references guide you to a fuller understanding of the information you need. The entries on the history of our craft and its materials are intended to provide a deeper awareness and appreciation of the ready-made material we can easily take for granted. Such an appreciation will also lead you to new opportunities for experimentation and discovery.

Because there are well-written technical manuals readily available, this is not primarily a how-to book. We suggest that you use it in conjunction with a good manual, such as *The Calligraphers' Handbook* (1986), and of course, if possible, a good teacher.

Introduction
by Hermann Zapf

For some years calligraphy has become widely accepted as an art form, not merely as another aspect of graphic design. There are also many people who are now starting to practice calligraphy as a hobby. Enthusiastic beginners the world over are wanting to discover more about the origins and history of calligraphy and how to develop their own skills.

This dictionary is not only meant for the calligrapher but also for anybody studying art history in general. Contemporary calligraphy has been ignored for many years, as the art has lacked a scientific approach. We hope this book will stimulate a better understanding of this form of artistic expression – to see in it not only a craft or a metier, but also an opportunity to pursue the many ties and connections with art forms that are already fully recognized in our Western society.

Although paleography and medieval studies are so closely linked with letterforms, unfortunately university and art school curriculae do not include calligraphy. The revival of calligraphy and fine handwriting as an art started with Edward Johnston in England at the beginning of this century. He laid the foundation for all of us by recommending study of the historic alphabets, which would enable us to develop a mode of personal expression later on. He wrote the first modern instruction book, *Writing & Illuminating, & Lettering* (1906), describing many of the old techniques and principles, and teaching their use in our modern-day work. Of course, if you learn from books you will not always be able to avoid mistakes because there is no teacher around to correct them at once.

There are various ways of learning calligraphy – by studying such books or attending workshops, for instance. Your age or your artistic background should be no hindrance to you, as long as you have the will to learn. Of course, you will need some self-confidence (something no book can give you), discipline, and the patience to do the exercises. Practical instruction books are available everywhere, with hints, examples and descriptions. However, you will also come across technical terms that are not always explained. A dictionary has been needed for a long time to define and clarify a name or word in an instruction book that is unfamiliar and that needs a clear understanding if you are really interested in practicing this fascinating art. As soon as you have started studying calligraphy and you notice some progress in your handling of the tools, you will become curious to sound the depths of this world of letterforms. New lessons are always to be discovered in masterpieces of the past. An acquired knowledge of the history of letterforms will open doors and may provide a guideline for your studies. And in this field especially you will very often be confronted with unfamiliar words.

An index in an instruction book is not enough. Very often you need precise explanations. This book was written for such a purpose, but it is more than a dictionary. It should be your *prevarium calligraphicum*.

forked A

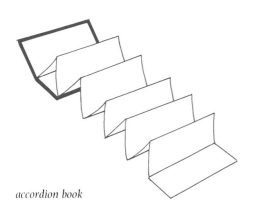

accordion book

A The first letter of the alphabet derives acrophonetically from the North Semitic symbol ⟨ *aleph* (ox). The Greeks in turn wrote **A** and **A** , calling the symbol "alpha." Some of this symbol's other forms were **A** (ETRUSCAN, *c.* 600 BC) and **A** (early Latin MONUMENTAL, *c.* 100 BC). FORKED A: Widely used in MEDIEVAL MSS (such as the BOOK OF KELLS), it is Greek in origin.

abbreviation Saving time and space through shortened forms was widespread in MEDIEVAL writing. Most commonly, a horizontal line was drawn above the MINUSCULES (and through any ASCENDERS), of an abbreviated word. Certain signs above a word denoted the deletion of specific groups of letters.

abecedarian sentence Originating in MEDIEVAL times or before, a sentence that contains all the letters of the alphabet. From *abecedarius*, the Latin for "alphabet." Scribes and typists use such sentences for practice. For example, "a quick brown fox jumps over the lazy dog"; "pack my box with five dozen liquor jugs"; "sphinx of black quartz judge my vow."

abecedarium Primer containing the alphabet as well as rules for spelling, grammar, etc. in use before 1500.

above center A visual entity, such as a line of writing, page of writing, illustration, etc., whose bottom MARGIN is, or appears to be, larger than its top margin. *See* CENTERED, OFF CENTER.

accent Mark above, below or through a letter indicating a particular sound or stress.

accordion book Also concertina. Book folded like an accordion, from one strip of paper.

acetone Volatile liquid ketone (the active ingredient in nail polish remover). Wiping a new NIB with a paper towel soaked with a few drops of nail polish remover is one way to eliminate the oily coating on the nib, helping ink to flow freely from it.

acid Any substance with a pH value of lower than 7 on a scale of 14. Its presence in art materials, such as WOODPULP PAPER, can reduce the life of a work to as little as a few months.

acid etching By means of hydrofluoric acid corrosion, a milky-white or frosted design may be made in glass. The areas not to be corroded are coated with a special RESIST, and the surface is washed or immersed in acid.

acid free Material whose pH value is neutral (around 7), and which will therefore not turn brown, crumble or be otherwise damaged by acid. *See* ARCHIVIST'S PENCIL.

acra pigments Synonym of QUINACRIDONE PIGMENTS.

acridine Colorless crystalline compound occurring in COAL TAR and important as the parent compound of certain DYES and LAKES.

acrophony The sound of the initial letter of a word, a key element in the development of alphabetic systems. Acrophony can best be explained by example: ⌐, or *beth*, is a Semitic sign for the word "house"; as SEMI-ALPHABETIC systems developed, the sign came to denote simply the sound "b." Likewise, ⋉ , or *aleph* (ox), became the sign for the sound "a," etc.

acrylic Any material made by polymerizing acrylic acid esters. The hard acrylic resins so formed are used to make thousands of synthetic items such as paint BRUSH hairs, PEN HOLDERS and PLEXIGLAS for framing. Ground up finely as PIGMENT, they are suspended in mineral spirits to make acrylic PAINT, and in water for polymer paint.

acrylic gloss medium Milky liquid used to thin acrylic PAINT. It can also be used as a GILDING ground, as described in the book *Secreta* (1986) by Joyce Grafe.

addorsed Term in HERALDRY for two figures depicted back-to-back.

adem uncial Since all majuscule bookhands were called "uncial" during Roman times, this name distinguished the uncial that featured a distinctive "a," and rounded "d," "e," "h," and "m" – the script we call UNCIAL today.

adjustable curve Also flexi-curve. A plastic-covered metal strip for ruling, about 12″ (30·5 cm) long, which can be shaped to hold any curve into which it is bent. Better suited for penciling than inking the curves so made.

adjustment 1) INITIAL ADJUSTMENT: the initiating movement made with the pen on the writing surface before launching the actual stroke. 2) TERMINAL ADJUSTMENT: the pen's final movement at the end of a stroke. Both can result in a FINIAL.

adsorption Property of a solid to bond to itself a thin layer of another substance, as GESSO does with water when breathed upon in GILDING.

agate Semi-precious stone, useful for BURNISHING SHELL GOLD.

agglomeration The attraction between particles of PIGMENTS ground in the paint-making process sometimes causes them to cluster, or agglomerate, after being separated in grinding. As a result, molecules must be made unattractive to each other through chemical or electrical means.

A.I.G.A. American Institute of Graphic Arts, founded in 1914. *See* Appendix, SOCIETIES.

air bridge The "synapse" between two separate sequential strokes in which the pen's, or brush's, movement above the paper can be charted without having been graphically recorded.

alcohol The denatured variety is ethyl alcohol with 10% methanol and ·5% pyridine. British name is methylated spirit. A solvent of dried oil, it has two main uses in calligraphy: 1) A piece of paper towel or cloth wetted with denatured alcohol will remove oil from a new metal NIB, helping ink to flow freely. 2) A small amount may be used as a PRESERVATIVE in GUM solutions.

air bridge

Alcuin of York (*c.* 735–804) One of the best scholars of his time, he was invited to Frankia by CHARLEMAGNE in the late 8th c. to supervise educational reforms, including the revising of the Bible. He was later chosen to be abbot of Tours. The script Alcuin and his associates developed for their work is now known as CAROLINGIAN MINUSCULE.

aleppo gall Type of GALL NUT. *See* IRON GALL INK.

Alice (Koeth) American (b. 1927) Student of Arnold BANK. Distinguished graphic designer, calligrapher and teacher who lives in New York City. Known especially for the banners and posters she has designed for the Pierpont Morgan Library.

aligning numerals Also modern numerals. Those that are all the same height and sit on the BASELINE. *See* NON-ALIGNING NUMERALS.

alizarin Brilliant, permanent, dark red SYNTHETIC ORGANIC PIGMENT; a translucent LAKE with good TINTING STRENGTH. First synthesized in 1869, it approximates the organic ROSE MADDER, although the latter remains the more FUGITIVE color. The names "alizarin" (originally only synthetic rose madder) and "madder" (originally only genuine rose madder) are often used indiscriminately today.

alkali Chemical opposite of an ACID, and when mixed with acid, both will be neutralized. These caustic substances, such as LYE, were formerly used in the making of LAKE pigments.

alphabet 1) System of written language wherein symbols, each representing a sound in the corresponding spoken language, are arranged to represent words in that language. The earliest known examples of true alphabetic writing (whose vowel signs are of equal importance to the consonants) date from *c.* 1400 BC, and were found in 1928 on the Mediterranean coast in Syria. However, consonant-only "alphabets," which are natural for Semitic languages whose vowels are predictable, remained the rule until the Greeks implemented vowel signs for their language *c.* 800 BC. 2) A commonly used, but misleading term for the word SCRIPT, denoting a style of lettering or letters which share a family resemblance, as in "the UNCIAL alphabet."

alum Potassium aluminum sulfate; comes in white powder form. It has three main uses in calligraphy: 1) In small proportions it helps to "set" DYE or SIZE into fabric, PARCHMENT or PAPER. It was a component of the earliest fabric dyes and of MEDIEVAL home-made IRON GALL INK. 2) In larger proportions, and mixed with alkaline reagents, it can give body to dye, thus turning ink to paint. Today, an alum by-product (pure ALUMINUM HYDRATE) is used for LAKE pigments. 3) Used to fix the SIZE in WOODPULP PAPER. However, it will eventually cause the paper fibers to disintegrate.

aluminum hydrate Also alumina hydroxide. Inert translucent white powder which turns to a gelatinous pulp when water is added. It is used as a substrate for LAKE pigments and as an EXTENDER in WATERCOLOR.

aluminum leaf Very thin sheets of aluminum, used in GILDING, which oxidize rapidly from a shiny gray to a dull gray. By coating applied leaf with GLAIR, oxidation can be kept to a minimum.

American roundhand Synonym of COMMERCIAL CURSIVE.

ammoniac Synonym of GUM AMMONIAC.

ampersand The sign ''&,'' originally from the Latin *et* (and).

analytic Term used to describe scripts, such as Chinese, or early IDEOGRAMS, whose basic units are words, as opposed to letters or syllables.

Anderson, Donald American (b. 1915) Former professor of art at the University of Wisconsin where he taught, among other subjects, calligraphy and design. Author of *The Art of Written Forms* (1969).

Angel, Marie British (b. 1923) Studied with Dorothy MAHONEY at the Royal College of Art, and with Irene WELLINGTON. Known primarily for the delicate, sensitive and sometimes humorous paintings of animals which are integral to her manuscripts. Author of *Painting for Calligraphers* (1984).

Anglo-Saxon majuscule Strictly speaking, this script was written only by natives of Scotland and England *c.* 7th–8th c., the LINDISFARNE GOSPELS being the best-known example. In many cases, however, it is indistinguishable from its antecedent, IRISH MAJUSCULE.

Anglo-Saxon minuscule Like the majuscule, this script is Irish in origin; but it stayed in use long enough to develop its own Anglo-Saxon flavor. It greatly influenced MEDIEVAL writing as missionaries carried it throughout Europe in the 8th and 9th c. After the 11th-c. Norman conquest, its use declined.

angular hand One of the many 19th-c. handwriting systems which were sold as being easy to write, but which failed because they were also illegible. This script looked merely like a series of acute angles. *See* COMMERCIAL CURSIVE.

aniline dye Once a generic term for COAL TAR COLORS, but in reality only one of many DYESTUFFS made by chemically altering coal tar distillates. Although aniline dyes have been famously untrustworthy since the mid-1800s, many are today reliably PERMANENT.

antiphonary Also antiphoner. Book containing the choral parts of a BREVIARY.

antiqua Also *lettera antica*. 15th-c. Italian term for the scripts we now call HUMANIST, based on models *c.* 1st–12th c.

antiquarian Paper size measuring 53 × 31'' (134.5 × 78.7 cm).

antiquarii Classical in origin, a MEDIEVAL word for SCRIBES.

antique finish Non-CALENDERED paper surface. Soft and rough, it was the usual surface of paper before modern printing techniques in the 18th c. began to demand smoother surfaces.

apex Upper point of a majuscule ''A.''

Anglo-Saxon minuscule

arabesque

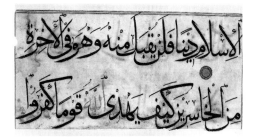

Farsi

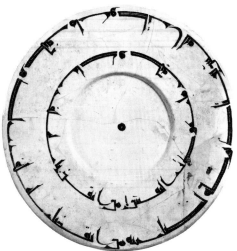

Muhaqqaq

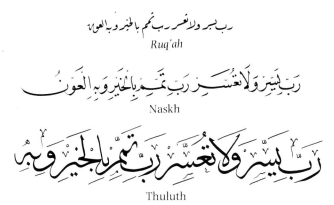

Kufic

apograph Handwritten copy of a book.

apparent height The size letters appear to be, affected by various optical illusions. For example, letters that meet the CAP LINE at a point (such as "A") or curve (such as "O") have a shorter apparent height than letters whose crossbar touches the cap line (such as "T"). Because letters that measure the same as each other can have different apparent heights, tiny adjustments must be made by the artist to compensate for these optical differences, especially when drawing large letters.

aquarelle Regular (often translucent) WATERCOLOR, to which no chalk-like substance has been added for opacity. *Compare* GOUACHE.

aqueous Describes a solution which is water-base (as compared with oil-base, spirit-base, etc.).

arabesque Type of decoration distinguished by intricate interlacings of stylized vines, leaves, flowers and other similar devices. Associated with MEDIEVAL Arabic and European MS illumination.

Arabic numerals Our ten figures, 0 through 9, introduced to Europe around 1100 from India by the Arabs, via Spain and Italy. They were not regularly used until the 13th c., and not widespread until the 15th.

Arabic writing Written from right to left with a BROAD EDGE REED PEN cut to a left CANT. Most strokes are "push" strokes, so the paper used is usually very smooth. The Arabic letterforms stem originally from the PHOENICIAN, as do GREEK, HEBREW and Latin. In *The Calligraphy of Islam* (1979) Mohamed Zakariya explains that the basic forms of Arabic calligraphy were in use around the early 6th c., about a century before the advent of Islam. At that time there were two main kinds of writing. The first was called "dry writing," because of its precision and its angular and sober character. It is a MONUMENTAL script written slowly with a crisply cut reed. This script developed into a series of styles loosely called *Kufic*, which were used for important documents. The second, "soft writing," was more rounded and CURSIVE, and was written with a pointed or blunt reed. This style became the basis for the many modern scripts, including *Farsi* (also known as *Nasta'liq*, the Persian writing probably most familiar to Westerners), *Naskh, Thuluth, Muhaqqaq* (perhaps the most elegant of all), and *Ruq'ah* (from which modern Arabic handwriting derives).

Ruq'ah

Naskh

Thuluth

Aramaic *See* HEBREW WRITING.

arch Segment of a letter resembling an arch, such as the rounded portion of a minuscule "n."

archivist's pencil To test the pH VALUE of a given paper, a mark is made on the paper with this pencil. The mark is then wetted with distilled water and will turn a color that can be matched up with the accompanying pH color guidesheet, indicating the pH value of the paper.

Arkansas stone Very fine, hard stone from Arkansas, U.S., for honing QUILL KNIVES and for sharpening metal NIBS. Gray-white stones can be more desirable, being finer grained than the black.

arm Horizontal stroke of a letter which is attached to a STEM at one end, as in the capital "E."

armarian Monk responsible for the book collection in a MEDIEVAL monastic library, who sometimes also supervised the work of COPYISTS.

armarium Classical Latin word for the closet or chest in which books and scrolls were kept.

Armenian bole Natural clay pigment (aluminum silicate) available in green, white, yellow and other earth colors. 1) The BOLE used for GILDING and ILLUMINATING is the red-brown variety almost exclusively. For most purposes, this reddish ground for gold is thought most satisfactory, lending a warmth to the finished gilding and being a pleasant color to show through, should small pieces of the gold flake off after time. Historically, both plaster and bole have been used as the primary ingredient in gilding GROUND (sometimes even layers of bole and GLAIR over GESSO), but slaked PLASTER OF PARIS is favored today. In most modern gesso recipes, bole is merely the colorant of the gilding ground, allowing the gilder to distinguish easily the area to be gilded from its white background. 2) Bole is dusted onto the paper that separates the leaves in a book of GOLD LEAF to prevent the leaf from sticking too much to the paper.

Arrighi, Ludovico degli Also known as Vincentino (*fl.* 1510–28). Vatican scribe. In 1522 he published the first illustrated printed writing manual, *La Operina*, with which he invited the public to learn, in a few days, an elegant *cancellaresca*, or ITALIC script. Arrighi's publication seems to have been the first book intended to provide complete instruction, dispensing with the services of a teacher. This was shortly followed by *Il Modo*, a book of sample scripts. *See* John Howard BENSON.

artificial uncial Synonym of late UNCIAL.

Arts and Crafts Movement A movement begun in England in the mid- to late 19th c., whose adherents were reacting against the dehumanizing effects of the Industrial Revolution. Their first exhibition, in 1888, included fine printing which led the way to consideration of LETTERFORMS as an art. *See* William MORRIS.

artwork 1) Used as a synonym of MECHANICAL, or that which is CAMERA-READY. 2) Original calligraphic art, individually or collectively.

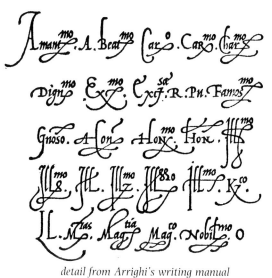

detail from Arrighi's writing manual

ascender The portion of a letter that rises above the WAISTLINE, as in the upper stem of the minuscule "b."

asiso Synonym of GESSO.

asymmetrical Design in which lines of writing and/or other elements are neither CENTERED nor FLUSH-left or -right.

atlas Paper size measuring $34 \times 26''$ (86.3×66 cm).

atramentum Early Latin name for black INK, as distinct from the purple ink used for royal documents.

aureolin Yellow PIGMENT of double nitrate of cobalt and potassium. PERMANENT if kept away from dampness after application.

autograph Handwritten MS, such as the original MS of a novel. Not necessarily beautifully written.

automatic pencil Pencil having a replaceable graphite core and a metal or plastic outer shaft. (The disposable variety does not have a replaceable core.) The first practical version was made in 1914 by the Eversharp Company. *See* PENCIL.

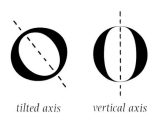

awl

awl Thin metal shaft with a handle, used for pricking holes in folded sheets in preparation for sewing into a book.

axis Also stress. Imaginary line drawn through the thinnest points in the "O" of a given script. Used to analyze and describe the nature of various letterforms.

tilted axis *vertical axis*

azo Precipitated, not mixed, SYNTHETIC ORGANIC PIGMENT.

azurite Obsolete PIGMENT of a basic copper carbonate mineral, known by various names in MEDIEVAL times, such as "azure d'Alemagna" (German blue), to distinguish it from the much more costly ULTRAMARINE blue which was mined outside of Europe. Ground coarsely, azurite retained its deep sapphire-like color, but was gritty. When finely ground enough to use in a pen, the color was paler and not so highly prized. Modern replacements are ultramarine, COBALT and CERULEAN blues.

B From the Semitic *beth* (house) written ⊓ in the Sinai *c.* 1500 BC, ⨁ in PHOENICIAN, ⟄ in early Greek and Β in classical Greek.

babery Also babewynnery. Derived from the Italian *babuino* (monkey). 14th-c. term for figures drawn in margins as decoration.

back margin Also gutter margin. MARGIN along the inner SPINE of a book.

backslant A characteristic of letters which slope to the left.

bad break Awkward division between lines or pages of text; for example, an undesirable end-of-line or end-of-page hyphenation, or a page beginning with a WIDOW.

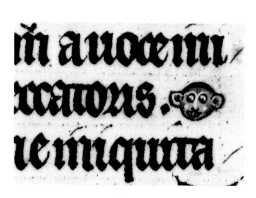

babery

bain-marie Synonym of DOUBLE BOILER.

Baker, Arthur American type designer (types include Signet), author of *Calligraphy* (1973), *The Calligraphic Art of Arthur Baker* (1983), and calligrapher, whose work and teaching catalyzed "The New Calligraphy" in the 1970s. Proponents use PEN MANIPULATION as a major feature in their work, which ranges from capitals based on CLASSICAL models to abstract paintings using calligraphic strokes.

ball-and-stick writing Synonym of PRINT SCRIPT.

ballpoint pen First patented in 1938. The point is a small tungsten carbide or steel ball bearing which revolves within the barrel of the pen and is fed with ink by gravity or capillary action. Its ink, which uses glycol as a solvent, is usually FUGITIVE.

ball terminal Approximately disk-shaped stroke-ending, found most commonly in pointed-pen scripts such as COPPERPLATE.

bamboo pen Pen made from a length of bamboo cut like a REED PEN.

Bank, Arnold American (1908–86) Attended the Art Students League in New York City. Art director at *Time* Magazine. Very influential teacher of lettering at the Art Students League, Brooklyn Museum Art School, Carnegie Institute of Technology (now Carnegie-Mellon University) and other institutions. Known for his no-nonsense teaching style and calligraphic artwork which often used letterforms as abstract shapes.

banker Lettercarver's easel for holding slate or other slabs of stone during design and cutting.

bank script, banknote script Two of the many names for COMMERCIAL CURSIVE.

bar Also crossbar. Horizontal stroke that can be either free at both ends or connected at both ends. Found in, for example, "t" and "H."

barb Flat, lightly ribbed material connected at one end to either side of the shaft of a FEATHER.

barbed serif *See* SERIF.

barium white Barium sulfate, a natural white powder formerly used as a base for LAKE PIGMENTS and as an EXTENDER in paints. Usually replaced by the artificial BLANC FIXE in modern PIGMENTS.

barium yellow Poisonous PIGMENT. Chromate of barium (also known as lemon yellow and permanent yellow). It is PERMANENT and slightly greenish.

bark The finest and thinnest inner part of the bark of trees such as lime, ash, maple and elm were incised and/or written upon by most early peoples, including the Central Asian, Indian and Native American.

baroque Style of art characterized by extravagant decoration and flourishes. Popular in 17th-c. Europe.

barrel 1) Part of a FEATHER below the BARBS. 2) SHAFT of any pen.

ball terminal

P. VIRGILII

300 Tum duo Trinacrii
Affueti filvis, comit
Multi præterea, qu
Aeneas quibus in r
Accipite hæc animi

Baskerville typeface

vous que vous n
ceulx qui habitent e
chafcun vne cotte l
quilz repofent encoz
Jufques le nombre f
Qui font a oruir a

batarde script

barrel pen Tube made of a thin piece of flat metal. The seam where the edges meet becomes the pen's slit. *See* METAL PEN.

barytes Natural barium sulfate from which natural BARIUM WHITE was made, replaced by the artificial BLANC FIXE in modern pigments.

baseline Writing line, real or imagined, on which the body of the letter sits.

basis weight Weight, in pounds, of 1,000 full-size sheets of a given paper. Thus, paper is identified as "60 lb.," for example. *See* COVER WEIGHT, TEXT WEIGHT.

Baskerville, John (1705–74) British WRITING MASTER and letter-carver who set new standards of excellence in printing. Invented the HOT PRESS paper-making process along with other technological advances to aid in the printing of his innovative typefaces. These faces were characterized by a vertical AXIS.

Basu, Hella German (1924–80) Lived and worked in England from 1950. Graphic artist, lecturer, teacher, book designer. Known for her imaginative treatment of letter shapes and their arrangement. Her work can be seen in *Calligraphy Today* (1976).

batarde Also GOTHIC cursive, SECRETARY, CHARTER SCRIPT. Any of numerous scripts, written *c.* 13th–16th c., known by a name denoting their common, workaday function as compared with the nobler FORMAL scripts. Written quickly, with a BROAD EDGE quill, they were versions of formal GOTHIC, featuring pointed arches and the connected letters characteristic of speedy writing.

Bauhaus School of design begun by Walter Gropius in 1919 in Weimar, Germany. Known for the "international" style which glorified function and did away with decoration. Characteristic letter styles were MONOLINE and SANS SERIF.

b-d uncial Early BOOKHAND (*c.* 5th c.) featuring "b" and "d" which are similar to our modern minuscule "b" and "d"; an example of handwriting forms beginning to affect the shape and speed of more FORMAL scripts. This process eventually resulted in MINUSCULE letters.

beak serif *See* SERIF.

beam compass Instrument for drawing very large circles, in which the drawing point is attached at the opposite end of a straight metal piece to the pivot point, as compared with the inverted "V" shape of smaller compasses.

beard Stroke which descends from the JAW of some capital "G"s.

beater sized Also rosin sized, engine sized. Paper to which SIZE has been added while its pulp was being beaten, prior to manufacture. Rosin size is fixed by alum, which causes wood fibers to disintegrate after decades, so not a process for lasting paper.

Beauschesne, Jean de (1538?–after 1610) Author of the first English COPYBOOK, *A Booke Containing Divers Sortes of Hands* (1570), which included variations of the SECRETARY HAND.

beeswax 1) Used by ancient Romans to coat gold and silver paint (powdered metal mixed with gum). 2) Used to coat linen thread in BOOKBINDING.

Beneventan script

beveled edge of a mat opening

below center Visual entity (line of writing, page of writing, illustration, etc.) whose top MARGIN is, or appears to be, larger than its bottom margin. *See* CENTERED, OFF CENTER.

Bembo Modern name of a MONOTYPE typeface based on a design cut in Rome in 1495 by Francesco GRIFFO for Aldus MANUTIUS. One of the first faces, now called "OLD STYLE," and among the first satisfactorily to assimilate UPPER CASE and LOWER CASE letters. Named for Pietro Bembo, the author of the first book in which the face was used.

bend Diagonal band going from the upper left to the lower right (as viewed, not as worn) on a HERALDIC SHIELD. *See* ORDINARIES.

bend sinister Band going from upper right to lower left (as viewed, not as worn) on a HERALDIC SHIELD. *See* ORDINARIES.

Beneventan Southern Italian script, one of the so-called NATIONAL SCRIPTS which predated the widespread use of CAROLINGIAN. It is unique, however, as it flourished in political and cultural isolation from the rest of Europe (*c.* 8th–13th c.) due to the powerful influence of Monte Cassino, the monastery where it was best written.

Benson, John American (b. 1939) Son of John Howard Benson. Proprietor of the John Stevens Shop in Newport, Rhode Island, and one of America's top lettercarvers. His commissions include the J. F. Kennedy Memorial at Arlington National Cemetery near Washington D.C.

Benson, John Howard (1901–56) American printmaker, letter-carver, calligrapher, teacher, scholar and author who lived and worked in Newport, Rhode Island. Wrote the instruction book *Elements of Lettering* in 1936. In 1954 he published a translation of ARRIGHI's *La Operina*, writing the English text in the CHANCERY CURSIVE style.

Berry, Jean, Duc de French (1340–1416) Prominent patron of the arts, and brother of Charles V, King of France. A book in his collection, *Les Très Riches Heures*, contains perhaps the finest examples of MS illumination of its time.

beta naphthol Available in powder form, it is dissolved in water and then allowed to cool for use as a PRESERVATIVE in GUM solutions at ·5%.

bevel 1) Angled top-cut on a quill or reed pen. 2) Angle cut made for aesthetic reasons along the edges of a MAT opening.

biased stress Synonym of tilted AXIS.

bibelot An unusually small book.

bibliography 1) List of sources used in a given project, or list of sources useful to a given subject. 2) The study of books as artifacts; the analysis of their description, classification, and history.

Bibliothèque Nationale Paris, France. *See* Appendix, LIBRARIES.

bice Synonym of BLUE VERDITER.

Bickham, George, Senior British (1684–1758?) COPPERPLATE writing master and engraver of *The Universal Penman* (1743;

facsimile edition 1954), a famous and showy volume of engraved writing and decoration.

bifolium A single sheet folded once to make two FOLIOS, or four PAGES.

binder Component in paint which binds the PIGMENT to the writing surface. GUM ARABIC, GELATIN SIZE, PARCHMENT SIZE and GLAIR are the most common in WATERCOLOR.

Bischoff, Bernhard (b. 1906) Distinguished German scholar and PALEOGRAPHER. Assisted E. A. LOWE on *Codices Latini Antiquiores.* Author of *Paläographie des romanischen Altertums* (1979), among many other titles.

bistre Obsolete, FUGITIVE brown PIGMENT made from wood soot.

biting letters Letters that are FUSED.

black IVORY BLACK: carbon PIGMENT made by calcinating (burning) bones. Tends toward blue. LAMP BLACK: carbon pigment made by burning petroleum or natural gas. Tends toward brown. VEGETABLE BLACK: carbon pigment made from burning vegetable oil, hemp, wine lees, etc.

All these blacks are the most PERMANENT of all pigments, because carbon has completely oxidized, and will not be noticeably changed by heat or light.

blackletter Also textura. As the name suggests, a dense, compressed GOTHIC, which leaves relatively little white space between letters, words and lines.

blanc fixe Artificial BARIUM SULFATE, an inert white pigment used since the 19th c. in three ways: 1) As a base for LAKE PIGMENTS. 2) As an EXTENDER to reduce a pigment's TINTING STRENGTH (sometimes too much is added to cheap paints). 3) Added to WATERCOLOR paint to produce the more opaque GOUACHE.

blazon The written description of armorial bearings, employing its own terminology. It concerns CHARGES used, what TINCTURE they are and how they are placed on the HERALDIC shield. As long as the blazon is followed, an artist has freedom to design the shield according to the requirements of the job and personal taste.

bleed 1) Too much absorption of writing fluid into the writing surface, causing blurring or "feathering" of the letters. Bleeding can often be controlled by changing the wetness or flow of the writing fluid (use paint instead of ink, use a reservoir, increase the slant of the drawing board) and/or by modifying the writing surface (apply SANDARAC or a spray FIXATIVE, or BURNISH the surface). 2) In printing, a bleed occurs when the design requires at least some of the printing to go all the way to the outer edge of the finished piece. To achieve this, the image is printed slightly larger than the desired final paper size. The edges are then trimmed to the required dimensions, so that the image continues to the edge of the paper.

blind loop A loop in handwriting, so narrow that it has been inadvertently filled in.

blind printing Damp paper is run through a press with an uninked metal plate that contains a design. The result is paper

whose design is seen only in the shadows of its embossed surface, given by the plate under pressure.

blind rules GUIDELINES scored into a sheet with a smooth, pointed STYLUS such as an extra-fine ballpoint pen with no ink. In MEDIEVAL times, lines were often scored on PARCHMENT with enough pressure to show through as a raised line on the OVERLEAF, which cut lining time in half.

block letters MONOLINE capital letters, SANS SERIF or with slab SERIFS.

block printing Synonym of WOODBLOCK PRINTING.

blotter Piece of very absorbent paper sometimes used to soak up wet ink on a freshly written page of handwriting.

blue verditer Also bice. Obsolete PIGMENT. Any one of many blue to green copper carbonate or copper salt pigments made from MEDIEVAL times into the 20th c. Bice served as an inexpensive substitute for AZURITE and ULTRAMARINE BLUE. Modern replacements are synthetic ULTRAMARINE, COBALT and CERULEAN.

board Paper at least nine mils (thousandths of an inch) thick.

Bobbio Monastery founded by ST. COLUMBA in 612 in North Central Italy. Important center of religious and cultural life, including MSS production, 9th–12th c.

Bocskay, Georg Hungarian (16th c.) Lived and worked in Vienna. Calligrapher, some of whose writing is almost microscopic in size, but still very beautiful. One of his MSS, exquisitely illuminated by Georg Hofnagel, is MS 20 at the J. Paul Getty Museum in Malibu, California.

Bodleian Library Oxford, England. *See* Appendix, LIBRARIES.

Bodoni, Giambattista (1740–1813) Italian printer and type designer whose faces, characterized by a strong contrast between thick and thin, by a vertical AXIS and by hairline SERIFS, are still used as models today.

body 1) Portion of a letter that is between the WAISTLINE and BASELINE. 2) The writing area on a page is known as the body of text.

body color Synonym of GOUACHE.

body height Height of letters between the WAISTLINE and BASELINE, that is, without their ASCENDERS or DESCENDERS.

bold Also heavy. Typographical term which describes a letter whose strokes are relatively wide for their height.

bole Clay PIGMENT ranging in color from gray to brown, yellow and red. The type used by illuminators is the brick-colored ARMENIAN BOLE.

bond Originally 100% RAG, GELATIN-SIZED paper used for bond and stock certificates. Today, the term refers to TEXT WEIGHT (thin) paper, often with partial rag content, used for calligraphic practice, typing and photocopying.

bone folder Flat piece of bone (originally whale bone) or plastic, 5–8″ (12–20 cm) long, which is rounded at one end and gently

Quousque tandem abutêre, Catilina, patientià nostrà? quamdiu etiam furor iste tuus nos eludet? quem ad finem sese effre-

a Bodoni typeface

pointed at the other. Used to fold, crease and coax paper, leather or parchment during hand bookbinding.

book Single sheets of SKIN, BARK, PAPER, PAPYRUS, fabric or dried leaves, single TABLETS or strips of clay, wood or bone, or any other single writing or printing surfaces which are attached to each other to form a unit. The oldest book known is the papyrus scroll *Prisse*, now in the Louvre in Paris. It contains Egyptian HIERATIC writing and is ascribed to *c*. 2500 BC. *See* ACCORDION −, CODEX, DIPTYCH, ORIHON, PALM LEAF, SCROLL.

bookbinding Craft of joining together loose sheets and protecting them with a cover. *See* FLEXIBLE BINDING, HALF BOUND, QUARTER BOUND, SEWING, WHOLE BOUND.

bookhand Same as FORMAL script, but connotes use during Roman, Byzantine and MEDIEVAL times as opposed to modern times. Used mainly for books. Characterized by being written relatively slowly and carefully. Examples are UNCIAL, SQUARE CAPITALS, RUSTIC, IRISH MAJUSCULE and CAROLINGIAN.

Book of Durrow Latin text of the Gospels, written in Northumbria or Ireland late in the 7th c. Intricately ILLUMINATED. Now housed at Trinity College Library, Dublin.

book of hours Collection of Christian prayers and devotions for various hours of the day. Their production in luxury volumes, with paintings and elaborate borders in and around the text, was developed to a high art in late MEDIEVAL and RENAISSANCE times.

Book of Kells Created *c*. 800 in Ireland, exact origin uncertain. This book is one of the supreme art works of Western culture. It contains the four gospels written with a quill in dark brown ink in the IRISH MAJUSCULE script. Its 340 parchment leaves are about 13 × 9″ (33 × 22 cm). Now housed at Trinity College Library, Dublin. (Facsimile edition: London and New York, 1974.) *See* IRISH MAJUSCULE *for additional illustration.*

bookplate Printed label which shows book ownership, usually pasted inside the front cover.

border Decorative design or space surrounding the WRITING FIELD.

bordure Band running the entire perimeter of a HERALDIC SHIELD. *See* ORDINARIES.

boss Protruding metal ornament on leather, paper or other surface. Can also serve to protect the surface, such as on a leather book cover.

boustrophedon Greek word, meaning "as the ox plows." It describes a mode of writing dating from the 6th c. BC in which alternating lines are read in opposite directions. In some cases the horizontal lines were read in order from the bottom of the page to the top.

bow Synonym of BOWL.

bowl Also bow or round. Curved stroke which makes an enclosed space within a character, as in "R" or "B."

bracketed serif Serif forming an angle (with a stroke of a letter) that has been largely filled in. *See* SERIF *for illustration.*

IN ENGLISH
BOUSTROPH
EDONWOULD
LOOKLIKETHIS

boustrophedon writing

Opposite: *the symbols of the four Evangelists, from the Book of Kells*

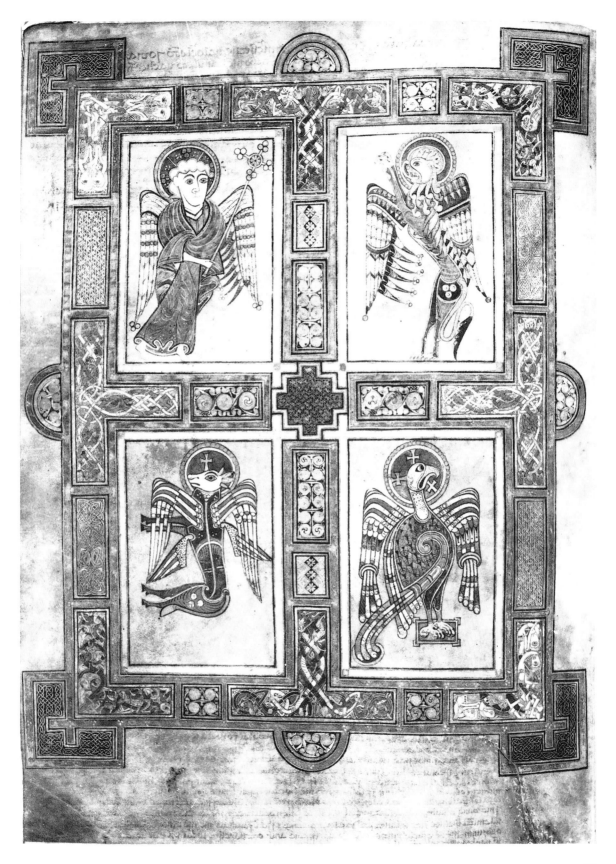

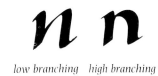

low branching high branching

branching A term describing the way an ARCH connects to the STEM of a letter. High branching is generally found in FORMAL, slowly written script, while low branching is associated with speedy, more CURSIVE writing.

brazilwood Several varieties of the tree *Caesalpinia* have a light yellow wood from which a deep cherry-red dye can be extracted by boiling. It grows (among other places) in South America. The country Brazil was named for this dye, which had been imported to Europe for dyeing cloth, vellum, paint and ink. Modern ALIZARIN paints are similar in color, but the lovely brazilwood dye is still available.

breadcrumbs Dry breadcrumbs have been used as POUNCE since MEDIEVAL times to absorb grease from PARCHMENT's surface. Sometimes the crumbs came from loaves of bread baked with ground glass for the purpose of bringing up the NAP. Also used to erase pencil lines.

breathing tube Tube of bamboo, reed or paper in the general neighborhood of 6″ (15·2 cm) long and $\frac{3}{8}$″ (·9 cm) in diameter. Used to channel moist breath from the lungs onto MORDANT, before laying the gold leaf in GILDING. A plastic, glass or metal breathing tube can be undesirable, as it may drip condensation onto the work. Some illuminators prefer to avoid any kind of tube, for fear of condensation, and breathe directly on the mordant.

breviary Book containing the prayers, hymns, psalms and readings for certain hours of the day.

bridge Used in sign painting, or other large work, this is a flat piece of wood with "feet" at both ends. It serves as a handrest to allow continued work without smudging wet areas.

bristle brush Stiff brush made from selected hog bristles. *See* BRUSH.

British Library London, England. *See* Appendix, LIBRARIES.

broad edge Also chisel edge. A term that describes any writing tool whose NIB meets the surface at a line, creating thick and thin strokes without SPLAYING the nib or changing the PEN ANGLE. In actual writing, of course, a flexible nib will splay slightly and the pen angle will change as needed. It seems that the Egyptians started cutting hollow reed pens this way around 600 BC. This was picked up by the LATINS around 300 BC and was adopted for use with quills around the 6th c. AD.

broad pen Pen which has a broad edge.

broadsheet Synonym of BROADSIDE.

broadside Work, especially a large piece, designed to be hung on a wall, as compared with work meant for a folder, book or scroll. Originally referred to a sheet printed on one side only.

Bronze Age EARLY: *c.* 3500–2000 BC, MIDDLE: *c.* 2000–1500 BC, LATE: *c.* 1500–1200 BC.

brush Used to write letters directly, to outline or to fill in outlined letters, to paint designs or to fill pens with paint or ink. Theoretically, any brush can be used in any of these ways, but

the following brushes are generally recommended for certain uses: 1) Watercolor brush (a good pointed brush), is used for painting designs and for any fine work. Sizes 0 to 2 are useful for ILLUMINATION. For direct brush-lettering any size from 000 to the largest (usually 12 or 14) can be used. Winsor & Newton series 7, a sable brush, is of reliably high quality and will last for years. Cheaper brands are apt to lose their point or annoyingly leave hairs in the paint and on the work. 2) A scriptliner is also a pointed sable brush, but with longer hairs, for painting lines and VERSALS. 3) The red sable striper has a round FERRULE but is slightly BROAD EDGED for square stroke beginnings and endings and wider strokes. It is a popular SIGNWRITING brush. 4) The bright bristle is stiff, and good for loading a nib without a RESERVOIR with hand-ground stick ink, as its bristles clean the nib with every application. A good size for this is No. 4 ($\frac{1}{4}$'' wide). Can also be used for lettering. 5) The red sable one stroke approximates the action of a broad pen, but is much more sensitive to pressure. Good for ROMAN CAPITALS and large letters that have a pen-made look. 6) Old or inferior brushes can be useful for loading ink or paint onto a nib which has a reservoir. These brushes need to be big enough (about size 6) to hold in one brushful enough liquid to fill the pen, and good enough not to leave brush hairs behind wherever they touch down. Dimestore brushes are sometimes better qualified for this than so-called artists' brushes.

TYPES OF HAIR
Finest RED SABLE brushes are made of hairs from the tail of the kolinsky, a Siberian mink. Sable brushes are usually kolinsky or similar hair mixed with the hairs from an ox's ear or other type that is less expensive. BRISTLE brushes are stiff, and made from selected hog bristles. If the brush is ''bright,'' the bristles are short and the brush is a flat one.

BRUSH ANATOMY
FLAG END is the end of the hair that was external to the animal. These are never trimmed to make a good brush, but are left to taper naturally, or in the case of a bristle, to fork naturally at the end of each hair. BUTT END is the root end of the hair or bristle. This is trimmed, then cemented into the ferrule, which is then crimped to hold the brush hairs firmly.

BUYING A BRUSH
Buy a good one. Since they are made by hand, each one is unique, and some of the same type are better than others. Starch or GUM ARABIC is put on the hairs, making each brush perfectly shaped, but it may not be when the coating is soaked off. You may ask to remove the coating with water at the art supply store, so you can see what you're buying. You can get a good idea of its character while it is still damp and stroked to a point with your fingers. For watercolor brushes, neither A) nor B) is desirable. (This test applies to red sable brushes only.)

BRUSH CARE
A very good brush is best used with the purest media: hand-ground INK and PAINT, and good WATERCOLOR. Most bottled PIGMENT, such as SUMI INK, contains a lot of ACID and SHELLAC which will gum up and ruin a brush if left to dry in the hairs even once. *You must always clean your brush before the paint or ink has*

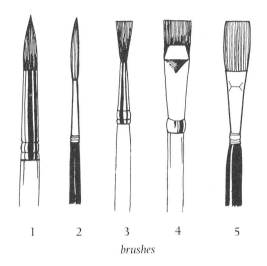

brushes

1 2 3 4 5

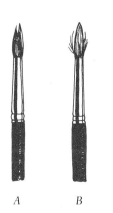

A B

dried in it. One procedure is as follows: 1) Swish it around in lukewarm soapy water and/or gently work up a lather in the palm of the hand with the brush. 2) Rinse. 3) Repeat 1 and 2 until no color comes out of the brush. 4) Shake to remove excess water. 5) Form into its original shape (point or flat) with fingers. 6) Let brush dry lying down or with hairs pointed down, to avoid water collecting in ferrule. If you own inexpensive brushes, the above steps will seem overly fastidious and a waste of time. But if you are the doting (and impoverished) owner of a large series 7 red sable, you will wonder if there is anything else you can do to make its life more comfortable.

brush pen Used by very early Egyptian scribes and made from a solid-stemmed rush, *Juncus maritumus*, frayed at the end to form a brush-like pen for writing.

bubbles In PAINT or GESSO, bubbles can impair the liquid's silky texture, and can mar the dried surface. To discourage bubbles, stir slowly with the brush handle (rather than its air-trapping hairs) and avoid the repeated plunging of stirrer into liquid. A little earwax added to a mixture is an ancient remedy for bubble infestation.

built-up letters Synonym of CONSTRUCTED LETTERS.

bullet Typographic term meaning a dot of any size, usually used to separate visually two entities of text, or for decoration.

burin 1) Also graver. A pointed stylus with a handle used in engraving. 2) A type of INTAGLIO printing.

burnish To enhance the smoothness or shininess of a surface (usually gold or paper) by rubbing, when sufficiently dry and hard, with a BURNISHER.

burnisher Usually a tip of stone or tooth fastened to a handle and rubbed on metal LEAF or other surface such as paper to make it shinier or smoother. The following stone burnishers are common examples: PSILOMELANITE, for metal leaf, large and small areas; HEMATITE, for large areas of metal leaf; and AGATE, best for powdered metal paints, but also useful for very small areas of metal leaf. Among the many types are blunt –, CLAW –, and NEEDLE –, TRANSFER LETTERS are applied with a metal burnisher which has a small knob at the tip.

burnt sienna PIGMENT made by roasting the EARTH PIGMENT SIENNA.

burnt umber PIGMENT made by roasting the EARTH PIGMENT UMBER.

burr Small metal ridge formed on the upper edge of a knife or nib during sharpening. May be removed by grinding it off on a sharpening stone, leather strop, or by rubbing with CROCUS CLOTH.

business script Name used by American PENMEN of the late 19th and early 20th c. for the SPENCERIAN, PALMER and ZANERIAN styles of COMMERCIAL CURSIVE (pointed pen handwriting).

butt end *See* BRUSH.

hematite psilomelanite blunt needle claw

agate

burnishers

C Derived from the Semitic *gimel* from which G also derives. Attained its modern form in early Roman times, having resembled a mirror-image "C" for many centuries.

cacography From the Greek *cac* (bad) and *graphein* (to write). Horrid, illegible writing due to carelessness.

cadels Elaborately flourished GOTHIC BROAD PEN writing, often executed without lifting the pen. Popular in 15th-c. northern Europe.

cadmium colors PIGMENTS made since the 19th c. from the silvery metal cadmium, they range from pale yellow through oranges and reds to maroon. LIGHTFAST and of excellent consistency in the pen. Can deteriorate if stored in damp after application. Poisonous due to their heavy metal content.

cadmium oranges Pigments from mixtures of cadmium sulfide and selenide. Poisonous.

cadmium reds Pigments from mixtures of cadmium sulfide and selenide. Poisonous.

cadmium yellows Sulfide of cadmium PIGMENTS. Poisonous.

cake watercolor PIGMENT with GUM and varnish to be reconstituted with a wet brush for use as paint.

calamus From the Arabic *qalam* (reed), a REED PEN.

calcine To change (usually darken) the color of an EARTH PIGMENT by roasting it in a furnace. Thus, BURNT UMBER, for example, is calcined raw umber. Also refers to the roasting of natural ingredients to obtain a pigment. Thus, ivory black is made from calcined bones.

calender 1) Also glazing machine. Machine with horizontal rollers between which passes a sheet of paper, which is thereby given a smooth, polished surface. 2) To polish paper, giving it a smooth surface. On Islamic papers, this meant BURNISHING by hand with a stone.

caliper Also micrometer. Instrument for measuring the thickness of a sheet of paper in mils (thousandths of an inch).

calligram Calligraphic or typographic composition in which the words themselves form the design. Existed at least as far back as early MEDIEVAL times. A popular form of decoration in some Jewish MSS, where it is called micrography.

calligraphy From the Greek *calli* (beautiful), and *graphein* (to write). It is thought the word first came into use in the early 17th c., and usually refers to beautifully formed letters written directly with a pen or brush. However, the word is often used more generally to include not only WRITING, but also LETTERING and ILLUMINATION.

cadels

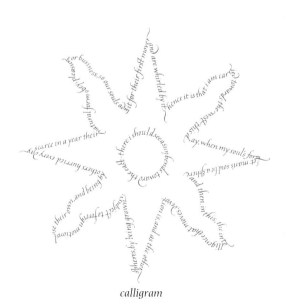

calligram

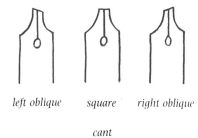

left oblique *square* *right oblique*

cant

Calligraphy Review Quarterly magazine published in Norman, Oklahoma. It publishes an annual collection of some of the year's best calligraphy from around the world. Formerly *Calligraphy Idea Exchange.* Founded in 1983. *See* Appendix, PUBLICATIONS.

camera-ready Technically this means a MECHANICAL (artwork) which is ready to be reproduced at the same size. In actual use, however, it includes mechanicals which must be reduced when photographed.

Camp, Ann British (b. 1924) Studied with M. C. OLIVER and Dorothy MAHONEY at the Royal College of Art. Went on to teach and practice calligraphy professionally. Author of *Pen Lettering* (1958, 1984), an excellent basic instruction manual.

cancellaresca Synonym of CHANCERY CURSIVE.

cant The angle of the NIB's cut.

Canterbury Cathedral city in East Kent, England. Important center for MS production, 8th–13th c.

cap Commonly used abbreviation for CAPITAL LETTER.

cap height Height of a CAPITAL LETTER from the BASELINE to the top of the letter.

capital letter The word "capital" derives from the Latin *caput* (head); thus, "capital letter" denotes a letter of great importance, as does MAJUSCULE, from the Latin *magnus* (a letter of great size or importance); thus, the two terms are almost synonymous. "Capital" is used more frequently to denote these letters when they are used at the beginning of proper nouns and sentences written with MINUSCULE letters, or to refer to Roman inscriptions in stone. "Majuscule" is more likely to describe the Latin BOOKHANDS such as SQUARE CAPITALS, UNCIAL, and IRISH MAJUSCULE, which were written without minuscule letters.

Capitals were first used in conjunction with minuscules in the 8th c. to indicate that the text was in verse. By the 11th c. they were used for initials of important words; often the first letter of a section of text. It was not until the 16th c. that they came to be systematically used as we do today, at the beginning of each sentence.

capitalis quadrata Synonym of SQUARE CAPITALS.

capitalis rustica Synonym of RUSTIC.

cap line Assumed line which runs across the top of the CAPITAL LETTERS in a text.

caput mortuum Obsolete name for a fully CALCINED RED IRON OXIDE PIGMENT. The name, translated from the Latin as "dead man's head," describes the pigment's dull violet color.

carborundum Type of SANDPAPER.

cardboard Thick, stiff paper. Because of its ACID content, should not be used in contact with lasting work.

carbon ink Made of fine particles of carbon suspended in water, gum and various additives. Carbon PIGMENT was used in cave paintings at least 17,000 years ago, but the earliest record of its use for writing is from Egyptian inscriptions on pottery *c.* 3000

Carolingian minuscule

late Carolingian minuscule

Caslon typefaces

detail from Cataneo's specimen book

BC. Although crude, this ink was much like modern CAKE WATERCOLOR.

Carlovingian 18th-c. word for CAROLINGIAN.

carmine Bluish-red LAKE available as a permanent SYNTHETIC ORGANIC pigment and as a FUGITIVE natural lake pigment made from COCHINEAL. *See* CRIMSON.

Caroline Synonym of CAROLINGIAN.

Carolingian minuscule Named after Emperor CHARLEMAGNE by scholars in the 20th c., it was an early Latin MINUSCULE script, developed in France *c*. 780. This script fused many contemporary scripts into one which was thought most serviceable and beautiful by Charlemagne's scholars. Through its subsequent use, Carolingian minuscule became the dominant script in Europe by the 10th c. and was for a time the official papal script. It was revived by Italian HUMANISTS in the 15th c., based on 12th c. models, and thus is the ancestor of most text typefaces. With Carolingian developed new devices for improving legibility: the use of some capitals in the text, space between words and sentences, punctuation and division of text into paragraphs. *See* ALCUIN OF YORK. LATE CAROLINGIAN: not strictly Carolingian, as Charlemagne had been long dead. But the name is used for 11th and 12th c. writing whose "o" is nearly round or a slightly CONDENSED oval, and whose letters are clear and distinct. Edward JOHNSTON based his FOUNDATIONAL on this script. As the letters became more condensed (in the late 12th c.) they grew toward early GOTHIC.

carpenter's pencil Pencil whose graphite core is wide and flat, therefore producing lines which approximate those of a BROAD PEN.

carpet page MS page filled with intricate designs, not writing. Particularly associated with INSULAR and ARABIC MSS.

casein Glue made from sour milk or cottage cheese. It has been used in the bindings of MEDIEVAL MSS and as a BINDER in PAINT and GESSO; casein paint is rarely if ever used in a pen.

Caslon, William British (1692–1766) After apprenticing in London as an engraver of decorations on guns, he set up shop doing metal work, including the cutting of letter stamps and other bookbinding tools. This led to work as a PUNCH CUTTER and typefounder. His designs, such as "Old Face," remain primary models today.

cast Type is cast when molten metal is poured into a matrix (mold) to make a new letter which can then be set for printing.

cast coated COATED paper with a high gloss finish.

Catach Psalter Earliest extant Irish MS, probably from the late 6th c. Written in IRISH MAJUSCULE and decorated with pen-drawn initials.

Cataneo, Bernardino Italian (*fl.* 1544–before 1564) He is believed to have worked at Siena. His one surviving MS, an exquisite calligraphic specimen book, was published in facsimile in 1981, edited by Stephen Harvard.

cedilla

catchword To ensure that a MS or printed book's QUIRES (sections) were bound in correct order, the first word of a quire was written or printed under the last line of the previous quire. These words were called catchwords.

catenati Latin for "CHAINED BOOKS."

Catich, Father Edward (1906–79) American scholar and letter-cutter who worked in Davenport, Iowa. Known primarily for research on the proper formation and execution of incised ROMAN CAPITALS, and for his book *The Origin of the Serif* (1968).

Caxton, William British (1422?–91?) Published the first printed book in English, in Bruges, Belgium, in 1475. The type used was BATARDE, designed by a scribe named Colard Mansion.

cedilla Accent used on a French "c" to soften the sound.

Cennini, Cennino 15th-c. Florentine painter. Author of *Il Libro dell'Arte* (*The Craftsman's Handbook*), a treatise which includes sections on GILDING and ILLUMINATION. The modern translation (1960) is a reprint of the 1933 edition by Daniel V. Thompson.

centered VERTICALLY CENTERED: describes the position of work (line of writing, page of writing, illustration, etc.) on a page, where the top and bottom MARGINS are equal. HORIZONTALLY CENTERED: having equal left and right margins. VISUALLY CENTERED: appearing centered, although it may not measure that way. For example, the bottom margin of a page of text is often made slightly larger than the top margin to counteract the fact that Western eyes perceive any bottom space as being smaller than an equal top space. *See* FLUSH RIGHT *and* FLUSH LEFT.

center-stitching Method of binding a single section book by SEWING through the center fold.

Central Lettering Record Photographs of lettering housed at Central School of Art and Design in London. Founded by Nicolete GRAY. *See* Appendix, LIBRARIES.

centred *See* CENTERED.

ceriph Synonym of SERIF.

cerulean blue From the Latin *caeruleus* (heaven). Made of cobalt stannate, it is a bright, PERMANENT blue PIGMENT with a greenish undertone. It has a creamy texture, excellent COVERING POWER, and is delightful to use in a pen.

chained books In monastic and "public" libraries, especially during the period 15th–17th c., volumes were often chained to desks and tables for protection against theft.

chain lines The vertical lines about one inch apart in LAID paper.

chalk Synonym of WHITING.

chalk line Used in signwriting. A piece of string coated with chalk is laid where a GUIDELINE is required. It is then lifted away from the surface and allowed to snap back onto it, leaving behind a removable chalk guideline. Since two hands may be required to hold the chalky string at either end, a second piece of string may be tied in the middle, held taut and then released with the lips.

chancery cursive script

chalky Quality displayed by paints which do not contain enough BINDER (GLUE or GUM), and thus turn to powder and come off the page when dry.

chamois Type of soft leather favored by some over cloth or paper as a PEN-WIPER because it does not give off fibers which could get caught in the pen.

chancery cursive Called *cancellaresca corsiva* in Latin, it was used in briefs at the papal chancery in 16th-c. Rome. The similar *cancellaresca formata* was used for more formal documents. These scripts are the antecedents of all the ITALIC scripts and TYPEFACES.

chancery hand Synonym of SECRETARY HAND.

Chappell, Warren American (b. 1904) Student of Rudolf KOCH. Calligrapher, illustrator and designer whose typefaces (Lydian, Trajanus) have continued in popularity since the 1930s. Author of *A Short History of the Printed Word* (1970).

character Individual letter, numeral, punctuation mark or other figure.

charge Any design or DEVICE used on a HERALDIC SHIELD.

Charlemagne (742–814) Also Charles the Great. Emperor of the Frankish Merovingian Empire (modern France and much of southern Germany). Although he was only semi-literate, he strongly promoted the blossoming of religious and classical literature. He was also deeply interested in consolidating his power. A result of these two interests was the eventual standardization of European writing with the script which now bears his name, CAROLINGIAN MINUSCULE. *See* ALCUIN OF YORK.

charter Written document concerning transfer of property, granting of rights and privileges or other legal matters.

charter script Also charter hand, charter cursive, court hand; in England called SECRETARY or CHANCERY HAND. A SEMI-CURSIVE BATARDE handwriting used in everyday business and legal documents of 15th–17th-c. England and Europe. Nomenclature during this time is prolific and therefore can be imprecise.

chevron Inverted "V"-shape extending edge-to-edge across a HERALDIC SHIELD. *See* ORDINARIES.

chief Type of DIVISION on a HERALDIC SHIELD. The top portion of the shield, $\frac{1}{3}$ to $\frac{1}{2}$ of the shield's height. *See* ORDINARIES.

Child, Heather British. Student of M. C. OLIVER at the Chelsea School of Art. Calligrapher who has written and edited important books, such as *Calligraphy Today* (1963, 1976, 1988), *The Calligrapher's Handbook* (2nd. edn 1985), and *Heraldic Design* (1965, 1979).

china clay Natural hydrated aluminum silicate, occasionally used as an EXTENDER in paint or as a LAKE base. For fine paints, the purer artificial product BLANC FIXE is preferred.

Chinese ink Non-specific term. Usually means STICK INK from China or liquid CARBON INK.

Chinese white PIGMENT that has great COVERING POWER. Made from a dense variety of zinc oxide. First introduced in 1786, it has been used by artists since the mid-19th c.

standard Chinese script

cursive Chinese script

Chinese writing Chinese IDEOGRAMS have been employed for over 3,500 years. Their structure has changed remarkably little in all that time. For many centuries, they were carved in bone or drawn on wood or silk. In the 3rd c. BC, STICK INK as we know it was developed, as was paper in the 1st c. AD. The classical Chinese script, *kaishu*, was developed in the 4th c. and has remained the standard for writing the now tens of thousands of characters in the language. The five main scripts are seal, clerical, standard, semi-cursive and cursive, all of which have countless variations.

small seal Chinese script

chisel edge Synonym of BROAD EDGE.

chroma In the MUNSELL COLOR SYSTEM, a color's purity, saturation, vividness. NEUTRAL COLORS do not have the quality of chroma.

chrome colors Chromates of lead first produced commercially in the early 19th c. These PIGMENTS, including chrome orange, – deep, – lemon and – yellow, are poisonous and not PERMANENT when exposed to the sulfur in the air. The artist is better off using CADMIUM COLORS if possible.

cinnabar Natural mercuric sulfide used as a dark orange-red PIGMENT since ancient times. A main source is near Almadén, Spain. In ancient writings it was synonymous with MINIUM, but the latter came later to mean RED LEAD. Cinnabar is generally inferior in PERMANENCE and purity to its successor, VERMILION. Today, the CADMIUM COLORS have replaced both, when possible, because they are extremely permanent.

cinquefoil Five-lobed ornamental DEVICE.

cipher Arrangement of letters, such as a person's initials, in which the letters do not share any common members, although they may be overlapped or intertwined. *Compare* MONOGRAM.

circinus Latin name for DIVIDERS, used to prick holes in parchment sheets to mark GUIDELINES, so that identically spaced lines could be marked on many sheets at once.

civilité 16th-c. typeface cut by Robert GRANDJON, based on MEDIEVAL and RENAISSANCE French BATARDE script.

civil service hand 19th-c. English version of COMMERCIAL CURSIVE, characterized by letters joined by fairly long hairlines.

clarify Synonym of CURE, as with a QUILL.

clasp Decorative metal clasps, for holding a book closed, were common in Europe from late MEDIEVAL times to the early 17th c. They helped to prevent the warping of a book's cover.

classical Non-specific term referring to Roman and Greek culture between *c.* 200 BC through the 3rd c. AD, and the letters

civilité typeface

produced at that time. ROMAN INSCRIPTIONAL capitals are the prime example of classical letters.

claw burnisher Piece of L-shaped agate set into a handle for BURNISHING metallic LEAF or metallic PAINT. *See* BURNISHER *for illustration.*

clay colors *See* EARTH PIGMENTS.

Clovio, Giulio (1498–1578) Croatian monk who lived and worked in Italy. Perhaps the most famous painter of MINIATURES of his time.

clothlet Common in 14th-c. Italy and earlier, a small piece of cloth for storing dye for MS painting: a piece of linen was soaked in berry or other plant juice and dried; wetting the clothlet in a dish with water and GLAIR or GUM released the dye for painting or drawing flourishes. These dyes were never LIGHTFAST, but their use in books made for little exposure to light.

clubbed serif Serif used especially in CAROLINGIAN MINUSCULE. *See* SERIF.

coal tar colors Although the term is synonymous with SYNTHETIC ORGANIC colors, it was more commonly used mid-19th c. to mid-20th c. when these DYES and PIGMENTS had a reputation for IMPERMANENCE. In fact they were so disastrously unreliable that in 1819 a law was passed in Prussia barring their use in official documents. Since the advent of PHTHALOCYANINE blue and green in the 1930s, however, many coal tar colors of excellent permanence have been developed and are widely used today under the name "synthetic organic."

coated paper Paper thinly coated in fine white clay with an adhesive binder. The surface of some matte ("dull") coated paper allows for crisp lines in both pen-and-ink work and printing. The shiny surfaced papers are rarely used for hand work because their slickness discourages thin hairlines, but they are common in printing.

coat of arms Originally a linen coat worn over armor for protection from sun. Later, this coat had the arms (insignia) embroidered on the front and back for identification in battle. Today refers only to the insignia. *See* HERALDRY.

cobalt blue (cobalt aluminate or phosphate) Vivid, PERMANENT blue with a slightly greenish undertone. Gritty and slightly translucent, thus difficult to use in a pen without the addition of white or some other smooth paint. Discovered in 1802 in France, it is made by furnace-firing cobalt and aluminum oxides with phosphoric acid. It replaced SMALT as a blue pigment.

cobalt violet Very expensive, PERMANENT, reddish-violet paint. Formerly made with poisonous cobalt arsenite, it is now phosphate of cobalt mixed with cobalt blue.

Cobden-Sanderson, Thomas James British (1840–1922) Influential binder who, with Emery WALKER, owned the Doves Press from 1900 to 1909. Their books reflected the ideal of a lively harmony among type, illustration, binding, etc. chosen for a book. *See* William MORRIS.

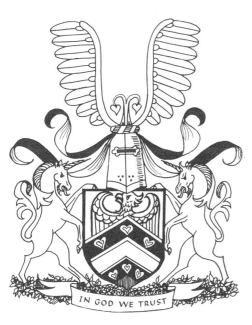

coat of arms

cochineal DYESTUFF, also called CARMINE. Similar to CRIMSON, except that the resin from which it is made comes from Mexican cactus plants stung by the *Coccus cacti* insect. With ten times the TINTING STRENGTH of crimson, and greater PERMANENCE, it all but replaced crimson in the 16th c. A LAKE PIGMENT from cochineal dye is available in Winsor & Newton watercolor.

Cockerell, Sir Sydney Carlyle British (1867–1962) Longtime director of the Fitzwilliam Museum, Cambridge, England. Collected MEDIEVAL manuscripts. Having been secretary to William MORRIS, it was he who, in the late 1890s, suggested to the young Edward JOHNSTON which MSS in the BRITISH LIBRARY might be useful for study.

cockling Bumps or waves in the surface of paper or parchment, caused by heat or moisture. Also caused by folding paper CROSSGRAIN instead of with the GRAIN.

codex From the Latin *caudex* (bark of a tree). Any BOOK which is made of pages, as compared with a SCROLL or other type of book. Began to replace the scroll in the 4th c.

Codex Alexandrinus Greek bible from the 5th c. Written in Greek UNCIALS on VELLUM. In the BRITISH LIBRARY since 1757.

Codex Amiatinus English parchment MS from the early 8th c. Written at the WEARMOUTH-JARROW monasteries in a crisp, late UNCIAL hand. Earliest known complete Latin bible, now housed at the LAURENTIAN LIBRARY, Florence.

Codex Siniaticus Parchment MS written in Greek UNCIALS, dating from the 4th c. Most complete New Testament of its age known, also the oldest Greek VELLUM CODEX. Purchased by the British Museum from the Soviet government in 1933, the Russians having obtained it in 1869 when it was presented to the Tzar as patron and protector of the Greek Church.

codicil From the Latin *codicillus* (diminutive of *codex*). Appendix or supplement added to the original text of a book.

codicology Recent term adopted by some scholars of MEDIEVAL MSS to denote the study of the book as artifact in all its aspects, in conjunction with the traditional studies of content, script and decoration.

cojoined letters Synonym of FUSED LETTERS.

cold press Handmade PAPER which has been dried without much pressure, allowing it to retain a mildly rough, porous surface.

cold type Originally denoted metal type which was ordered from a type foundry and set by hand, as compared to hot metal type which was made actually in the typesetter's shop. Today, it has come to mean phototypesetting.

colombier Paper size measuring $34\frac{1}{2} \times 23\frac{1}{2}''$ (87·6 × 59·7 cm).

colophon From the Greek *kolophon* (summit, finishing touch). It now denotes two things: 1) Note at the end of MS or printed book giving details of production, such as scribe, printer, place of production, and sometimes date. MS colophons sometimes include stock phrases describing, for example, how difficult a task it was to copy the book and how relieved the scribe was to complete it. 2) Logo or emblem employed by a publishing house.

color 1) In the area of paint, several color terms are useful to know: PRIMARY COLORS: red, yellow, blue; SECONDARY COLORS (from mixing the primaries with each other): green, purple, orange; TERTIARY COLORS (from mixing the secondaries): red-orange, yellow-green, etc.; COMPLEMENTARY COLORS: those which are directly across from one another on the color wheel; WARM COLORS: colors on the red-yellow side of the color wheel; COOL COLORS: those on the blue-green side of the color wheel. *See* COLOR WHEEL, NEUTRAL COLOR, SPECTRUM, COMPLEMENTARY COLORS.
2) Dark or light "color" in calligraphy and typography describes the visual impact of writing or type, as determined by how densely or loosely the letters, words and lines have been spaced. "Uneven color" means that certain areas are darker (denser) or lighter (looser) than others. This can be a problem if the RHYTHM of the writing has not been consistent.

color circle Synonym of COLOR WHEEL.

colored inks Usually made from DYESTUFFS, so are rarely PERMANENT enough or opaque enough for lasting work. They come in waterproof and non-waterproof (use only non-water-proof in a fountain pen). PIGMENTED colored inks cannot always be used in fountain pens and are not always permanent. Unless you need the translucence of colored inks, or the project is temporary (as for reproduction), stick to WATERCOLOR and GOUACHE for work with color.

colored pencil The core is often PIGMENT or DYE mixed with clay. Many varieties, colors and qualities are available. For use in lasting work, PERMANENCE must be checked.

coloring matter DYESTUFFS or PIGMENTS which impart color to a given medium such as water, chalk, cloth or paper pulp.

coloring power Synonym of TINTING STRENGTH.

color wheel Also color circle. Pie- or ring-shaped representation of colors as they appear sequentially in the SPECTRUM. Used as a tool in learning color theory, and as a reference for the practicing artist.

column 1) Consecutive columns of text were a necessary feature in SCROLLS. When the CODEX came in, the page usually determined the width of its one column, although there are many examples of two or more per page. 2) Greeks and Romans commonly inscribed texts at the base, head or directly on a stone column, usually to commemorate a person or event. The one most familiar to scribes is the TRAJAN COLUMN.

combatant HERALDIC term for two beasts facing each other in fighting posture.

comma Indication of a pause in a sentence, which first appeared as a point around the 5th c., to be replaced by a slanted line in the 6th c. *See* PUNCTUATION.

commercial A The sign "@," standing for "at" or "for" as in "three cucumbers @ $2.00."

commercial cursive Easily written 19th-c. descendant of the more formal ROUNDHAND; practical for commerce when all such communication was done by hand and needed to be efficient.

color wheel

This kind of writing is associated with the pointed steel DIP PEN, which supplanted the quill in the 1830s. The many names used for commercial cursive, or systems for teaching it, include SPENCERIAN, BANK SCRIPT, PALMER, AMERICAN ROUNDHAND in the U.S. and CIVIL SERVICE HAND in England. *See* SPENCERIAN *for illustration.*

compartment HERALDIC term synonymous with MOUND.

compass Inverted "V"-shaped instrument, one leg of which serves as an anchor, while the other, loaded with ink or graphite, traces a circle of determined diameter.

complementary colors Any two colors directly opposite each other on the COLOR WHEEL. To make any color less brilliant, add a touch of its complement to the paint mixture. Complements set next to each other on the page will visually "jump," an effect that can be used to advantage in the right context. It must be remembered that not any red and any green, for example, will be complementary. If a red is just a little orangey, its complement will be a slightly bluish green. It is well worth the time to implement such subtleties when mixing paint for fine work.

compound curve Synonym of OGEE.

compound letters Synonym of CONSTRUCTED LETTERS.

compressed Synonym of CONDENSED.

concertina Synonym of ACCORDION BOOK.

condensed Lettering in which the characters and spaces between them are narrower than normal. *Compare* EXPANDED.

conservation Choosing lasting materials and treating them well is the best guide to creating artwork which will not fade, darken or disintegrate, perhaps for centuries. Not all work is intended to last, but if that is your aim, you will want to consider these suggestions: 1) Be sure all materials are as ACID FREE as possible. 2) Keep all materials, before and after use, out of direct sunlight, high heat and high humidity. All three are catalysts for chemical change, and may bleach, darken or warp the artwork. Ideal temperatures are between 50–80°F. Humidity should be in the general neighborhood of 50%. A sealed frame will help keep acidic gases in the air from damaging the work. 3) Find out if the materials you are using together will adversely affect each other.

constructed letters As distinct from letters directly written, they are drawn or outlined and filled in, or built a section at a time, sometimes with more than one tool. These letters are common in the most FORMAL work and in letters for reproduction. They can be of any style, but commonly include VERSALS and ROMAN CAPITALS. During the RENAISSANCE, theoretical treatises were written for constructing the ROMAN MONUMENTAL capitals by using geometry; that is, by drawing blueprint-type plans for every angle and curve, as they believed the Romans had done. It is generally agreed today that the most successful letters are drawn with skill and understanding rather than with mathematically predetermined angles and arcs.

contraction Type of ABBREVIATION in which a letter or letters are omitted from the middle of a word.

condensed letters

Mr. & Mrs.
Gordon
Patterson

the river is afraid of
children for all their
of a great city move
off south the country's

copperplate script

Coptic letters

hebron·cuncta
ric· confument
uer fuf m dabira
uaftauit. Regem
omnia quem cir

Corbie script

cool color A color on the blue-green side of the COLOR WHEEL. *See* COLOR.

copperas Sulfate of iron. Formerly referred also to sulfate of copper. A component of IRON GALL INK.

copperplate Also engraver's script. Term derives from the thin plate of copper on which letters were engraved for INTAGLIO reproduction. As engraving became widespread in the 17th c., the letters so produced were modeled after contemporary quill-written ITALIC, but they soon acquired a character all their own. After that, it was pen-written letters which mimicked the technically perfect engraved ones, with their extremely fine HAIRLINES and elaborate FLOURISHES. Copperplate script (then called ROUNDHAND) was the result. It is written (sometimes almost drawn) with a pointed metal nib, set into an OBLIQUE HOLDER which facilitates the extreme slant of the script. These tools replaced the traditional quill in the 19th c. Thicks and thins are achieved by varying the pressure on the flexible nib, and occasionally by RETOUCHING with the same nib. ZANERIAN copperplate is the most FORMAL variety. It involves lifting the pen at every WAISTLINE and BASELINE, creating sharp contrast between thick and thin in a supremely elegant script. Instruction can be found in the *Zanerian Manual of Alphabets and Engrossing* (1981).

Coptic Alphabet used by the Copts, an early Christian sect in Egypt. Their alphabet was borrowed primarily from the Greeks, but was augmented by some Egyptian DEMOTIC characters.

copy Text to be rendered in calligraphy.

copybook Book containing examples from which to practice a given script or scripts, but with no instruction. From 1522 until 1571 these books were printed from WOODBLOCKS; after that they were usually engraved from INTAGLIO plates, until the advent of OFFSET PRINTING. *See* MODEL BOOK.

copyist A SCRIBE who reproduces texts by hand, although not necessarily in fine calligraphy. The printing press, photocopy machine, typewriter and computer have largely taken over the work of the copyist, but there is still demand for unique MSS etc. to be handwritten.

copyright Exclusive right of reproduction and sale of a work of art. In the U.S. and the U.K., this extends from date of copyright to fifty years after the artist's death. Notice of copyright is given by placing the symbol © with the artist's name and the date in a visible place on the work. Scribes may copy once in calligraphy a short poem or part of a longer work. Anything more may be considered an infringement on the copyright of its author, especially if the calligraphy is to be duplicated. It is wise to obtain permission from the author or his estate for any substantial use of his words if they are still under copyright.

Corbie Monastery established at Corbie, France, in the mid-7th c. by monks from LUXEUIL. Its SCRIPTORIUM employed several related scripts which were comparatively easy to read by early MEDIEVAL standards. The Corbie scripts had great influence on the development of CAROLINGIAN MINUSCULE.

corrections

coulée script

Cresci's monumental Roman capital "G"

correction One method of correcting misspellings etc. is to erase the mistake with an ELECTRIC ERASER, then to BURNISH (always over another piece of paper placed over the mistake, to avoid shining the original surface), possibly followed by a light dusting of SANDARAC. On soft paper, it is advisable to use STICK INK ground to a fairly thick consistency to avoid the ink BLEEDING when you write over the erased area. Successful correction requires experience, as every surface is different from every other. Traditionally, mistakes on VELLUM were scraped away with a sharp blade. However, if the mistake was too great to be scraped out, it had to be dealt with in another way. Phrases mistakenly written twice were often crossed out. Sometimes, when a phrase had been left out altogether, it was written in the margin, with humorous drawings noting where in the text it should have been placed.

couchant HERALDIC term describing a beast in repose.

coulée Mid-17th-c. French COMMERCIAL CURSIVE developed by the Ministry of Finance. Pointed pen script with slight BATARDE influence.

counter Fully or partially enclosed space within a character.

coupler HAIRLINE which joins letters in ITALIC HANDWRITING.

court hand One of the many names for what is called SECRETARY HAND. "Court" meant "administrative offices."

covering power Also hiding power. The ability of a paint to cover opaquely the surface on which it is painted. GOUACHE paints have greater covering power than their watercolor counterparts due to the addition of white pigment.

cover weight Also cover stock. Paper for printing; thick enough for brochure covers, business cards, etc. *Compare* TEXT WEIGHT. *See* BASIS WEIGHT.

c.p. 1) Stands for chemically pure, meaning the highest grade PAINTS or PIGMENTS, or those without unnecessary EXTENDERS. 2) COLD PRESS paper.

Crafts Study Centre, Holburne Museum, Bath, England. *See* Appendix, LIBRARIES.

Cresci, Giovanni Francesco Italian (*fl.* 1552–72) Vatican SCRIBE, author. Among his writing books was *Essemplare di piu sorti lettere* of 1560 (facsimile edition and translation by A. S. Osley, 1968) with which he introduced an ITALIC script written with a narrow-cut nib, which he believed would be speedier and more efficient than the precise, angular CHANCERY CURSIVE written with a BROAD NIB. With this book he also illustrated his belief and teaching that MONUMENTAL ROMAN CAPITALS could be better achieved by drawing than by geometrical rendering – an unusual concept in his time.

crest Topmost feature in some HERALDIC designs. Painted above the HELM. In MEDIEVAL and RENAISSANCE times it was an actual carved figure attached to the top of a helmet.

crimson A deep red paint with bluish undertone, available as ALIZARIN CRIMSON and ALIZARIN CARMINE (both of excellent PERMANENCE) and CARMINE (low permanence). The word derives

from the Sanskrit *Krmis* (worm). Originally a dye for cloth made by boiling in water and alkali the red resinous encrustation on trees such as the prickly oak (*Quercus coccifera*). The trees' exudation is caused by the sting of insects such as *Coccus ilicis*, which die by the thousands in the red sap. This type of red dye, made from the resin of various insect/tree combinations, was called by various peoples throughout India, East Asia and Europe by the following names: *qirmiz, kermes, kermesium, lac, lacca* (possibly from the Indian *lakh*, meaning ten thousand, referring to the numbers of insects) and *crimson*. From *lakh* also come our words "lacquer", "shellac" and "lake". The insects, when clustered together, resembled a berry, and thus both the Greeks and the Romans called the dye after their word for berry, *kokkus* and *granum* (from which we get our phrase "dyed in the grain") respectively. The dye was even called *vermiculum*, from the Latin *vermis* (worm), although it has nothing chemically to do with modern VERMILION. These names did not necessarily refer to specific insect resin dyes, but were used interchangeably by manufacturers who lived long before scientific standardization was the rule.

After centuries of use as a dye for silk and wool, crimson began in the Middle Ages to be used as a pigment. The dyed cloth was boiled in LYE and ALUM added to produce a LAKE PIGMENT. Crimson was replaced by COCHINEAL in the 16th c.

crocus cloth Very slightly abrasive cloth which contains a rouge polish (ARMENIAN BOLE). It is used to polish nibs and knives after sharpening.

crop To make a piece of paper, or other surface, smaller by cutting or tearing around its border. The usual purpose is to focus attention on the desired part of the image.

crop marks Lines on a MECHANICAL which indicate to the printer where to CROP the sheet after printing, or where the image area ends.

cross Intersecting vertical and horizontal bands on a HERALDIC SHIELD. *See* ORDINARIES.

crossbar Synonym of BAR.

cross grain Also cross direction. Perpendicular to the paper's GRAIN. A sheet folded cross grain is likely to COCKLE slightly at the fold.

cross-over serif SERIF found on some capital "A"s and "N"s. *See* SERIF *for illustration.*

cross stroke Mark made horizontally, left to right or right to left.

crown Paper size measuring $20 \times 15''$ (50.8×38.1 cm).

crow quill Today, a pointed metal pen, used for fine lines, which has a tiny cylindrical SHAFT. The name derives from quills made of an actual crow's FLIGHT FEATHER which has a much narrower barrel than those of turkey and goose.

crystal parchment Synonym of GLASSINE.

cumdach 9th-c. Irish word for a decorated container for MSS.

cuneiform Generic term for any of the many PICTOGRAPHIC, SYLLABIC and SEMI-ALPHABETIC writing systems which used

mechanical displaying crop marks

crow quill nib and shaft

groupings of wedge-shaped strokes to form their words or syllables. Some were written left to right; some right to left. First developed for commerce by the SUMERIANS in Mesopotamia (modern Iraq) c. 3000 BC, it flourished in the succeeding 2000 years from Iran to Greece. Clay was plentiful in Mesopotamia, hence its natural choice as a writing surface. The inscribed clay was left to harden or baked to preserve the writing.

Since it is messy and awkward to write on soft clay with a pointed STYLUS, a flat strip of reed, wood, bone, or some similar material was held in the scribe's fist to impress groupings of flat lines, which often derived from drawn or carved pictograms. As the scribe sped along (this was for commerce), the stylus swung from one of its corners to the other with each impression. The corner which dug in first was deeper than the other, thus a wedge-shaped impression was made. This wedge, natural to a flat stylus in clay, was imitated in the carved writing of the time. Cuneiform began to lose popularity as linear ALPHABETIC writing spread, c. 1200 BC. Although it died out completely around the first century AD, it is worth noting that modern Hebrew forms, with their thin strokes ending in an exaggerated thickness, may be direct descendants of cuneiform. It is also possible that when the chisel and brush formed the thickened stroke endings on ROMAN letters, the ancient precedent of cuneiform helped these SERIFS to be visually acceptable and desirable. *See* TABLET *for illustration.*

cupped serif *See* SERIF.

cupric acetate Synonym of VERDEGRIS.

cure To make a material harder, usually by heating it. A QUILL is cured by heating until its BARREL turns from milky white and soft to translucent and hard. This is necessary to prevent a pen from quickly developing a permanent SPLAY, and will last perhaps for hours of writing without needing to be sharpened, depending on the smoothness of the writing surface, and the speed and size of the writing.

One method of curing involves cutting off the feather's tip, soaking the feather in water overnight, removing the inner membrane, and then plunging the end into 350°F sand for 55 seconds. (The time the process takes to complete will vary with the thickness of the feather and the fineness of the sand.)

For methods of curing reeds, see REED PEN. *See also* DUTCHING.

curlicue Term for FLOURISH, often one which is overdone.

current Synonym of CURSIVE.

cursive From the Latin *currere* (to run). Any of numerous SCRIPTS characterized by slanted letters joined with hairlines, both of which are results of speedy, informal writing. As long as the materials allowed it (stone, for example, was not conducive to speedy writing), people have always lapsed into cursive versions of their various scripts, some of which are extremely beautiful and legible. Of course the common scribble had great influence on contemporary "serious" writing as well, a development which gave us, among other things, MINUSCULE letters. Two of the most elegant cursives are GREEK minuscule and CHANCERY CURSIVE.

cursive humanist Synonym of ITALIC.

Mesopotamian cylinder seal and imprint

xmo зiбраß
ßажливi є
δ'ютьcя за

Cyrillic letters

deckle edges

cuttlefish ink Synonym of SEPIA.

cylinder seal A cylindrical stone, around 2″ (5 cm) high and ½″ (1·3 cm) wide, carved with pictures and signs. Used in Mesopotamia (modern Iraq) as early as 4000 BC, it was impressed on the seals of doors and vessels to safeguard property, and was used as a signature on clay tablets.

Cyrillic Named for St. Cyril, who set out from Greece in 863 to preach among the Slavs. Because they had no alphabet, he devised one with 43 letters which was based on Greek UNCIAL. He called it *glagol* (word). Its use became widespread when Christianity was established in 988 in Kievan Rus (modern Ukraine). Adaptations, now called Cyrillic, have been used ever since in most Slavic countries.

D The North Semitic word *daleth* (door) was written ◁. It came to denote the sound "d." Early Greeks wrote it as △ (delta). As a ROMAN NUMERAL it stands for 500.

DaBoll, Raymond Franklin (1892–1982) American calligrapher and designer who lived and worked in the Chicago area. Student of Ernst DETTERER at the Art Institute of Chicago. Coined the often used phrase "calligraphy is disciplined freedom." *With Respect to RFD: An Appreciation of Raymond Franklin DaBoll & His Contribution to the Letter Arts* (1978) is an informative volume on his life and work.

da Spira, Johannes A German, he was the first of the famous printers in Venice. His first book was completed in 1469, and its type is believed by some to have been cut by Nicolas JENSON.

David, Ismar German (b. 1910) Lives and works in New York. Graphic, book and type designer, and illustrator. His letters, including metal sculptures of HEBREW WRITING, are distinguished by their clarity and strength of design.

Dead Sea Scrolls Leather scrolls written with ink *c.* 3rd c. BC–68 AD. They were found in 1947 by two Bedouin goatherds, in a cave near the Dead Sea in what is now Israel. The find included eleven scrolls, the largest $10\frac{1}{4} \times 23\frac{3}{4}$″ (26 × 60.3 cm), made of 17 sheets sewn together with thread. The sheets were lined by scoring with a semi-sharp point. Written in square HEBREW, early Hebrew and Aramaic scripts, the texts are mostly Old Testament with commentaries and related writings.

deckle edge Uneven edge or edges on a sheet of paper, formed around the perimeter of the MOLD on which the paper was made. Usually associated with handmade paper, but machine mold-made paper also has a deckle.

deep gold 22k. GOLD LEAF, a little deeper in color because of its slight copper content.

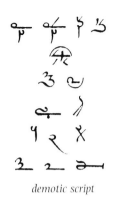

demotic script

diaper pattern

deluxe Describes luxuriously executed MSS created for rich patrons. Among such volumes were the early New Testaments written in gold ink on purple-dyed parchment.

demotic Greek for "pertaining to the people." This was the popular, SEMI-CURSIVE script derived from Egyptian HIEROGLYPHIC carving. The relationship is somewhat similar to that of our everyday handwriting to ROMAN MAJUSCULES. It, in turn, was carved, for example, on the ROSETTA STONE. It emerged *c.* 700 BC and died out at the beginning of widespread Christianity *c.* 450 AD.

demy Paper size measuring $22\frac{1}{2} \times 17\frac{1}{2}''$ ($57\cdot2 \times 44\cdot4$ cm).

descender That portion of a letter that falls below the BASELINE; the lower stem of the minuscule "p," for example.

designer color High quality GOUACHE of special use to those doing work for reproduction. As such, the wide range of colors, some very bright, may not be PERMANENT enough for use by artists doing lasting work.

designer's gouache Non-specific term, but often means GOUACHE of high quality.

detergent Synthetic water-soluble organic preparation which is chemically different from soap, but is able to EMULSIFY oils and to act as a WETTING AGENT. Regular dish detergent can be used as a lubricant for honing a QUILL KNIFE. This avoids the use of oil which ruins paper and vellum, should it ever come in contact. A small amount in water-based paint can also help the paint stick to glossy paper.

determinative Auxiliary mark such as a dot, which clarifies the meaning of a sign, but does not alter its pronunciation. Primarily used in ancient SYLLABIC writing when one sign had many possible meanings. *See* HOMOPHONE.

Detterer, Ernst Frederick American (1888–1947) Having studied with Edward JOHNSTON, he brought Johnston's calligraphic philosophy to his teaching posts in Chicago. There he instructed many who became prominent American calligraphers. Became custodian of the John M. Wing collection at the NEWBERRY LIBRARY, where he organized a calligraphy study group.

device 1) Small visual entity, such as a flower, triangle, leaf, etc., that may stand alone, be repeated or be elaborated upon as part of an overall design. 2) Trademark or distinctive design used by printers and publishers to distinguish their work.

dexter Right side of a HERALDIC SHIELD (as worn), or left side as viewed.

diacritical marks Marks placed above letters to improve legibility or pronunciation, such as the dot on an "i."

diaper pattern From the French *diapré* (diversified with flourished or sundry figures). Geometric DEVICE repeated to form an all-over pattern, used primarily in illumination as a background.

Didot, Pierre and **Firmin** Brothers in 18th-c. France who were part of a family of type designers, printers and publishers. They designed one of the first typefaces known as "modern," which were modeled after very refined engraved letters, as compared

dingbats

dished stroke ending

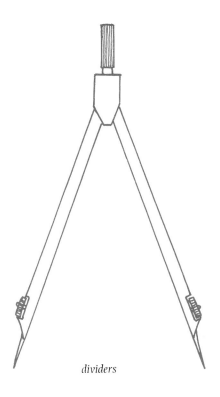

dividers

with the more organic-looking pen-made letters. Their work greatly influenced that of BODONI.

dieresis Two dots over a vowel to indicate that its pronunciation is separate from the adjacent vowel.

dingbat Printer's term for a small visual DEVICE to fill space decoratively or to call attention to part of the text.

dioxazine purple PERMANENT SYNTHETIC ORGANIC PIGMENT used to make mauve and magenta pigments.

dip pen Pen whose NIB must be dipped into an ink supply or have ink or paint brushed onto it, as distinct from one which carries its own ink supply, such as FOUNTAIN, FIBER TIP or BALLPOINT.

diptych In Roman times this was a hinged writing tablet. Two portable wooden panels were each shallowly scooped out on one side, leaving a raised wooden margin and an indented surface on which a thin layer of blackened wax was poured. The cool wax served as the writing surface for a STYLUS. The wax surfaces, being indented, did not touch each other when the tablets were closed together for protection. Today a diptych is any work of art made in two parts joined or displayed together.

dished Type of stroke TERMINAL sometimes found in TEXTUS PRESCISSUS which requires PEN MANIPULATION and which is therefore not merely the result of the quill's natural stroke.

displayed HERALDIC term for any bird of prey in the "spread eagle" position.

display face TYPEFACE designed for headings rather than text.

distilled water Pure water, which is acid free (tap water is acidic). When it dries it will not leave behind chemicals which destroy the paint, ink and paper with which it is used.

dittography The writing twice of what should have been written only once, a common mistake made when a text is copied by hand.

dividers Inverted "V"-shaped device which looks like a compass. It can be used by calligraphers to measure, compare or duplicate exactly distances, such as spaces between writing lines. In illumination it can be used to make regularly spaced border designs and other decorations. Its Latin name is *circinus*.

division A section made by dividing a HERALDIC SHIELD into two or more design areas. *See* ORDINARIES *for illustration.*

document A single sheet used as proof of transfer, receipt or other transaction. However, it can mean any instrument used to convey information.

dog tooth Actual tooth from a dog or animal similar in size, fastened to a handle. Commonly used since MEDIEVAL times to BURNISH gold.

dormant HERALDIC term describing a sleeping beast.

dotting Clusters of colored or gold dots used for MS decoration.

double boiler Also *bain-marie*. Vessel containing a substance to be heated, standing within a pan of water which boils. Used for making PARCHMENT SIZE.

double gold leaf Thicker than single GOLD LEAF, but not actually double the thickness.

double pencil Writing with two pencils bound together is sometimes used as a method for analysis of the structure of writing (for the pencil lines represent the outer edges of a BROAD PEN's stroke).

double spread Two facing pages which contain a design and/or words running continuously across both pages.

doubling The reading of the same line of text twice by mistake. A result of lines that are too long or have too little space between them, and which thus fail to guide the eye easily to the next line.

Dowicide A and **B** Trade name for sodium othophenylphenate, a fine powder which, when used as a $\cdot5-1\%$ solution ($\frac{1}{8}$ tsp. per two gallons), can be used as a PRESERVATIVE. "A" is for plant glue (GUM ARABIC) and "B" is for animal glue (PARCHMENT SIZE, for example).

downstroke Stroke directed toward the bottom edge of the writing surface.

draft Synonym of LAYOUT.

dragon's blood Dark brownish-red resin which exudes from wounds in the bark and from the fruit of certain East Asian and Indian palms. In the 1st c. AD, the historian PLINY recorded that its source was the mingling of elephant and dragon blood during mortal battle. Because it is soluble in alcohol and benzol but not in water, it was used primarily to color varnishes. It is thought that the resin was ground to a powder for use in TEMPERA solutions, but is fugitive in tempera and so was never very popular with illuminators.

draught See DRAFT.

drawing board Also drawing table, drafting table. Table whose top surface can be adjusted to any angle for writing. See LAPBOARD.

drawing ink Formerly CARBON INK, as opposed to writing (IRON GALL) ink. Today it is a non-specific term. See INK.

drawing nib Pointed metal nib whose SHAFT is a semi-cylinder (a CROW QUILL's shaft is a cylinder). Used primarily for COPPERPLATE and COMMERCIAL CURSIVE scripts.

drolleries Humorous drawings in the margins of illuminated MSS. Their popularity began in 13th-c. France.

dry brush Technique of lettering with a brush containing little ink, resulting in brush strokes through which the paper shows.

ductus Direction and sequence of the strokes of each letter.

dull finish Surface of COATED PAPER which is MATTE, not glossy.

dummy 1) Mock up of a book for planning layout, PAGINATION, etc. 2) Mallet used in LETTERCARVING.

durable Synonym of PERMANENT.

Dürer, Albrecht German (1471–1528). Created detailed mathematical systems for constructing INSCRIPTIONAL ROMAN CAPITALS

drolleries

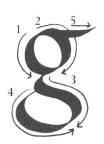

ductus of looped "g"

and GOTHIC letters, as published in his book *Of the Just Shaping of Letters* (facsimile edition 1965).

Durham Book Synonym of LINDISFARNE GOSPELS.

dutching Any of several methods of CURING in which the QUILL is manipulated with a DUTCHING HOOK while cooling, sometimes having started on a hot metal surface. Useful for forming flattened quills which yield larger pen sizes.

dutching hook Small spatula-like metal tool used in dutching.

Dutch metal Also schlag. Type of imitation GOLD LEAF.

Dwiggins, William Addison American (1880–1956) Studied with Frederic GOUDY. Lettering artist and illustrator of great originality who designed books and type (Electra, Caledonia). Worked at Yale and Harvard university presses, at Mergenthaler LINOTYPE Corp., and was instrumental in developing the elegant typography and design of books published by Alfred Knopf. Many of his book designs included lettering and calligraphy.

dye, dyestuff Soluble coloring matter which is used to stain other materials, as it has no substance and little COVERING POWER of its own. *See* LAKE *and* PIGMENT.

E Representing the Semitic word *he* ("lo!") it was a mirror-image of today's form for many centuries. The Greeks codified the modern form in the first centuries BC.

eagle Paper size measuring $42 \times 28\frac{1}{2}''$ ($106\cdot7 \times 72\cdot4$ cm).

ear Small stroke projecting from the top of the LOOPED "g."

early Gothic *See* GOTHIC SCRIPTS.

earth pigment Any of various pigments composed of clay and silica which derive their color from hydrous and anhydrous iron oxide. Many of the best quality deposits for earth pigments are found in France. The colors range from bright yellows through browns, reds, purples and even soft greens. Natural earth pigments have been used since Neolithic times for body decoration and painting.

Heat and oxidation are two primary culprits in causing changes in artists' pigments. Because these natural deposits have been subject to oxidation and heat for millennia, earth pigments undergo very little subsequent chemical change, so are among the most PERMANENT pigments available. Paints derived from earth pigments include: yellow ochre, red ochre, sienna, umber, Indian red, light red, Naples yellow and Vandyke brown.

earwax Gilders have known since MEDIEVAL times that a small amount of earwax added to liquid GESSO or GLAIR helps to eradicate air bubbles which can impair the liquid's gesso texture and scar its dried surface.

Edward IV Late 15th-c. English king whose large collection of illuminated books began the Royal Library. He and his sister Margaret (married to the Duke of Burgundy) were also patrons of the first English printer, William CAXTON.

egg WHITE: beaten egg white and water are the ingredients of the BINDER called GLAIR. YOLK: a few drops can make VERMILION or other warm colors look richer, although the yellow of the yolk itself is FUGITIVE and will fade quickly. Yolk lends itself to STICK INK COLORS or powdered pigment rather than tube paint which already has a lot of additives.

Egyptian Typographical name for MONOLINE capitals, sometimes with slab SERIFS. Term is rare in calligraphy.

Egyptian writing *See* HIEROGLYPHS.

elbow nib COPPERPLATE NIB for a regular PEN HOLDER.

elbow pen holder Synonym of OBLIQUE PEN HOLDER.

electric eraser Hand-held machine with a detachable eraser (called an eraser plug) which spins very quickly, allowing for much faster erasure than by hand. Of the many kinds of plugs available, the one best suited for PAPER and PARCHMENT is of the same consistency as a pencil eraser, and off-white in color. Erasing in short jots, and thereby avoiding prolonged contact with the surface, can help prevent heat build-up, COCKLING, or wearing a hole in the surface.

electric pencil sharpener A sharpener that starts automatically when a pencil is placed in it, and that shuts off automatically when the sharpened pencil is taken out.

elephant Paper size measuring $27 \times 20''$ ($68 \cdot 6 \times 51$ cm).

ellipsis Mark or marks which indicate the omission of words or letters in a text. Three dots or a dash are the most common.

em Typographical term, rarely used in lettering. Square unit of measurement, equaling the height and width of the "m" of any given typeface. The amount of space between words, for example, can be described by how many ems wide it is.

emblazon To render in paint a HERALDIC shield from its BLAZON (written specifications).

emboss To stamp, by machine, or to manipulate, by hand, a raised design, usually in a paper surface or leather BINDING. Soft paper is embossed by placing it over a piece of cardboard or other hard material and gently easing the cardboard design into the paper with a BONE FOLDER or similar tool.

embryo writing The very beginnings of writing in any culture, usually mostly concerned with myth and magic. Generally, writing before any system has developed.

emerald green Formerly made with arsenic, it was poisonous and sometimes turned black on contact with other colors. Today, however, it is a brilliant, sassy green-blue which is PERMANENT and flows well from a pen.

emery paper Variety of SANDPAPER. Sometimes leaves a gray residue on VELLUM.

emulsion Suspension of fine particles or globules of one liquid in another liquid, such as EGG YOLK, which is an oil/water emulsion. In yolk, lecithin is the emulsifier, or the substance that keeps the oil and water from separating.

en Unit of measurement, half the width of an EM.

end-line fillers Decorative extensions of a letter or other design used to fill up a line of writing containing too few words to reach the right-hand MARGIN. Popular in MEDIEVAL times.

endpaper Blank or decorated paper which can be glued to the inside of a book's cover or used as a FLY LEAF.

engine sized Synonym of BEATER SIZED.

English half uncial Synonym of ANGLO-SAXON HALF UNCIAL.

engraver's script Synonym of ZANERIAN COPPERPLATE.

engraving Type of INTAGLIO printing.

engross To copy a document in a formal, ornate way for ceremonial purposes. Today, "engrossing" connotes the rendering of a certificate or resolution in a 19th-c. style of lettering, often employing GOTHIC, COPPERPLATE and LOMBARDIC capitals (sometimes all in the same piece of work). This style is typified by the meticulous work in the *Zanerian Manual of Alphabets and Engrossing* (1895, 1981). Until the mid-1970s, many American scribes who made their living handlettering awards called themselves engrossers. Since then, the label "calligrapher" is much more common.

Enschedé In Holland in 1743 the Enschedé brothers started a printing house which produced work of the highest caliber. The house continues today, and owns one of the world's largest collections of antique type. 20th-c. designers employed there include Jan van KRIMPEN.

entasis Slight thinning in the center of the STEM of some letters, as in ROMAN CAPITALS. Done to lend grace to strokes which might otherwise look too mechanical. In architectural columns, the word "entasis" denotes a slight bulge in the middle.

epigraphy Study of inscriptions that are cut, engraved or molded in hard materials such as stone, metal or clay. *See* PALEOGRAPHY.

eraser The standard pink variety is raw rubber crushed, ground and mixed in roller mills with additives such as sulfur. When heated ("vulcanized"), the particles fuse into a mass, to be cut up as required. Ancient erasers include a damp sponge (for PAPYRUS and PARCHMENT), a sharp knife (for parchment), PUMICE stone and pieces of bread or BREADCRUMBS. *See* KNEADED –, ELECTRIC –, CORRECTIONS.

erasing shield Thin metal or plastic sheet punched with variously sized holes, which, when placed over a spot to be erased, especially with an ELECTRIC ERASER, protects the surrounding area from damage.

escutcheon Synonym of HERALDIC SHIELD.

Etruscans A people who migrated, apparently from Asia Minor, to the north-west Italian peninsula during the late Bronze Age (*c.* 1500–1200 BC). They were driven out of Italy by the Latin-

engrossing

Etruscan toy jug with inscribed alphabet, c. 7th c. BC

expanded letters

speaking people in 509 BC, but not before passing on to the LATINS, among other things, the alphabet (*c.* 700 BC) which they had acquired from the Greeks and had developed to their own use. Little is known about the Etruscans. Although their alphabet is from the Greek, their language is unrelated, and has never been deciphered by modern research. Our lack of knowledge is due in part to the political stake which the Romans had in obliterating any record of the Etruscan history and culture.

exemplar In MEDIEVAL times this was the book from which COPYISTS worked. Today, it is the model from which a student copies the writing he is learning.

exordia Opening words of a chapter emphasized by being all in capitals.

expanded Letters that are wider than normal, meaning that the spaces within and between them have been widened. *Compare* CONDENSED.

explicit A Latin word, meaning "unrolled" or "declared." It was used by MEDIEVAL SCRIBES in texts to say "here ends" this section, or this book. *Compare* INCIPIT.

extended Synonym of EXPANDED.

extender Inert white powders such as ALUMINUM HYDRATE, BLANC FIXE, CLAY and CHALK, used in paint for three purposes: as a substrate for LAKE pigments; to reduce the TINTING STRENGTH of pigments such as yellow ochre, which are otherwise too concentrated; and as an additive to cheap paints to make the consumer believe he is getting more pigment than he actually is. This is why the higher priced brands of paint can be more economical – they go much further.

extra bold Typeface whose strokes are extremely wide for their height.

extruder Synonym of ASCENDER and DESCENDER.

F From early Greek times until about 200 BC this sign looked something like a backward "F," and had the sound of a modern "W." The LATINS gave it the form and phonetic value that we use today.

f. Abbreviation of FOLIO. ff. = folios.

face Abbreviation of TYPEFACE.

facsimile The reproduction of a MS at its original size. However, the term commonly denotes a reproduction of any kind used for study.

fade A lightening or weakening of a color, usually from the effects of light, atmospheric gases or heat.

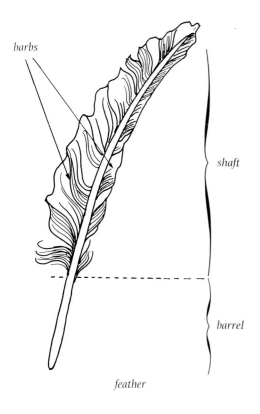

barbs

shaft

barrel

feather

Fairbank, Alfred John British (1895–1982) Student of Graily HEWITT. Champion of ITALIC HANDWRITING, calligrapher, teacher and type designer. *A Book of Scripts* (1949), *A Handwriting Manual* (1932) and *The Story of Writing* (1970) are among his publications. Founder of the SOCIETY FOR ITALIC HANDWRITING in 1952.

Fanti, Sigismondo Italian (*fl.* 1514–35) Author of the first printed writing manual, entitled *Theorica et pratica de modo scribendi* (1514). It contained no illustrations of writing.

faulting After an area is GILDED, there may be small areas unintentionally left ungilded. The process of faulting entails re-gilding these parts to create an even surface of gold.

feather Feathers of use to scribes are the FLIGHT FEATHERS, also called "primaries," of a large bird such as a goose, turkey, and swan. These are the first five feathers, counting in from the wing tip. They can be recognized when detached from the bird by the wide BARBS on one side of the shaft, and narrow barbs on the other. Each type of bird produces feathers of different quality. Goose feathers generally make thin, flexible QUILLS, whereas turkey quills are usually thicker and stiffer, yet not as hard as those from geese.

feathering The blurry spreading of ink outward from a stroke due to watery ink and/or absorbent or loose fibers in the writing surface. Similar to BLEEDING, but less serious.

Feliciano, Felice Italian (*fl.* mid-15th c.) Veronese antiquarian who believed that the painters of letters in classical ROMAN inscriptions had used COMPASS and STRAIGHTEDGE to lay out their letters for carving in stone. He was the first to produce a treatise on letter design using geometry, in the early 1460s. A modern edition of this work, *Alphabetum Romanum*, was published by Giovanni MARDERSTEIG in 1960.

ferrule The part (usually metal) of a BRUSH that holds the brush hairs.

fess Band across the middle of a HERALDIC SHIELD. *See* ORDINARIES.

fess point Center of a HERALDIC SHIELD.

fiber-tip pen The spirit- or water-base ink used in these nylon or felt-tip pens is FUGITIVE. Useful for layouts and other temporary work, such as for reproduction. In use since the mid-20th c.

field Background of a HERALDIC SHIELD, which may be a solid TINCTURE, a DIVISION or DIAPER PATTERN.

field of writing Synonym of WRITING FIELD; the area of writing on the page.

filigree Ornate decoration made of fine, curving lines.

filler Synonym of EXTENDER.

fillet 1) Very slight filling in of the angle formed by a STROKE and its SERIF. Fillets are not natural to calligraphy directly written, but occur in CONSTRUCTED LETTERS and in TYPE. *See* SERIF *for illustration*. 2) Design impressed on a book cover.

financière Any of several kinds of French SECRETARY HAND, such as RONDE and COULEE.

Fine Print Important bookarts journal published since 1974 in San Francisco. Often includes articles concerned with calligraphy. *See* Appendix, PUBLICATIONS.

finger cot A thin latex covering used to protect an individual finger from poison such as lead or CADMIUM during the mixing of GESSO or paint, or from stickiness while mixing something like GUM AMMONIAC with the finger.

finial Tiny "sub-stroke" often made unconsciously when starting or ending a stroke or letter, especially in handwriting. More common words for this are "TICK" (in informal writing or handwriting) or some kinds of SERIF (in FORMAL writing).

finis The Latin word for "finish," sometimes written or printed at the end of a book.

fish glue Made from fish skins, not heads and bones. This is the best glue for GESSO. It is sold in cakes and broken sheets. That sold in tubes contains adulterants such as PLASTICIZER and PRESERVATIVE, and does not work as well.

fishtail Two-stroke decoration found on some FRAKTUR letters.

fixatif, fixative Clear spray to protect a surface which has been written on from moisture and smudging. Also used to help keep particles of pastel or charcoal from falling off the artwork. Traditionally these sprays were RESINS dissolved in ALCOHOL, which usually provided a shiny coating. Today you are more likely to find synthetic resins such as nitro-cellulose, dissolved in ACETONE or some equally noxious medium, providing a MATTE finish. In any case, fixative slightly changes the color of the artwork, so a light coating is recommended, and only when necessary. WORKABLE FIXATIVE is a spray coating which allows you to continue working on the surface after spraying. Other fixatives may repel ink and paint. *See* HEALTH HAZARDS.

flag end The tapered point of a pointed BRUSH.

flamed stroke Heavy shading on the inside of a curve or the end of a straight stroke, found primarily in 19th-c. American COMMERCIAL CURSIVE or ORNAMENTAL HANDWRITING.

flanche A curved marking. Used in pairs to flank the sides of a HERALDIC SHIELD. *See* ORDINARIES.

flat terminal Stroke ending which is flat against the WRITING line due to a 0° PEN ANGLE, or stroke ending which is drawn to simulate such a pen angle. *See* TEXTUS PRESCISSUS *for illustration.*

flesh side The surface of VELLUM that was the side of skin internal to the animal's body, and normally the less desirable side to write on. Although it can be difficult to distinguish from the HAIR SIDE, some shallow impressions made by blood vessels can often be seen. This side is usually the whiter, and no hair follicles are present.

fleuron Ornament shaped like a formalized flower. In TYPOGRAPHY it is usually circular, but not necessarily a flower.

flexible binding Also limp binding. Binding in which the covers are leather, or leather and thin paperboard, and use no wooden boards.

fishtail on ascender of fraktur "h"

flamed stroke

flexi-curve Synonym of ADJUSTABLE CURVE.

flight feather Also primary feather. Any of the first five feathers, counting in from the wing tip. *See* FEATHER.

floriated Term to describe an initial, border, binding, etc., decorated with flower patterns.

flourish From the same root as the word "flower," a non-structural embellishment added to a letter or letters.

flour paper British name for the finest grade SANDPAPER.

flush left An arrangement of text that has an even left-hand MARGIN.

flush right An arrangement of text which has an even right-hand MARGIN.

fly leaf Blank page(s) at the beginning and end of a book.

foil From the same root word as "leaf." Thinly rolled out soft metals; thicker, however, than metal LEAF and not used for scribal GILDING.

fold Smoother when done along the GRAIN of paper, or along the direction of the animal's spine in PARCHMENT. LONG FOLD: a fold along the shorter dimension. SHORT FOLD: a fold along the longer dimension.

foliate To number the LEAVES instead of the PAGES of a book.

folio 1) Book whose text is contained on a single sheet of PAPER or PARCHMENT folded in half (BIFOLIUM). 2) Book whose page size is half a sheet of paper; thus, a large book. 3) In MEDIEVAL and RENAISSANCE times it was likely to mean what we mean by LEAF today; that is, only half the folded sheet. Medieval MSS are usually not PAGINATED, but FOLIATED; thus, pages 1 and 2 are f.Ir (r for RECTO) and f.Iv (v for VERSO).

font Complete typeface, including punctuation, accent marks, and numerals as well as letters.

foolscap Paper sheet measuring $13\frac{1}{2} \times 17''$ ($34\cdot3 \times 43\cdot2$ cm).

foot Lower portion of any downstroke which terminates at the BASELINE. Such a stroke can be described as "off its foot" if it fails to reach the baseline.

fore edge Edge of a book opposite the SPINE.

forel Type of PARCHMENT used for book covers, inferior as a writing surface.

form Abbreviation of LETTERFORM; the shape of any figure. Also synonym of FORMAT.

formalin Preservative which, when used in watercolor, may ruin its texture, but which can be used successfully, for example, in paper SIZING solution and book binding paste, to prevent growth of bacteria and mold.

formal script Characterized by letters that do not touch each other and that are written at relatively slow speed, as compared with SEMI-FORMAL and CURSIVE. The term connotes modern use of these hands, as BOOKHAND suggests their ancient use.

said unto Saul, I cannot go for I have not proved them. put them off him. And he in his hand, and chose him stones out of the brook, and the shepherd's bag which he

foundational script

format One's primary concept in designing or laying out a project, as in "flush left –," "three dimensional –," "circular –," etc.

formata Synonym of SEMI-FORMAL.

Forty-two Line Bible Synonym of the GUTENBERG Bible, so called for the number of lines on each page.

foundational Script developed by Edward JOHNSTON around the turn of the 20th c. for teaching the basics of calligraphy. Derived from the late English CAROLINGIAN hand found in the RAMSEY PSALTER.

foundry type Synonym of HAND-SET TYPE.

fount British name for type FONT.

fountain pen Refillable pen with self-contained ink supply. The ink is fed to the paper through capillary attraction. The first of its kind was patented by L. E. Waterman in 1884, although many were introduced before and many improvements were made after.

Modern calligraphic fountain pens are useful for everyday handwriting and informal work, providing the ink/pen combination does not clog or hemorrhage. They are hardly ever used for the best work because the ink is rarely lightfast or black, and because the sharp hairlines provided by DIP PENS are often impossible to achieve with them.

fountain pen ink The easiest to use is a non-waterproof dye INK. To darken the color, allow the ink to evaporate a little in the bottle. Pigmented ink may clog, and an ink that is truly waterproof will clog and ruin the pen. *See* INK.

Fournier family Eighteenth-c. French family of distinguished typefounders and printers. Pierre Simon Fournier developed the first system of identifying and measuring type, including an early POINT system.

foxing Brown spots, usually a mold, which can grow on paper that has been kept in dampness.

fraktur RENAISSANCE German LETTERFORM, first cut in type in the late 16th c. The handwritten version was an imitation of the type. Fraktur is a BATARDE which became the standard script and type in Germany from the mid-16th c. until 1941, when Hitler forced it out in favor of the more legible ROMAN types. An informal version of it was also the model for German handwriting during that time. *See* NEUDÖRFFER *for illustration*.

free hand INFORMAL version of SET HAND, in use in England, 12th–16th c.

Freeman, Paul (1929–80) American calligrapher, painter, ceramicist and sculptor. An inspiring teacher known for his playful use of LETTERFORMS. Founding member of the SOCIETY OF SCRIBES in New York in 1974.

French curves Plastic template for drawing curved lines.

French fold Sheet of paper folded in half twice, so that four pages may be printed on one side of a sheet.

French fold

French ultramarine Synthetic ULTRAMARINE blue pigment.

frisket *See* RESIST.

frontispiece Illustration facing the TITLE PAGE of a book.

Fugger, Wolfgang German (*c.* 1515–68) Protégé of master penman Johann NEUDÖRFFER. Wrote and printed very early letter design manual for PUNCH CUTTERS and printers, *Nutzlich und wolgerunt Formular* (1553). Two modern editions are: *Wolffgang* [sic] *Fugger's Writing Manual*, H. Carter, ed. (1955) and *Wolfgang Fuggers Schreibbuchlein*, A. Kapr, ed. (1958).

fugitive COLORING MATTER whose color fades easily when exposed to light. Some of the more fugitive PIGMENTS are the LAKES. The ink used in most FOUNTAIN PENS and FIBER-TIP PENS is fugitive as well. *Compare* LIGHTFAST. *See* PERMANENCE.

fused letters Also cojoined letters. Two letters that share a member in common, like Siamese twins. *Compare* LIGATURE.

fusion Unit made by FUSED LETTERS.

futhark, futhork Another name for the alphabet of RUNES. The name is taken from the first letters of this alphabet.

fused letters

G Derived from the Semitic *gimel*, it was written ⋀ in the Sinai *c.* 1500 BC. This sign had roughly the phonetic value of our "G," but because the cultures who used the letter drew little or no distinction between the sounds of the letters "C," "G," and "K" (in the same way as we make no difference between certain C and K sounds), the *gimel* (*gamma* in Greek) eventually became the Greek letter "C" (being the original *gimel* turned 90°). The Romans developed the letter "G" ("C" with a crossbar) *c.* 300 BC. LOOPED "g": "g" as compared with "*g.*"

gaken dish A dish made of unglazed porcelain, so GRINDING on this white surface will not add gray to the color of WATERCOLOR ink sticks as a slate stone will.

gallic acid White crystalline acid found widely in plants. Extracted by bruising and soaking GALL NUTS in water for use in IRON GALL INK.

gall nuts Growths of a very small size – up to 2″ (5 cm) in diameter – resulting from the gall wasp's deposit of eggs in the leaves, bark or roots of certain Asian oak trees. The galls are soaked in water to release their gallic acid for use in IRON GALL INK.

gallo-tannic ink Synonym of IRON GALL INK.

gamboge Used for centuries in Asian painting, it is a yellow GUM RESIN which exudes from several species of garcinia trees, found mostly in India, Sri Lanka and Thailand. Incisions in the trees yield a yellowish-brown milky juice which hardens in the air. This is then ground to powder which is mixed with a BINDER and

gaken dish

Garamond roman and italic typefaces

gilder's cushion

gilder's knife

water to make watercolor paint. Gamboge is FUGITIVE, but has lasted well in some MEDIEVAL MSS.

NEW GAMBOGE is a synthetic paint made by Winsor & Newton, blended from arylamide yellow and toluidine red; more OPAQUE and LIGHTFAST than natural gamboge.

Garamond, Claude (1480–1561) French PUNCH CUTTER instrumental in popularizing ROMAN (as opposed to the then-popular GOTHIC) LETTERFORMS in France; and for designing roman and ITALIC "families" of typefaces harmonious with each other.

garlic juice Actual juice of garlic, used as a size in GILDING. Probably commonly used in late MEDIEVAL times for gilding on fabric (banners, etc.).

gathering Synonym of QUIRE.

gelatin Colorless, odorless, tasteless protein substance made by boiling animal or vegetable tissue, and available in sheets or granules. It is the gelatin content which makes animal GLUE and PARCHMENT SIZE useful as BINDERS in PAINT and GESSO and as a size for PAPER. VEGETABLE GELATIN is made from, for example, seaweed.

gesso Also asiso. Used as a GROUND for GILDING. A mixture of slaked PLASTER OF PARIS, sugar (a PLASTICIZER for flexibility), GLUE (for stickiness while moist and hardness when dry), white lead (for hardness) and a little color, usually reddish, to help distinguish the applied gesso from the surface to which it has been applied.

gild To apply gold or other metal LEAF to a sticky ground which has been put on the writing surface. WATER GILDING: gilding onto a plaster GESSO base. A term used mainly by framers to distinguish it from mordant or oil-base gilding. MORDANT GILDING: gilding done with oil-based grounds on wood, glass, metal, etc. This yields a MATTE finish. It is not done on paper or vellum because the oil would spread on such surfaces. NOTE: although the mordant/gesso distinction is made by other craftspeople, scribes use the word "MORDANT" to describe all gilding grounds, including gesso.

gilder's clay Synonym of ARMENIAN BOLE. The name refers to some GILDING GROUNDS that use it as their primary ingredient; a rare type of ground for MSS illumination today.

gilder's cushion Pad on which to cut LEAF during gilding. A common type is a board of about 7 × 10″ (18 × 25 cm), with a layer of cotton (not cotton cloth) placed on it. A piece of suede is stretched over the cotton and tacked to the board. A screen of PAPER or PARCHMENT can be added to prevent air currents from disturbing the fragile gold leaf. Some gilders dust the cushion with a little talc or ARMENIAN BOLE to keep the leaf from sticking to the cushion.

gilder's knife A knife with a sharp, straight blade, 7–8″ (17–20 cm) long. Used for cutting leaf into conveniently sized pieces on the gilder's cushion. The knife must be kept free of grease by using it only for cutting leaf, by not touching its surface with the fingers and by dusting it with talc or wiping the blade often with clean silk during gilding. If grease does get on the blade, the gold will stick to it.

picking up leaf with a gilder's tip

gilder's tip Two pieces of stiff paper about 4″ (10 cm) square, between which is set a row of camel hair (for gold) or badger hair (for silver or other heavier leaf). The hair is stroked against one's own hair or skin to collect enough oil on the tip to pick up pieces of leaf from the gilder's cushion.

Gill, Eric British (1882–1940) A student of Edward JOHNSTON, he was a master stonecutter (letters and human figures), designer, illustrator, and calligrapher. He designed six typefaces, including Gill Sans (a SANS SERIF face based on the London Underground face of Johnston) and Perpetua.

Gillott, Joseph British (1799–1873) A former Sheffield steel worker, Gillott in 1822 developed a machine which could stamp out steel pen nibs in great quantities, lowering their cost dramatically.

gingerbread Overwrought decoration, common in the 19th c.

glair To make glair, stiffly beaten egg white is placed in a dish, three or four tablespoons of WATER are poured over it if desired, and the substance is left to sit refrigerated overnight. Then, the resulting glair liquid is reserved while the foam is discarded. Glair can be used as a BINDER in WATERCOLOR and GESSO. It was widely used thus by medieval ILLUMINATORS, who found it had very delicate properties desirable for use with, for example, light blues. For richer colors, GUM was favored, as it helps bring them out. Most often a mixture of the two served best. Glair will stay good in the refrigerator for a few days.

glass engraving Also hyalography. To scratch letters in crystal with a diamond-tipped STYLUS and/or an electric rotary tool. The more lead in the crystal, the better the surface for incising. The design, on paper, may be taped on the reverse side of the glass as a guide for engraving.

glass gold Signmakers' name for loose leaf GOLD LEAF.

glassine Also crystal parchment. Thin but tough, slick, nearly transparent paper sometimes put on GESSO gilding during the first tentative passes with the BURNISHER after LEAF is applied. Its slick surface and ACID-FREE composition make it ideal for placing between individual pieces of artwork in storage.

glass muller Type of MULLER used in mixing GESSO or PAINT.

glaze 1) To CALENDER paper. 2) To cover with glass, as in a picture frame.

gloss 1) Secondary words inserted between lines of writing or in the margins of a page of writing or printing, sometimes added centuries later. Often a commentary on the main text, but can also be a translation of the main text into the vernacular. 2) The quality of shininess in a surface; opposite of MATTE.

glue Varieties most used in the scribal arts are FISH –, WHITE –, PARCHMENT SIZE (glue made from VELLUM), and WHEAT PASTE. *See* RABBIT SKIN –.

glue stick Translucent white glue which comes in a lipstick-like tube. Will not damage surfaces, but cannot be relied on to hold fast over a long period. Useful for pasting up rough drafts or other temporary work.

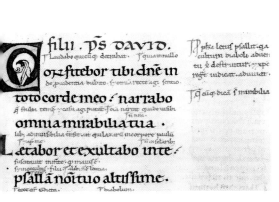

text with gloss

glycerine Today a by-product of soap manufacture, it was first prepared in 1779. It is a clear, syrupy substance, chemically an ALCOHOL. Because of its HYGROSCOPIC nature, it is used as a PLASTICIZER to impart flexibility to WATERCOLOR.

Sometimes upon squeezing a tube of paint what first comes out is nothing but clear glycerine which has separated from the paint. Too much of it in the paint you use can cause stickiness and slow drying.

glyptic Work carved or engraved, especially seal engraving. *See* CYLINDER SEAL.

goatskin 1) Type of PARCHMENT. 2) Type of leather for BINDING books.

gold leaf Sheets of gold $3\frac{3}{8}''$ (8·6 cm) square and 1/275,000 of an inch thick. Such thinness is achieved by running sheets of gold between rollers, then hand-beating them between layers of soft animal skin and/or intestine (formerly it was all done by hand-beating). As the gold becomes thinner, a quarter of it is removed, that quarter is beaten and quartered, and so on until one ounce of gold has been hammered into 2,000 standard leaves, available in two kinds of booklets. LOOSE GOLD is sold on pages of thin paper coated with ARMENIAN BOLE to prevent the gold from sticking to the pages. This type gives a finer finish than TRANSFER GOLD, also known as patent gold, which comes attached to its pages by pressure during manufacture. Thus, the whole page is pressed face down onto the gesso. Although this is easier to handle, it is considered inferior to loose gold.

Many types of gold leaf are available, but those most commonly used by illuminators are called "regular" or "selected" and are $23-23\frac{1}{4}$ k., single or double thickness. Double gold, although not literally twice as thick as single, is thicker and easier to handle. *See* LEAF *for related entries.*

gold powder Fine particles of gold available from gold beaters (makers of GOLD LEAF). When mixed with a SIZE, such as GELATIN, FISH GLUE or GUM ARABIC, and with water, a paint is produced which is used with a brush or pen like watercolor. This paint can be BURNISHED when dry. To grind a tablet of gold powder into finer particles or to make GOLD LEAF or SKEWINGS into gold powder, the following method has been suggested by Thomas Ingmire, a well-known San Francisco calligrapher and teacher: break up tablet or place equivalent amount of gold leaf in a small glass mortar. Add a quarter teaspoon of salt, three or four drops of honey, and enough water to lubricate. Grind with glass pestle for 10–15 minutes. Fill the mortar with water and swirl around to mix. When gold settles, drain off the liquid, reserving the gold. Add and drain water four or five more times, and let gold dry in mortar. Melt a small gelatin capsule, or $\frac{1}{2}$ a medium one in a teaspoon of warm water and add to the gold, stir thoroughly and pour the mixture into original container (or cup about one inch across), where it will be ready for use. If allowed to dry, reconstitute with wet brush. See SHELL GOLD.

gold size Any substance such as GESSO, GUM AMMONIAC, ACRYLIC GLOSS MEDIUM, GARLIC JUICE, etc., used to stick GOLD LEAF to the writing surface. *See* SIZE *and* GILD.

gooping Excessive deposit of ink made by a ballpoint pen. A way to minimize this is to wipe the point with tissue frequently.

goose quill pen QUILL pen made from a goose feather.

Gothic "Gothic" became a contemptuous term given by RENAISSANCE scholars for the late MEDIEVAL style in architecture, letters, etc. (*c.* 1200–*c.* 1500) which used angular, pointed arches; a style also called "*moderna*." It is thought to have originated not with the Goths (the Goths were powerful, adventurous Germanic tribes who played an important role in the crumbling of the Roman Empire, finally sacking Rome itself in 410 AD), but in the Near East, coming to Europe during the Crusades. Dubbing this style "Gothic" was to imply its barbarity in comparison with the recently rediscovered "*antiqua*," or CLASSICAL ROMAN style, with its rounded arches and aura of a golden age. Since this name for the style dated from the Renaissance, the late medieval scribes themselves would probably have called their work simply "writing," or perhaps "*moderna*" or TEXTURA, not "Gothic."

Important developments during the Gothic period were the establishment of universities in Paris, Bologna and elsewhere, the rise of paid scribes instead of solely scribal monks and nuns, and the emergence of literature in the vernacular (Chaucer in English, Dante in Italian), instead of in Latin.

Gothic scripts BLACKLETTER, BATARDE, FRAKTUR, SCHWABACHER and ROTUNDA are characterized by angular arches and/or close INTERLETTER SPACING and INTERLINEAR SPACING. They were widely used *c.* 1100–*c.* 1500. EARLY GOTHIC (*c.* 1100) is a narrower, slightly angular version of late CAROLINGIAN.

Above and right: *early Gothic script*

Gothicized italic script

Goudy Old Style

Gothicized italic Script developed by Edward JOHNSTON combining features of ITALIC and BLACKLETTER. Unlike blackletter, it contains no straight lines, giving it a lively fluidity.

Gottingden Model Book This and the Berlin Model Book are the only two medieval MODEL BOOKS known to give the reader step-by-step instructions in painting designs for MS illumination. It is unique in that many MEDIEVAL MSS (including some GUTENBERG Bibles) have been identified as having followed this very book. Originally written in the 15th c., a modern edition has been edited by Helmutt Lehmann-Haupt and published in 1972 in German with an English translation.

gouache Also body color, designer's gouache. WATERCOLOR with BLANC FIXE or other chalk added for opacity, a quality which often makes it superior to watercolor for lettering.

Goudy, Frederic William American (1865–1947) Originally an accountant, he became the most prolific and influential Ameri-

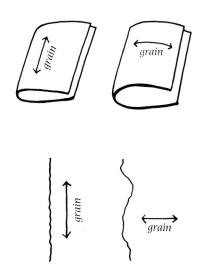

can type designer of the early 20th c. Wrote *The Alphabet and Elements of Lettering* (1918, 1963). His best-known type designs include Goudy Old Style, Kennerley and Deepdene.

graffito, *pl.*-ti Unauthorized writing or drawing which is scratched, scribbled or painted in public places.

grain 1) Direction in which most of the fibers of machine-made paper are lying. The direction is important if paper is to be folded or rolled. It will fold more easily and smoothly *along* the grain. Two methods of determining grain are firstly, to bend the paper in half, noting how much it resists bending; and secondly, to tear the paper. Handmade paper may be folded indiscriminately, as it has no grain. Its fibers are lying evenly in all directions. 2) From the Latin *granum* (berry), a red insect dye. *See* LAC *and* CRIMSON.

graphite Crystalline form of carbon. The Aztecs were using crayons of graphite in 1520, as Cortés recorded. Since 1891 it has been made artificially.

graphite paper Thin, translucent paper covered with a dense film of graphite powder, used to transfer designs from one surface to another without the indelible marks that standard carbon paper would leave. The homemade variety is a piece of tracing paper rubbed on one side with a pencil. *See* TRANSFER PAPER.

graphology Study of character from handwriting.

graver Synonym of BURIN.

gravure Variety of INTAGLIO printing process.

Gray, Nicolete British author whose books discuss a wide variety of writing and lettering and their cultural context: *Lettering as Drawing* (1971, 1982); *A History of Lettering: Creative Experiment and Letter Identity* (1986). Founded the Central Lettering Record at Central School, London, where she taught.

Greek writing The basis for all Western alphabets comes from the Greek alphabet, which was appropriated and modified from PHOENICIAN writing around 1000 BC. The Greeks began writing and carving "right to left" like the Semites, and later wrote BOUSTROPHEDON style, which alternates the direction with each line of text. The letters themselves would often be reversed, usually while writing or carving "right to left," because the direction in which letters progress across the line has no bearing on the ease of the lettercarver's task. The writing at that time was an imitation of carving, and followed suit. Writing was done on PAPYRUS with a REED BRUSH, a portion of rush grass pointed and frayed at the end. As writing became more common, and with the advent of the SPLIT REED PEN, *c.* 600? BC, it became clear that to avoid smears "left to right" was superior, and the letters gradually became standardized "facing right" as they do today.

Although, like Latin, Greek had a CURSIVE version almost from the beginning, which was simply the result of speedy writing, it remained, like Latin, a MAJUSCULE alphabet until MEDIEVAL times.

green earth Ancient dull green EARTH PIGMENT composed of magnesium and aluminum potassium silicates. Although it was used in MEDIEVAL MS paintings, mainly as underpainting for flesh tones, today it has been replaced by OXIDE OF CHROMIUM in AQUEOUS PAINTS.

Greek late majuscule (top) *and minuscule script*

green vitriol Iron sulfate, used to produce IRON GALL INKS.

Griffo, Francesco Italian goldsmith and PUNCH CUTTER who worked with Aldus MANUTIUS at the end of the 16th c. His many seminal typefaces include BEMBO (1495) and the first ITALIC (1500).

grinding Before machine-ground PIGMENT and paint, pigments had to be ground by breaking up large chunks of mineral or resin in a mortar and pestle, which were then ground for some hours with water, with a MULLER and slab. There is an optimal particle size for each pigment in each MEDIUM, a fact to keep in mind when mixing and grinding one's own paint. For example, MALACHITE becomes too pale when ground too fine, whereas VERMILION seems only to get richer with much grinding.

Grinding STICK INK on unglazed porcelain, slate or other ink stone with water produces liquid ink.

grinding dish Synonym of GAKEN DISH.

grinding stone *See* INK STONE *or* SHARPENING STONE.

grotesk Term sometimes used by printers for SANS SERIF letters.

grotesques Fantastic human and animal forms.

ground 1) In calligraphy, the writing or painting surface, such as PAPER, VELLUM, etc. 2) In GILDING, the base for metal LEAF, such as GESSO, GUM, etc.

guard sheet Thin sheet of paper placed under the hand while writing to keep moisture and hand grease, which repels ink, from the writing surface.

guideletter Also initial instruction letter. Tiny letter written lightly in a blank space on a page of text to indicate to the illuminator which decorated letter he is to place there.

guideline Lines marking any or all of the following: BASELINE, WAISTLINE, CAP LINE, ASCENDER LINE or DESCENDER LINE. Used during lettering to keep the writing precisely as intended. If curved writing is wanted, the guidelines are so curved. Guidelines may be erased after writing or kept as decoration. In MEDIEVAL MSS, guidelines often "suggested" rather than delineated the waistlines and baselines, while the actual writing was done by eye.

gum Plant exudation which dissolves or swells in water. *Compare* RESIN.

gum acacia Synonym of GUM ARABIC.

gum ammoniac Also ammoniac. Dried lumps of the milky secretion of a very large member of the carrot family, which grows in North Africa and Iran. The lumps are soaked in a little water overnight, then strained through a square of nylon stocking material. The resulting thick liquid is used as a MORDANT in GILDING. It produces a gilded surface less shiny than that of GESSO, and cannot be effectively BURNISHED, as the friction-heat produced softens the gum, thus dulling the gold which is laid on it.

gum arabic Also gum acacia. The dried exudation from the bark of various species of the genus Acacia found in Africa, Australia

and Asia. As a paint BINDER it dissolves slowly but completely in water to give a viscous fluid of great adhesive power. It dries to a lustrous transparent film like a varnish, and is redissolvable in water after it has dried. However, it tends to crack as it contracts over a period of years, so only as much as necessary should be used. As a binder for GOLD POWDER, it will be duller after burnishing than if gold is mixed with FISH GLUE or GELATIN.

gum benzoin Like other gums, this is an exudation from certain shrubs. Dissolved in water, it was used in the 15th c. to "varnish" paintings in books, which deepened and enriched their color.

gum kordofan Synonym of GUM SENEGAL.

gum sandarac Synonym of SANDARAC.

gum senegal Like GUM ARABIC, used as a paint BINDER, but harder and less easily dissolved in water.

gum tragacanth Exudation of the shrub *astragalus*. Contains a small quantity of gum, and a large proportion of a mucilaginous substance which swells in water but does not dissolve. Its main use is as a BINDER in pastel crayons.

gum water Sold in bottles as 2 parts GUM ARABIC and 1 part distilled water. Used as a paint MEDIUM.

Gutenberg, Johann German (1394?–1468) While in political exile in Strasbourg, c. 1440, he began with a group of others to experiment with ways to develop MOVABLE TYPE. A goldsmith, he was familiar with PUNCHES, the metal rods whose carved tips containing the goldsmith's trademark were hammered into the finished pieces of gold. It was punches, now with a carved letter at the tip, which were hammered into soft metal to form the MATRIX, or mold for casting metal type. His research also included the development of presses, paper and ink which were suitable for the new technology.

Working now in Mainz, his first dated work was a papal indulgence from 1454, but his most famous and remarkable work is the "Forty-two line Bible," also called the Gutenberg Bible, printed (partly on VELLUM and partly on paper) in TEXTURA type and decorated with hand-drawn colored initials. There are 48 known original copies extant. One is on public view at the Library of Congress (Washington D.C.). A few collections which also have copies are the Gutenberg Museum (Mainz), the Bibliothèque Nationale (Paris), the British Library (London) and the Huntington Library (San Marino, California). Gutenberg's printing career was cut short, due to foreclosure by a business partner who, in 1460, repossessed all the equipment and sent Gutenberg out to live on a pension.

gutter The central spine in an open book.

gypsum Raw chalk (WHITING) from which PLASTER OF PARIS, used in GESSO, is made.

textura type from the Gutenberg Bible

H From the Semitic word "heth," a guttural breathing sound. It was written ⟨symbol⟩, ⟨symbol⟩ and ⟨symbol⟩ during the late Bronze Age (*c.* 1500–1200 BC), ⟨symbol⟩ in ancient Israel (*c.* 1100 BC), and ⟨symbol⟩ in PHOENICIA (*c.* 1000 BC). Both classical Latin and Greek used the form as we know it today.

haematite Synonym of HEMATITE.

hairline Especially in alphabets which have a thick-thin variation of line, the thin lines are called hairlines.

hairline serif *See* SERIF.

hair side Side of animal hide on which the fur had grown, usually the better side to write on. Although it can be difficult to distinguish on very well-prepared VELLUM, some hair follicles are normally visible on the surface of this side. *See* FLESH SIDE.

half bound Style of BINDING in which a book's back and corners are of different material to its sides.

half-r *See* R.

half tone Artwork reproduced in tiny dots (called a "screen"), as with a newspaper photograph, allowing for intermediate tones between black and white. *Compare* LINEWORK.

half uncial Also semi-uncial. BOOKHAND common *c.* 600–1000. A fusion of everyday handwriting and the regal UNCIAL. Historically a very important script, being the first MINUSCULE and being widely used for centuries. It was the antecedent of other important scripts, such as CAROLINGIAN and IRISH MAJUSCULE. The term by itself refers to ROMAN HALF UNCIAL, although its many versions are identified by adding their regional name, as in ANGLO-SAXON –.

Hammer, Victor (1882–1967) Austrian painter, engraver and type designer who lived and worked in Lexington, Kentucky. His typefaces – American Uncial, among others – were all UNCIAL in character. He modeled his own handwriting after uncial and HALF UNCIAL forms, and based his type designs on this writing. He found uncial forms better suited than the ROMAN to express his aesthetic sensibilities.

hand 1) Personal version of any given SCRIPT. 2) Paper size measuring 16 × 22″ (40·6 × 55·9 cm).

hand letter 1) To write, draw or otherwise execute letters by hand. 2) Metal letter affixed to a handle, used to stamp titles, etc. on leather book covers.

handmade paper Sheets made individually by dipping a mold (a tray with a wire mesh bottom) into linen, cotton or other pulp, couching the sheet between layers of absorbent material such as felt, and letting the sheet dry under pressure. Characterized by durability, strength, a natural DECKLE EDGE and the fact that it has no GRAIN.

half uncial script

a Hammer typeface

hand rest Synonym of BRIDGE.

hand-set type MOVABLE TYPE in which each letter is set by hand. Letters are picked from a case (the upper case containing MAJUSCULE, the lower, MINUSCULE) and lined up on a composing stick. The rows of type are then assembled by hand to form a page of type. Although still used, this method was largely replaced by machine setting in the late 19th c. *Compare* LINOTYPE *and* MONOTYPE.

handwriting Informal, speedy writing for everyday use. Never was there a time when formally carved, written or printed letters did not have their popular counterpart in scribbled notes.

hanging indention Extension of a paragraph's first line out to the left.

Hansa yellow ANILINE LAKE SYNTHETIC ORGANIC PIGMENT. LIGHT-FAST. Usually sold as "permanent yellow."

Harrison, Richard (b. 1909) San Franciscan who in 1963 gave his important collection of 20th-c. calligraphy to San Francisco Public Library, where it is kept as the Harrison Collection. *See* Appendix, LIBRARIES.

hatchings Notations for the TINCTURES of HERALDIC designs rendered in black and white, when color is not possible.

Hayes, James American (b. 1907) Student of Ernst DETTERER at the Art Institute of Chicago. Worked full-time as a calligrapher and designer. Led the calligraphy study group at the NEWBERRY LIBRARY from 1947 to 1960.

head edge Top edge of a page.

headline Synonym of WAISTLINE.

head margin Blank space at the top of a page.

health hazards Dangerous materials are not a great concern in our field, but a few words need to be said about volatile liquids (FIXATIVES, oil-base paint, turpentine, etc.) and poisonous paint. When any volatile liquid is used, ventilation should include a fan at each end of the room, one blowing air in, the other blowing air out. This is what is meant by "adequate ventilation." Breathing noxious fumes for prolonged periods can cause kidney, nervous system, heart, and lung disorders, and can damage the fetus if you are pregnant.

Brushes should be formed with the fingers – not with the lips – after washing, to avoid ingesting paint which may be poisonous.

heavyweight *See* WEIGHT.

Hebrew writing Developed from the PHOENICIAN, as did Arabic, Greek and Latin. The earliest example known today of ancient Hebrew writing is the Gezer Calendar, an inscription from the days of King Solomon in *c.* 950 BC. The letters are vertical and pointy. Aramaic, a Semitic language whose alphabet also developed from Phoenician, was adopted as the language of diplomacy and trade by the Assyrian, Babylonian and Persian empires. Hebrew script underwent a radical transformation by the adoption of Aramaic script in the course of the Babylonian exile and the return to Zion. It eventually developed a formal version called "square" (*c.* 300 BC) used for writing the scriptures

| or (gold) | gules (red) | azure (blue) | vert (green) | purpure (purple) |
| sable (black) | ermine | ermines | argent (silver) | vair (gray) |

hatchings

Ashurit *(used for ritual scrolls)*

שלום עליכם מלאכי
השרת מלאכי עליון
ממלך מלכי המלכם
הקדוש ברוך הוא

Rulit *light italic*

באחד בשבת אחד
עשר יום לחדש סיון
שנת חמשת אלפים
ושבע מאות ארבעים

Bodko *regular*

מַה נִּשְׁתַּנָּה הַלַּיְלָה
הַזֶּה מִכָּל הַלֵּילוֹת?
שֶׁבְּכָל הַלֵּילוֹת אָנוּ
אוֹכְלִין חָמֵץ וּמַצָּה-

Yerushalmi *light (marks for vowelization included)*

along with cursive forms. It is written from right to left. Scribes of scripture use a pen cut to a left CANT with ink and VELLUM whose manufacture is firmly guided by tradition. Scripts not used for religious rituals may be written in any manner on any material.

Hechle, Ann British (b. 1939) Calligrapher whose work, teaching and philosophy have been widely admired. Has helped to oversee the cataloging, etc., of the work of her teacher Irene WELLINGTON where it is housed at the Crafts Study Centre in Bath, England.

helm Helmet, sometimes drawn surmounting a HERALDIC SHIELD as part of the design.

hematite Also haematite. Mineral used for BURNISHING large areas of GOLD LEAF.

heraldry Armorial bearings evolved in the 11th c. At first, the badge of one's group was painted on each shield used in battle. Around the 13th c., the painting of helmets and use of crests (carved figures attached to the helmet) were added. After the 15th c., armorial bearings were no longer used except ceremonially, but the idea lived on. Today, in the English-speaking world, a COAT OF ARMS is registered with the College of Arms in London, and may be used in perpetuity by the individual, family, town, guild, etc., who registers it. There are rules by which HERALDIC insignia are designed and executed that have broadened over the centuries. *See* BLAZON, COAT OF ARMS, CREST, DIVISIONS, HATCHINGS, MANTLE, MOUND, ORDINARIES, SHIELD, SUPPORTERS, TINCTURE, WREATH.

Hewitt, Graily British (1864–1952) Student of Edward JOHNSTON. Known primarily for research in techniques of GILDING and ILLUMINATION, as published in his book *Lettering* (1930, 1976).

hiding power Synonym of COVERING POWER.

hierarchy of scripts When two or more letter styles are used in a document, the more regal letters are traditionally used for titles and headlines, the next perhaps for the author's name or the opening sentence, on a descending scale finishing with the bulk of the text itself, done in the least formal of the chosen letterstyles. If there is a GLOSS, it is less formal still, usually in handwriting. If one were to use all the major scripts, the hierarchy would be thus: SQUARE CAPITALS for book headings, RUSTIC for EXPLICITS, UNCIAL for chapter headings, tables of contents and first lines of text, HALF UNCIAL for second lines of text and prefaces, CAROLINGIAN for text and HANDWRITING for the gloss. Was first codified at LUXEUIL.

hieratic Version of Egyptian HIEROGLYPHS developed *c.* 2500 BC, which were pen-written and informal (but not as informal as the DEMOTIC version). The Greek name means "priestly" because they thought erroneously that it was used only for religious writings.

hieroglyph Greek word for "sacred engraved writing." (The Egyptians themselves called it "the writing of the gods' words.") Used *c.* 3000 BC–400 AD, it was of the REBUS type, and used consonant sounds only. Lines of characters usually were read from right to left, although columns of these lines sometimes proceeded left to right. A less formal, pen-written version of this

hieratic script

Egyptian hieroglyphs incised on a stele

historiated initial "D"

horned "c"

system is called HIERATIC, and the version in handwriting is called DEMOTIC.

historiated Initial letters decorated with human figures, often depicting a story.

Hoefer, Karlgeorg German (b. 1914) Calligrapher, type designer, graphic designer and teacher whose brush writing has been very influential. Taught at the Hochschule fur Gestaltung. Author of *Kalligraphie: gestaltete handschrift* (1987).

Hofer, Philip American (1895–1984) He and his wife, Frances L. Hofer, were lifelong collectors, primarily of the graphic arts and specifically of the book arts. He founded and nurtured the Department of Printing and Graphic Arts at Harvard University, to which their collection of over 5000 MSS and printed books was bequeathed (her collection in 1978, his in 1984). *See* Appendix, LIBRARIES, Houghton Library.

homophone Found, for example, in Sumerian CUNEIFORM, this is a sign that has the same phonetic value, but a different meaning, to another sign. Modern examples would be our words "ring," "match," or "saw." To aid understanding, auxiliary signs called DETERMINATIVES were used.

hone To sharpen, as with a QUILL KNIFE.

honey 1) Due to its HYGROSCOPIC nature, liquid or crystalline honey may be used in GESSO or as a PLASTICIZER in WATERCOLOR paint, especially if paint contains GLAIR (a component which can make paint brittle). 2) Combined with salt, can be used to grind gold leaf flakes into gold powder. *See* GOLD POWDER *for process.*

honing oil When sharpening knives for cutting BAMBOO, REED and QUILL pens, it is suggested that water with detergent is superior to oil, since it can be disastrous for oil to come in contact with paper or VELLUM. *See* SHARPENING STONE.

hook serif *See* SERIF.

Hooker's green Traditionally made from a mixture of PRUSSIAN BLUE and GAMBOGE, the modern mixture of PHTHALOCYANINE BLUE and CADMIUM YELLOW is much more PERMANENT.

horae Latin for BOOKS OF HOURS.

horn Also thorn. The overextension of a stroke, frequently seen in the GOTHIC scripts, resulting in a spike at the pointed top of "e," "o," and other letters.

hot metal 1) Type made of metal for RELIEF printing. 2) Formerly denoted type which was cast by typesetters "in house," as compared with cold type which was ordered from a type foundry.

hot press Paper whose surface was formerly made smooth by pressure and heat. Heat is no longer used, but the term still describes smooth, CALENDERED, relatively non-absorbent paper. *See* COLD PRESS *and* PAPER.

Hours of Catherine of Cleves Famous BOOK OF HOURS illuminated around 1440 by a Dutch artist known now as the Master of Catherine of Cleves. The patroness was Catherine, Duchess of Guelders. The book is now at the PIERPONT MORGAN LIBRARY.

H.P. Abbreviation of HOT PRESS.

Vfcipe fanᴄte pater neʒ
omnipotēs eterne deus
banc imaculatam boftiā
ʒo indignus famulus tu
o tibi deo meo uiuo eʒ

Eft enim humdnarum
oref maioref natu prude –
unt · Sed d̄ comoditate
penef eof quof uetuftatif
ι paffim mentio fucurrerit
e adeo ftrictim ac leuiter

formal humanist (top) and humanist
italic script

hue The property of a color by which it is perceived with the normal eye to differ from black, white and the NEUTRAL grays. Simply put, it means "color," as in "the hue of the car is red."

humanist script Humanism evolved in late 14th-c. Florence by the example of PETRARCH. It was a scholarly movement which rediscovered the culture of antiquity, especially that of CLASSICAL Rome and Greece. Letters which resulted were adapted from CAROLINGIAN, and were thus called "*antiqua*" by the Florentines. The letters were characterized by round arches and strong, simple forms. *See* ITALIC.

hyalography Synonym of GLASS ENGRAVING.

hygroscopic The capacity of a material to absorb water readily. Such substances include SUGAR in GESSO, and HONEY and GLYCERINE in watercolor paint.

hyphen Short horizontal mark used to join words into a phrase or at the end of a line in which a word is continued on the next line. First used in the 8th c.

hyplar Trade name of ACRYLIC GLOSS MEDIUM, which can be used as a GILDING ground. It gives a shine much inferior to GESSO, but is useful in certain cases.

I This sign has had the same form since CLASSICAL Greek times, having been ⟍Z in the earlier Semitic writing. Oddly enough, as the ancient "I" resembled a "Z," so the ancient "Z" looked exactly like our "I." In early Rome, "I" had been both a vowel and a consonant, and the two symbols were used interchangeably in English until the 18th c. Gradually, the consonant value was assumed by "J." As a ROMAN NUMERAL it represents the number "1."

iconography The imagery of a work of art, often using conventional symbols. An example is the widespread use of an eagle to represent the evangelist John in illuminated MSS.

ideogram Sign which expresses an idea indirectly associated with the sign. For example, a picture of a foot could possibly signify "travel."

idiograph Synonym of trademark.

illumination A term derived from the effect of shimmering light given by gold on MSS pages, it originally meant only GILDING. Today it means any kind of text embellishment, including illustration, HERALDRY and colored letters as well as gilding.

impasto Thick, heavy application of paint. Useful for certain textural effects in BROADSIDES, but generally not in books.

imperial Paper size measuring $30 \times 22''$ ($76 \cdot 2 \times 55 \cdot 9$ cm).

Imperial alphabet Synonym of SQUARE CAPITALS.

impermanence The quality of a paint or other art material that is easily changed by light, heat or damp.

incipit The Latin word for "it begins." Written to mark the beginning of a book or section. *Compare* EXPLICIT.

incised writing Writing which has been impressed (in clay), scratched or carved (in stone, glass, wood, or bone). Because of the permanence of this form, most of the earliest extant writings are examples of incised writing. These include Chinese ORACLE BONES (*c.* 1500 BC), Teutonic RUNES, CUNEIFORM (*c.* 4000 BC), Mesopotamian CYLINDER SEALS and Philippine writing carved in bamboo.

incunabulum, *pl.* incunabula From Latin *cunea* (cradle), the infancy of anything, but in particular has come to mean a book produced in the earliest years of printing, before 1501.

indent To set the left edge of one or more lines of text further to the right than the bulk of the text.

India ink Waterproof carbon INK, but ink labelled as such does not always fit this description.

Indian ink Semi-waterproof carbon INK, but ink labelled as such does not always fit this description.

Indian red Purplish red PIGMENT, formerly a NATURAL IRON OXIDE from India, now a SYNTHETIC red iron oxide.

Indian yellow Obsolete pigment made from the urine of cows given no water, only mango leaves to eat. Replaced by PERMANENT yellow, also called HANSA yellow.

indigo Blue-black DYE made by fermenting the crushed leaves of the *Indigofera tinctora* plant of India. The dark precipitate of fermentation is strained, pressed into cakes and dried for use in painting. Not soluble in water, and FUGITIVE. Imported into Europe since the 17th c. because it was close in color but much more potent than the similar local dye WOAD. Thio-indigo was the first SYNTHETIC ORGANIC dyestuff produced from COAL TAR distillates, in 1880. Some modern paint called "indigo" is permanent.

inert Describes a substance which has a specific use, but does not interfere with the materials mixed with it. CHALK, ALUMINUM HYDRATE, GYPSUM and BARIUM sulfate are translucent white pigments used in watercolor and GOUACHE as EXTENDERS, and substrates for LAKE PIGMENTS.

inhabited initial Initial containing animal and/or human figures.

initial Large letter used to begin a chapter or section of text. A "drop initial" is embedded in the text below it; a "stick-up initial" sits on the top BASELINE, and rises above the text. Among the types of initials are ARABESQUE, HISTORIATED, INHABITED, and ZOOMORPHIC.

initial instruction letter Synonym of GUIDELETTER.

ink The realms of ink and paint overlap, so only a rather artificial distinction (that inks come in dry sticks and in bottles, while paint comes in tubes, pans and jars) differentiates the two in common parlance. In fact, any discussion of ink can only be a

guide for personal experimentation. Each of the hundreds of inks available has the qualities mentioned here in some measure, but no two inks will act the same way. The word ink comes from the Greek *inkauston* (to burn in). Possibly this refers to the coloring process of early baked tiles, or to the way iron gall inks burn into the page due to their acid content. The general types are: PIGMENTED INK: the coloring matter is finely ground insoluble particles suspended in a medium of GLUE or GUM and WATER, plus additives such as scent, SHELLAC (for shine), or preservative. These inks are usually LIGHTFAST, and rarely used in FOUNTAIN PENS because they clog. DYE INK: the coloring matter is soluble in water, and is always FUGITIVE. They can be used in any pen, including FOUNTAIN PENS. WATERPROOF INK: contains enough shellac to dry impervious to water. INDIA INK (*not* INDIAN) belongs to this group. Although waterproof ink is sometimes necessary for outlining or for work that will be handled a lot, it is not used much in the finest work because it gives poor HAIRLINES and clogs the nib. Many which claim to be waterproof are only marginally so, and must be tested for the particular purpose. SEMI-WATERPROOF INK: will resist moisture such as handling with dry fingers, but is not impervious. Many so-called waterproof inks are in this category. NON-WATERPROOF INK: is readily dissolvable in water when dry, and will bleed or smudge if touched with any moisture at all. Can be used in all pens. *See* CARBON –, CHINESE –, COLORED –, DRAWING –, FOUNTAIN PEN –, INDIA –, INDIAN –, IRON GALL –, JAPANESE –, PASTE –, SEPIA –, STICK –, SUMI –, SYMPATHETIC –.

Ink and Gall Journal devoted to marbling. Published in Taos, New Mexico since 1987. *See* Appendix, PUBLICATIONS.

ink horn Originally an inverted horn for storing INK. It came to mean any receptacle for liquid ink.

inkpot Synonym of INKWELL.

ink powder 1) Essential solids of IRON GALL INK sold in compressed tablets for easy storage and transport. When mixed with cold water they produce liquid ink. 2) Any powder to be mixed with water to make ink.

inkstand All-in-one implement which included an INKWELL, pen rack, POUNCE BOX and sometimes even a bell to summon a servant. Popular in the 18th c.

ink stick *See* STICK INK.

ink stone Slate or any suitable stone used for grinding STICK INK in water to produce liquid ink. In Asia they are often carved with fanciful figures of dragons, frogs, etc. Slate is used only for dark colors because it will rub off slightly into the ink. A GAKEN DISH is preferable for light colors, being of white unglazed porcelain.

inkwell Vessel with detachable top. Holds an ounce or so of ink at the writing desk. Some are made for traveling.

inorganic pigments Derived from minerals, from ore or processed from metals. *Compare* ORGANIC PIGMENTS.

inscribe To write or to print letters onto a surface.

inscriptional Roman Letters ''V''-CUT in stone during CLASSICAL ROMAN times. They have served as primary models for fine letter

ink stone

inscriptional Roman letters incised in stone

design for 2,000 years. *See* TRAJAN INSCRIPTION *for additional illustration.*

insular From the Latin for "island." Writing done in the British Isles, especially during MEDIEVAL times. Includes IRISH MAJUSCULE, IRISH MINUSCULE, ANGLO-SAXON MAJUSCULE and ANGLO-SAXON MINUSCULE.

intaglio Any of several kinds of printing in which letters and designs are incised, mirror-image, into a (usually) metal plate which is then inked. The ink on the surface is then wiped away, leaving only the incised crevices filled with ink. The ink comes off on paper as plate and paper are run through a roller press. Plates can be made either by directly incising with a tool (engraving) or by eroding with acid the areas of the plate that are not protected by a waxy coating (etching). Etching entails drawing the design through the coating with a needle before immersion in the acid. *Compare* RELIEF, PLANOGRAPHIC.

interlace Decoration containing curved or straight lines which weave in and out of each other.

interletter space Also interspace. Space between letters.

interlinear space Vertical distance between the BASELINE of one line of writing and the WAISTLINE of the one below. Usually measured in units of BODY HEIGHT.

internally sized paper That which has SIZE added while the pulp is being beaten, before the paper is made. *Compare* SURFACE SIZED.

interspace Synonym of INTERLETTER SPACE.

interword space Space between words.

intestine Ox intestines have been used as a buffer sheet in the hand-beating of GOLD LEAF.

iridium Extremely hard metal fused to the tip of a gold nib of a FOUNTAIN PEN to make it very hardwearing.

Irish half uncial Synonym of IRISH MAJUSCULE.

Irish majuscule Also Irish half uncial. Written in Ireland *c.* 600–900, it remains one of the great BOOKHANDS of Western culture. It developed from the HALF UNCIAL brought in the books of missionaries from France and Italy in the 6th c. The most famous example of Irish majuscule script, the BOOK OF KELLS, is known for its unsurpassed decoration, but also for its text, written in a particularly strong, precise, and beautiful version.

Irish minuscule Sixth-c. Ireland was relatively stable in its isolation as compared with England, which was at that time being invaded. Thus, it was able to maintain vital cultural centers which spawned this script and the Irish majuscule; both developed from the ROMAN HALF UNCIAL scripts.

Iron Age During the first Iron Age (*c.* 1200–1000 BC) alphabetic writing was becoming established. The second Iron Age (*c.* 1000–600 BC) saw the direct ancestors of our letters pass from the PHOENICIANS to the GREEKS, to the ETRUSCANS and then to the LATINS (pre-Roman peoples) in Italy.

iron gall ink Characterized by the way it often turns brown with age (CARBON INK is always black or gray) this ink was developed

Irish majuscule (top) and Irish minuscule script

as PARCHMENT began replacing PAPYRUS as the favored writing surface, *c.* 350. (The changeover from carbon to iron gall, as from papyrus to parchment, took a thousand years, and even then carbon ink was never completely abandoned. The two inks were sometimes even mixed together.) The ink was made from GALL NUTS, crushed and soaked. This infusion was mixed with IRON SALTS, ACID and GUM.

During Elizabethan times, a housewife would make ink at home, passing down her recipe as a family heirloom. A modern version of this might be: (parts by weight) 23·4 dry tannic acid; 7·7 crystal gallic acid; 30·0 ferrous sulfate; 10·0 gum arabic; 25·0 diluted hydrochloric acid; 1·0 carbolic acid; 1000·0 water at 60°F. (Recipe from D. Carvalho, *40 Centuries of Ink*, 1904, 1971.) This was the common writing ink (even though it ate through paper) until the mid-20th c. Because its color came from oxidation in 7 to 10 days, DYE was often added immediately to color this colorless liquid.

iron oxide pigments Synonym of EARTH PIGMENTS.

iron salts Also called green or blue vitriol or copperas. It is mixed with gallic acid in the manufacture of IRON GALL INK.

isinglass Nearly pure collagen, a glue from the boiled swim bladders of, primarily, the sturgeon fish. Can be used in GESSO or as a BINDER in watercolor.

italic The name derives from the ancient peoples of what is now Italy. Developed in the late 14th c. An Italian HUMANIST script characterized by slanted, oval-shaped letters. Easier to read and write than its GOTHIC predecessors ROTUNDA and BATARDE. Then called *cancellaresca corsiva*, or CHANCERY CURSIVE, it was officially adopted in the papal chancery by the Pontificate of Nicholas V (1447–51) for papal briefs. The first illustrated writing manual, *La Operina*, featured italic as its model. *See* ARRIGHI *for illustration*.

Italic type was first designed and used by Aldus MANUTIUS in Venice in 1501. In typography today, the term is often used promiscuously to describe a letter of any style as a synonym for "slanted." In calligraphy it remains truer to its roots, but now includes a range from the most FORMAL lettering to CURSIVE handwriting. Italic has proven itself to embody so well a synthesis of style and structure that it is what most people mean when they talk of "calligraphy." *See* CATANEO, CHANCERY CURSIVE *and* HUMANIST *for illustrations*.

italic handwriting Most CURSIVE form of italic, used for everyday writing. First employed in the early RENAISSANCE. After centuries of handwriting modeled after ROUNDHAND forms, this script is enjoying a 20th-c. rebirth through the pioneer work of Alfred FAIRBANK, Paul STANDARD, Lloyd REYNOLDS and the teachers who have followed them.

ivory black Pigment made from calcined (burned) bones. *See* BLACK.

italic handwriting

Japanese writing

'T heLORD is my shepherd;
I shall not want.
He maketh me to lie down
in green pastures:
He leadeth me beside
the still waters.

calligraphy of Edward Johnston

J Distinguished *c.* 16th c. from "I," which had until then represented both consonant and vowel sounds.

Jackson, Donald (b. 1938) British calligrapher. Student of Irene WELLINGTON. Influential teacher who has helped spark the current wide interest in the calligraphic arts in North America and Australia, through his classes and lectures in the 1970s and '80s, and through his four-part film *Alphabet: The Story of Writing* (1981), with its companion book *The Story of Writing.* Jackson now lives and works in Wales.

Japanese ink CARBON INK made in Japan. *See* CARBON INK, STICK INK, INK.

Japanese paper Traditionally made not from rice but mainly from the inner bark of the mulberry tree. It is usually thin and transiucent, usable with a pen, but made for the brush or for WOODBLOCK prints.

Japanese writing In the 5th c. Buddhist and other classical Chinese literature began arriving in Japan. At that time, there was no written version of the Japanese language: Japanese scholars read and wrote in Chinese. It was not until the 8th c. that Japanese, a language very different from its neighbor, began to be recorded in writing, using Chinese characters (LOGOGRAMS) phonetically to convey Japanese sounds. This written language is called *kana.* As in China, in Japan calligraphy is considered to be among the highest artforms.

Jarrow *See* WEARMOUTH-JARROW.

jaw The 90° angle found on a capital "G."

Jenkins, John P. American (1755?–1822?) Prominent WRITING MASTER. In 1791 in Boston published *The Art of Writing,* an engraved pamphlet. Developed a system of half a dozen basic strokes for writing COPPERPLATE script.

Jenson, Nicolas French (1420–80) Early training in coin-making led him to become perhaps the most influential PUNCH CUTTER of all. His supremely elegant ROMAN types of *c.* 1469–80, and the books in which they were printed, remain primary models today.

Johnston, Edward British (1872–1944) Rediscovered the use of the BROAD PEN and other techniques largely lost during centuries of disuse. In 1906 published *Writing & Illuminating, & Lettering* (1906, 1983), a "how to" book which instructed and inspired most of the 20th-c.'s greatest scribes. His design, calligraphy, writing and teaching have had incalculable influence on modern calligraphy. His 1916 SANS SERIF letter designs for the London Underground railway system have been very influential and are still used today.

Johnston, Priscilla British (1911–84) Edward Johnston's daughter and biographer. Author of *Edward Johnston* (1959, 1976).

Jones, David British (1895–1974) Artist and writer whose lettered paintings have influenced many of today's calligraphers. *The Painted Inscriptions of David Jones* by Nicolete GRAY (1981) provides a good introduction to his work.

Jones, Owen British (1809–74) The first publisher to make reproductions of MSS widely available. Author of *The Grammar of Ornament* (1856, 1987), which contains 100 color plates of decorative motifs from around the world.

justify Typographical term meaning to space the words in a text so that the lines extend to a given width. A justified text, therefore, has uneven word-spacing with even line length. *See* RAGGED, FLUSH LEFT, FLUSH RIGHT.

K Classical Greek sign for "K" and "G" sounds, having evolved from the North Semitic **Ψ** *kap* (palm of hand), the ETRUSCAN **Ͻ** and early Latin **K**.

k. Abbreviation of KARAT.

kaolin The whitest and purest form of CHINA CLAY, originally found in Kuo-Ling, Kiangsi province, China.

karat A measure of the proportion of gold in an alloy, expressed as the number of parts of gold in 24 parts of the alloy. In GOLD LEAF, therefore, 24k. is pure gold, 12k. is half gold, etc. The mixture is usually copper or silver, but can be other metals.

Kelmscott Press Founded in London by William MORRIS in 1891 and operated until his death in 1896. Through it, he pursued ways of producing "the book beautiful" with attention to the finest and most appropriate design, letter style, paper, binding and decoration.

kermes From the Persian *qirmiz* and French *kermes*, the name of this red dye also gives us the word CRIMSON. Because of confusion in ancient nomenclature, it is unclear today whether there was ever any difference between kermes and lac. *See* LAC.

kern The original meaning of this word in HOT METAL typography was the portion of certain letters that protruded beyond the metal rectangle on which the letter was mounted. Thus, the kerned letter would intrude somewhat into an adjacent letter's space to avoid a gap which would otherwise occur between the two letters. Today it describes two letters which are spaced closer together than normal to improve the overall visual spacing. The term is not used much in calligraphy because the concept is integral to the nature of the craft itself.

Klingspor, Dr. Karl (1869–1950) Distinguished German type-founder. Named after his family are the Klingspor type foundry, and Klingspor Museum in Offenbach, West Germany, which houses an important collection of calligraphic work. *See* Appendix, LIBRARIES.

kerned "f"

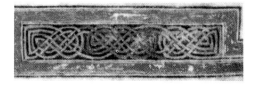

knotwork

calligraphy of Rudolf Koch

kneaded eraser Almost crumbless, grey and very soft, it is sold in a block shape. Before each erasure it is stretched and folded over to expose a surface free of graphite or other dirt.

knife *See* QUILL –, GILDING –, X-ACTO –, PALETTE –, and ARKANSAS STONE.

knotwork Interlaced decoration, associated with MEDIEVAL Celtic, European and Islamic MSS.

Koch, Rudolf German (1876–1934) Modern pioneer in calligraphy, type design, lettering and book design. The abundant zest, curiosity and fearlessness of his teaching, writing and art continue to influence calligraphers all over the Western World.

kolinsky The red Tartar marten or Siberian mink, found only in the Soviet Union. Hairs from its tail are used to make the finest red sable BRUSHES.

kozo A type of translucent, absorbent Japanese paper made from the inner bark of the mulberry tree.

Krimpen, Jan van (1892–1958) Distinguished Dutch type designer, calligrapher and book designer. Chief designer at ENSCHEDÉ in the 1920s. Types include Lutetia and Spectrum.

L From the Semitic *lamed* (goad). Has had a very similar form since early PHOENICIAN times; sometimes written mirror-image or upside down from the modern letter. As a ROMAN NUMERAL it represents 50.

lac Also lacca. From the Sanskrit *laksa*, and Hindi *lakh* (a hundred thousand). Certain species of tiny, prolific insects, including the *Coccus lacca*, attach themselves by the thousands to certain species of trees in India, such as the acacia, sucking the plants' juices and secreting a blood-red encrustation. The Romans called the red cluster of insects *granum*, and the Greeks *kokkos*, both meaning "berry." When twigs encrusted with dead insects are broken off, boiled in water with alkali and further refined, a red dye is extracted. The coloring agent is kermesic acid, the by-product is shellac. Because lac dye has been used for so many centuries in so many cultures for cloth and paint, the nomenclature is very entangled: throughout history, the name has commonly been confused with and substituted for similarly colored dyes such as KERMES, GRAIN, COCHINEAL, CARMINE, MADDER, and BRAZILWOOD. It is not clear today whether the dyes called kermes, grain and lac, apparently all from similar insect origin, were ever distinguished from each other in any way, and if so, how. Today all three are treated as one and the same, for lack of more knowledge of ancient terminology.

In MEDIEVAL times the method of turning the watery dye into paint (a process called laking) involved coloring wool with the dye, then extracting it by boiling the wool in lye solution. As alum was added to this mixture, the dye infused the alum with

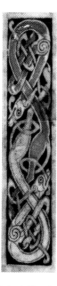

medieval panel depicting lacerine animals

color, and paint resulted. (The words "LAKE," "shellac," and "lacquer" all derive from "lac.")

lacerine animals Animal forms used as decoration in MSS since the 8th c. Their bodies are elongated into serpentine shapes ending in an animal's head.

laid Paper which has a fine grid pattern when held up to the light, and a slight texture as a result. The "laid lines" (closely spaced horizontal lines) and "chain lines" (vertical, about one inch apart) develop from the wire mold on which the paper is formed. Laid paper predated smooth, or WOVE, paper by several centuries. *See* PAPER.

lake The laking process transforms DYE, too watery and translucent to paint with, into a PIGMENT that has substance enough to be used for paint. The name derives from LAC, one of the first dyes to be processed this way many centuries ago. Lakes are made by infusing a translucent or opaque white powder with dye, thus changing the coloring matter to a substance whose color is in particles rather than in watery liquid. Laking is complex, but can be imagined as food coloring being stirred into powdered chalk: the chalk soaks up the dye, giving it substance and COVERING POWER.

Most lakes are SYNTHETIC ORGANIC dyes made from coal tar distillates, precipitated onto aluminum hydrate (translucent) or white chalk (opaque) substrates. Formerly, they were notoriously FUGITIVE because of the dyes used, but today many are reliably LIGHTFAST. *See* LAC.

lampblack Black PIGMENT made from burning oil. *See* BLACK.

lapboard Portable drawing board, one edge of which sits in the lap, while the middle rests on a table edge.

lapidary Denotes lettering or decoration carved in stone.

lapis lazuli From Latin *lapis* (stone) and Persian *lazhuward* (azure). Semi-precious stone ground to produce genuine ULTRAMARINE blue pigment. During MEDIEVAL times the pigment was imported from Afghanistan, and so was known as *appuro ultramarino*, or "blue from beyond the [Mediterranean] sea."

lapis quadratus Synonym of SQUARE CAPITALS.

Larisch, Rudolf von Austrian (1856–1934) His years as an archivist in the chancery of Emperor Franz Josef spawned an interest in beautiful writing. He began teaching calligraphy at the Vienna School of Art in 1902. In 1906 he published *Unterricht in ornamentaler Schrift* (11th edn 1940), a manual of ornamental writing and lettering. His approach emphasized the presence of the artist's humanity in the work, as well as the overlapping of crafts and collaboration among calligraphers and other craftspeople. This attitude has pervaded and helped to define 20th-c. calligraphy, especially the German school.

Lascaux paintings Large, hauntingly beautiful cave paintings of animals in the Dordogne, south-west France. Carbon-dated at around 15,000 BC, the paintings can be seen as precursors to writing, or as a means of expression before writing and painting were deemed separate. The pigments used included yellow and red iron oxides, soot, black manganese oxide and white porcelain

Lascaux paintings

clay mixed with cave water, whose high calcium content ensured great adhesion and durability. Brushes were made from bison hair and twigs shredded at the tips.

Latin From *Latium* (ancient Italy). 1) Pre-Roman Italian peoples. 2) Language and culture of the Roman Empire and its outposts.

Latin writing Like other scripts, it was originally written both left to right and right to left. In the 5th c., however, all Western Christian and secular writing settled into a left to right standard.

Laurentian Library, Florence, Italy. *See* Appendix, LIBRARIES.

layout Plan of a design done relatively quickly to help determine the final size, color and position of component elements. A final layout is quite precise.

lead In artists' materials, a powdered white lead is used. 1) The GESSO ingredient that provides hardness. Because it is so poisonous, the greatest care should be used in handling. 2) Ingredient in some oil paints, but extremely rare in AQUEOUS paints.

lead antimonate Yellow PIGMENT used by Egyptians, *c.* 4000 BC. The original NAPLES YELLOW. No longer used in AQUEOUS paint.

leading Originally strips of lead spacing put between lines of metal type. The term has been adopted by present-day usage to indicate the space between lines of PHOTOTYPESETTING as well, and is measured in POINTS.

leaf 1) Sheet of paper, or half a sheet when folded. 2) METAL LEAF is a combination of soft metals beaten very thin between layers of animal skin or intestine, for use in GILDING. *See* ALUMINUM −, DEEP GOLD −, GOLD −, PALLADIUM −, SILVER −, PALE GOLD −, LEMON GOLD −, VARIEGATED −, TRANSFER −, WHITE GOLD −, KARAT.

leather Used as a writing surface by the Egyptians and others at least as early as 2500 BC. Throughout the following 2,000 years the product became more refined, eventually evolving into PARCHMENT. The primary difference between refined leather and parchment is the tanning agent. In leather it is TANNIC ACID from tree bark or other plant source, and in parchment it is lime, which leaves the skin nearly white. Although the HAIR SIDE of leather can be a fine writing surface, it is more commonly used today in book bindings.

left-handed calligraphy There are many approaches to left-handed calligraphy, an adaptation of right-handed writing. Usually the best method is to start with the pen hold and paper angle that you use in your everyday handwriting, and make adjustments from there. Nibs sold as left-handed are useful to some scribes.

leg Lower diagonal stroke in "K," "k" and "R."

legible Readable, or at least decipherable.

lemon gold leaf LEAF containing about 18k. of gold, with about 6k. of silver. Used in GILDING. *See* LEAF, GOLD LEAF, SILVER LEAF.

lemon yellow Non-specific name for greenish bright yellow PIGMENTS such as BARIUM YELLOW and STRONTIUM YELLOW.

Lethaby, W. R. (1857–1931) British architect and friend of William MORRIS. In the late 1890s advised the young Edward JOHNSTON to pursue the study of lettering, and in 1899 appointed him to teach lettering at the Central School in London.

Leto, Giulio Pomponio Italian (*fl.* 1465–97) Famous scholar and teacher, whose graceful HUMANIST CURSIVE handwriting influenced a generation of contemporary scholars.

Letraset Trade name for a brand of TRANSFER TYPE.

letter 1) Sign which is a member of an ALPHABET, representing a sound from spoken language. 2) To do LETTERING.

lettercarving Traditionally, the craft of incising letters by hand into stone or wood with a chisel and mallet (called a dummy). Today, can include carving with a pneumatic chisel, especially for large letters.

letterform A letter's shape.

lettering CONSTRUCTED, drawn or RETOUCHED letters, as compared with writing done directly with a pen, brush or other tool.

letterpress RELIEF printing.

lettres de forme 14th-c. French name for GOTHIC letters.

lettres frizées Humorous way of writing affected by some writers and engravers, especially in the 16th and 17th c.

levigated pigments Also levigated colors. Frequently used as a name for PIGMENTS sold in powder form, which the artist then mixes with MEDIUM, to make his own PAINT.

levigation When a mineral such as MALACHITE or LAPIS LAZULI is ground for PIGMENT, it must be cleaned of the impurities found in its natural state. This process involves washing the powdered mineral in water and soap, letting the heavier impurities sink, while the finer particles are decanted with the water. Repeating this process several times serves also to separate the finer particles (usually more desirable) from the coarser, thus "grading" the pigment. This process is done today by machine.

librarii Latin name for monks who were COPYISTS.

ligature The linking together of letters by one or more strokes. *Compare* FUSION.

lightfast Material which does not change color upon exposure to light. Because sunlight accelerates the breakdown of art materials, direct sunlight is always detrimental. Materials that are lightfast will, when kept out of direct sunlight, keep their color more or less unchanged for centuries.

 A home test for lightfastness can be conducted by taping half of a test sample to a window. After a time, sometimes several hours, sometimes weeks, FUGITIVE colors will begin to change. The degree to which the color has changed will become evident by comparing it with the half of the sample that was kept away from light. Although not scientific, this gives a good indication of the relative lightfastness of various materials and illustrates the effects of sunlight.

lettres frizées

ligatured "st"

light table Tabletop of (usually translucent) glass or plastic covering fluorescent bulbs, which shine through the surface to provide light for tracing. A light box is a portable version.

lightweight *See* WEIGHT.

Limbourg brothers Pol, Jean and Herman de Limbourg were Dutch by birth. They produced some of the finest MS painting of all time for their patron Jean, Duc de BERRY, including the 14th-c. masterpiece, LES TRÈS RICHES HEURES. All three died, along with their patron, of unknown causes in 1416.

limner Late MEDIEVAL craftsperson who specialized in ILLUMINAT-ING (painting and gilding) the pages of MSS.

limp binding Synonym of FLEXIBLE BINDING.

Lindisfarne Gospels Also Lindesfarne Gospels. One of the most richly decorated MSS known, it contains the four gospels written in large ANGLO-SAXON MAJUSCULE on vellum at the end of the 7th c. It has 258 leaves, with two columns of 24 lines on each page. A GLOSS in ANGLO-SAXON MINUSCULE was inserted between the lines in the 10th c. Thought to have been written and illuminated by Bishop Eadfrith, its decoration is characterized by intricate combinations of interlacing knots, geometric patterns and pen-flourished creatures done in bright colors. It is housed in the BRITISH LIBRARY.

Linear A and B Synonym of MINOAN LINEAR A and B.

linen tape Because it is ACID FREE, can be used in contact with lasting artwork, for attaching artwork to a MAT, or providing hinges for a mat. Its dry glue is moistened before use.

linen tester Type of small magnifying lens attached to a collapsable stand. Used for inspecting knife and nib edges, quill nibs, brush points, etc., while leaving the hands free. Its original use was to inspect the weave of cloth.

linen thread Preferred for BINDING books.

line work Artwork of two tones, usually black and white, with no intermediate tones. *Compare* HALF TONE.

link Synonym of NECK.

Linotype Trade name for the typesetting system by which a keyboard operator activates a MATRIX for each letter in a line. At the end of each line, the joined matrices are CAST in metal, creating a solid line of type to take its place below the previous line. Invented by Ottmar Mergenthaler in 1886. Used for most mass-produced books and newspapers until the 1970s and the advent of PHOTOTYPESETTING.

littera moderna The readers and writers of what we now call GOTHIC (*c.* 1100–1500) called their script by this name, which means "modern letters" or "the new calligraphy." The writing it replaced was CAROLINGIAN.

littera monumentalis INSCRIPTIONAL ROMAN CAPITALS, specifically in the Imperial and Augustan periods.

loft-dried paper HANDMADE PAPER air-dried without much pressure, resulting in a rough surface.

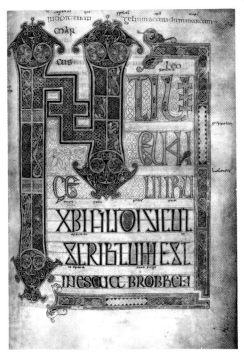

folio from the Lindisfarne Gospels

logo Unique sign or combination of signs identifying an organization or individual. From the Greek *logos* (word, unifying truth).

logogram Any sign that stands for an entire word, as in many ancient writing systems as well as in modern Chinese.

logotype Synonym of LOGO.

logwood Dark red natural DYESTUFF obtained from chemically treating the wood of the Central American tree *Haematoxylyn campechianum*. This FUGITIVE dye was being used by the natives of Central America at the time of the Spanish invasion.

Lombardic capitals Exaggerated style of drawn VERSALS featuring bulbous thick strokes and long, curving SERIFS.

Lombardic capitals

long fold *See* FOLD.

long s *See* S.

loop 1) Enclosed space in an ASCENDER or DESCENDER, which first appeared in handwriting as a way of avoiding time-consuming pen lifts. When it is unintentionally filled in, as in speedy handwriting, it is called a "blind loop." 2) Type of small magnifying glass.

looped "g" "g" as compared with "*g*."

loth German weight of about an ounce, formerly used to measure the weight of bundles of quill feathers.

Lowe, E. A. American (1879–1969) One of the very great PALEOGRAPHERS of the 20th c. Author of *Codices Latini Antiquiores* (1934, 1972), an indispensable guide to Latin MSS up to the 9th c.

lower case Typographic equivalent of MINUSCULE. In hand-set type, the majuscules (upper case) were kept in a case placed above that of the minuscules (lower case).

lozenge HERALDIC term for a diamond shape.

Lucas, Francisco Author of early Spanish writing book, *Arte de Escriver* (1577).

Luxeuil minuscule Version of MEROVINGIAN written in the Luxeuil monastery (founded *c.* 590 by ST. COLUMBA) in France, *c.* 650–750. This was the most important center of French book production until the Saracens invaded in 731, wiping out the population, after which CORBIE became France's primary scriptorium.

lye Strong alkaline solution such as sodium hydroxide or potassium hydroxide.

Luxeuil minuscule script

M From the Semitic *mem* (water). It has been written as various types of wavy and zig-zag lines for thousands of years. As a ROMAN NUMERAL it stands for 1,000.

Mabillon, Jean French (1632–1717) Classified pre-CAROLINGIAN scripts in his book *De re diplomatica libri* (1681), thus was a primary instigator of PALEOGRAPHY.

Macdonald, Byron Judson (1908–76) American calligrapher and teacher who lived in San Francisco. Author of *Calligraphy: The Art of Lettering with the Broad Pen* (1966).

machine-glazed paper Rough on one side, glossy on the other.

madder lake The DYESTUFF madder, whose color ranges from pink to purple, comes from the roots of the East Indian plant *Rubia tinctorum* in the form of a glucoside which is hydrolyzed when the dead roots ferment. This process generates the coloring matter alizarin (not identical to the modern synthetic dye of the same name, which is a more permanent substitute for the natural madder). Madder, like LAC dye, has been used for centuries, perhaps millennia, to dye cloth. In MEDIEVAL times, the dyed cloth was boiled in alkaline solution. When alum was added, the dye fused to the alum, and the result was PIGMENT used in paint. In the 1870s the synthetic alizarin became available, but genuine "rose madder" paint can still be obtained. *See* LAKE.

Magic Marker 1) Brand of spirit-based felt-tip pen. 2) Generic term for felt-tip pen.

magnifying glass Convex lens which enlarges (and distorts the outer edges of) an image. For inspecting subtleties in letters while copying, sharpening or cutting NIBS, preparing PARCHMENT, etc.

mahl stick Dowel with a padded leather or cloth bulb at one end. Held in the free hand to steady the working hand while painting or doing large lettering.

Mahoney, Dorothy British (1902–84) Student of Edward JOHNSTON, later his assistant and substitute teacher. Author of *The Craft of Calligraphy* (1982).

majuscule Any script in which all letters are of approximately equal height. Although the term CAPITAL is almost synonymous, it can be considered a subgroup of majuscules, which also include the MEDIEVAL bookhands such as IRISH –. In type, the comparable term is UPPER CASE.

malachite Green mineral pigment made from grinding natural basic copper carbonate. Used extensively in MEDIEVAL ILLUMINATION, it is now obsolete because it is FUGITIVE.

manganese blue Barium manganate. Translucent, permanent greenish-blue PIGMENT. Developed in the 19th c., it has been widely available only since the 1930s.

mahl stick

tum conful non idem funt . Nă quărto ante factos, quartum uero fignificat tu ctum, fed quod in M. Catonis originef thagmenfes fextum de fædere deceffe cat, quinquies ante contractum fædus & quadriformis, quatuor formarun quadriformiter. Item quatrurbem A

Manutius' italic type

marbled paper

manganese violet Manganese ammonium phosphate, a permanent bluish violet PIGMENT similar in color to the much more expensive COBALT VIOLET.

manipulation *See* PEN MANIPULATION.

mantling HERALDIC term referring to a drawing of a cloth draped over the HELM. Often rendered as having been sliced into decorative, lively, twisted strips. Originally a thick cloth worn over the helmet for sun protection.

manuscript From the Latin *manus* (hand) and *scriptus* (writing). 1) Document or book written by hand, as compared with a printed copy. Abbreviated MS. 2) "Ball-and-stick" writing taught to young children, also known as "print script."

manuscript skin PARCHMENT prepared for writing on both sides.

Manutius, Aldus (1450–1515) Born Teobaldo Mannucci in Italy. Early printer in Venice whose books were and still are of great influence. First printer to employ ITALIC type for inexpensive "pocket volumes" in the early 16th c. *See* Francesco GRIFFO.

marbling Technique of decorating paper, producing a colorfully patterned surface which resembles marble. Made by placing paper face down on special pigments floating on the surface of water. The pigments are fixed with alum. Often used as decorative paper in BINDING books; occasionally as a writing surface. The Japanese were marbling paper *c.* 800. The practice reached Europe in the early 17th c.

Mardersteig, Giovanni Italian (1892–1977) Famous printer. Established the Officina Bodoni in Verona. Printed and published fine editions, including those on calligraphy, such as Felice FELICIANO's treatise on CONSTRUCTED capitals.

margin Space between the writing or printing on a page and the edge of the page. Protects the writing from handling and visually frames the text.

marginalia Notes, often informally written, or illustrations in the margin of a page.

Mars pigments Artificial EARTH PIGMENTS.

masking fluid Type of RESIST.

masking tape Off-white adhesive tape with a slightly rough surface. For temporary use only; not PERMANENT.

masterpiece Originally, an item done by an apprentice craftsman to illustrate his degree of skill to the master. If it was found satisfactory, the craftsman would then become a fully fledged journeyman. Today, it means a supreme work of art.

mat Piece of paper board with a window cut in the center for the artwork. Serves to keep the art from touching the glass when framed, and to add visual beauty to it by increasing and accentuating the MARGINS. For lasting artwork, only ACID-FREE mats and backings should be used.

matboard Paperboard from which MATS are made.

matres lectionis Consonant sign to mark a vowel sound in, for example, early Aramaic and PHOENICIAN script.

matrix Copper or brass mold from which a metal type letter is CAST.

matte Satiny or dull finish in paper, ink, varnish, etc. Not glossy or shiny.

matte gold Synonym of SHELL GOLD. So called because it cannot be BURNISHED to a high shine, as can GOLD LEAF.

mechanical CAMERA-READY artwork for reproduction, ready for the printer, including instructions to the printer in the MARGINS or on an OVERLAY.

Medici, Cosimo de Italian (1389–1464) Nobleman and patron of the arts. Collected many hundreds of classical and contemporary books, as well as employing scribes to produce them. His library is now housed in the LAURENTIAN LIBRARY, Florence.

medieval This period began in Europe in the late 5th c. as the last vestiges of Roman influence faded, and came to an end in the late 15th c. as the RENAISSANCE blossomed. The major scripts were UNCIAL, ROMAN HALF UNCIAL, CAROLINGIAN, IRISH MAJUSCULE, ANGLO-SAXON HALF UNCIAL and GOTHIC.

medium *pl.* media 1) Material employed in a work; for example, watercolor and pastel on paper. 2) Paper size measuring 18 × 23″ (45·7 × 58·4 cm).

Mercator, Gerard (1512–94) Prominent Dutch cartographer and calligrapher. His way of representing the round earth on a flat surface (Mercator's Projection) is still used today. His manual for learning ITALIC, *Literarum Latinarum* (1540; facsimile edition 1970), took an unusually scientific approach to the teaching of writing, discussing PEN ANGLES, for example, in terms of degrees.

mercuric sulfide Synonym of VERMILION.

Mergenthaler, Ottmar German (1854–99) Invented the LINO-TYPE typesetting machine in 1886.

Mesopotamia Located in what is now Iraq; the land of the SUMERIANS, who, as early as 3500 BC, began writing PHONETIC as well as PICTOGRAPHIC signs in the administration of their systems of commerce and law.

Merovingian One of the NATIONAL SCRIPTS that preceded and influenced the development of CAROLINGIAN. Used in what is now France, *c*. 500–900.

metal leaf *See* LEAF.

metal nib As distinct from a DIP PEN whose NIB and/or shaft is of reed, bamboo, feather or other material. One-piece pens and, later, detachable nibs, of bronze, silver, gold and other metals have been made since at least as early as Roman times, the advantage being that, unlike softer materials, they stay sharp. However, even a good metal nib requires two conditions to ensure its success: a fairly smooth and hard writing surface and ink which does not clog or corrode the nib. Even on PARCHMENT or smooth machine-made paper (which did not appear until the 1820s) bottled CARBON INK clogged and IRON GALL, which worked beautifully with quills, had an acid content which corroded metal nibs. Even so, the metal nib progressed. The model first mass-manufactured, by William Mitchell of Birmingham, Eng-

Opposite: *medieval Carolingian minuscule script*

ate iohanni quae audistis & uidistis; Quia caeci
uident · claudi ambulant · leprosi mundantur ;
Surdi audiunt · mortui resurgunt · pauperes
euangelizantur ; Et beatus est · quicumque si fue
rit scandalizatus in me ; Et cum discessissent nun
tii iohannis · coepit dicere de iohanne ad turbas ;
Quid existis in desertum · uidere arundinem uento
moueri ? Sed quid existis · uidere hominem mollib.
uestimentis indutum ? Ecce qui in ueste pretiosas
& diliciis · in domibus sunt regum ; Sed quid exis
tis uidere prophetam ? Utique dico uobis · & plus
quam prophetam ;

hic est de quo scriptū ē ; Ecce mitto angelū meū ante
faciem tuā · qui praeparabit uiā tuā ante te ·

Dico enim uobis · maior inter natos mulierum pro
pheta iohanne baptista nemo est · Qui autem mi
nor est in regno di · maior est illo ·

Et omnis populus audiens · & publicani iustificauer
dm baptizati baptismo ioh · Pharisaei autem &
legis periti · consilium di spreuerunt in semet ip
sos · non baptizati ab eo ·

land, in 1822, was cut, shaped and refined entirely by hand. That same year, Joseph GILLOTT, in the same city, developed a process by which steel nibs could be machine-stamped, formed and polished, drastically reducing the price.

These developments, combined with the advent of the first non-corroding inks in the 1830s, spelled the end of the 1,500-year reign of the quill in everyday writing. The pointed metal nib itself was replaced in everyday writing by the FOUNTAIN PEN around the turn of this century, and these were later largely replaced by the BALLPOINT.

Metal nibs are available in many configurations, including those that give a striped effect, and those whose nib is in the shape of a square or a disk (giving MONOLINE strokes with squared or rounded ends). Broad edge metal nibs are the most popular among today's calligraphers, but the qualities of flexibility, responsiveness and sharpness of line available with the quill should not be overlooked.

Although modern metal nibs look ready to use immediately after purchase, two adjustments must often be made: the removal of an oily coating put on during manufacture to prevent rust (with ACETONE or a few seconds of flame); and the sharpening of the nib on a fine ARKANSAS STONE if HAIRLINES are too thick. This can be done with just a few feather-light passes on the underside and/or topside of the nib's tip. Inspect with a magnifying glass to see that the sharpening has been even along the edge. Remove any BURRS with CROCUS CLOTH. Metal nibs need only be sharpened once, as paper will not dull them.

methylated spirit British term for denatured ALCOHOL.

micrography Name for CALLIGRAMS in some Jewish MSS.

micrometer Synonym of CALIPER. For measuring the thickness of paper.

Middleton, Robert Hunter (1898–1985) American calligrapher, type designer, printer and PUNCH CUTTER. Lived in Chicago. Type director for Ludlow Typograph Company.

millboard Thick, smooth paper BOARD.

miniature Most of the painting done in MEDIEVAL times was in books. The paintings were therefore small, but their size is not the origin of their name. The word comes from the pigment MINIUM (red lead), which was often used to decorate MSS.

minim Little used term for a straight stroke that is as tall as the BODY HEIGHT of a given script, such as the first stroke of "m."

minium In ancient times it referred to almost any red-orange PIGMENT, including CINNABAR, VERMILION or RED LEAD. Since MEDIEVAL times it has meant almost exclusively red lead.

Minnesota Manuscript Initiative Group formed in 1981 for collecting important 20th-c. calligraphy. Collection currently housed at the Wilson Library, University of Minnesota, Minneapolis. *See* Appendix, LIBRARIES.

Minoan Sophisticated BRONZE AGE civilization which flourished on the Mediterranean island of Crete *c.* 2800–1400 BC. Named in modern times for the legendary King Minos. Their writing is now called PICTOGRAPHIC A and B and MINOAN LINEAR A and B.

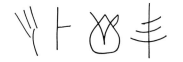

Minoan Linear A (above) and B (below)

Minoan Linear A Developed from PICTOGRAPHIC B, *c.* 1700–1450 BC, it was yet more CURSIVE than its predecessor and included between 76 and 90 signs. Written from left to right, examples have been found inscribed in stone, metal and clay and written with ink on pottery. It has not been deciphered.

Minoan Linear B Flourished in Crete and on mainland Greece *c.* 1600–1200 BC. This SYLLABIC system included 89 characters. Apparently not a direct descendant of "A," but seems to have developed from "A" with a great deal of Mycenaean (mainland Greek) influence.

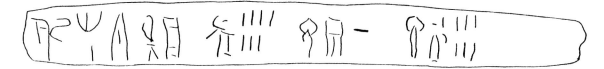

minuscule Scripts containing letters with ASCENDERS and DESCENDERS. They are a mixture of MAJUSCULE BOOKHANDS and of everyday CURSIVE majuscule handwriting of Greece and Rome, but did not become distinct from majuscules until the 6th c. AD, developing into fully fledged minuscules in the late 8th c. When majuscules are written speedily, they naturally develop strokes which go below the BASELINE and above the WAISTLINE, as well as changing their form. If "R" is written quickly it will become "r," for example. What we now call HALF UNCIAL was the first FORMAL script to incorporate these speedy writing forms. Spaces between words, punctuation and larger letters at sentence beginnings also became common with the development of minuscule script.

minuscule cursive Misleading name for ROMAN CURSIVE which was a MAJUSCULE script, but so quickly written that it took on the long ASCENDERS, DESCENDERS and SLANT of the later minuscule.

missal Book of Christian prayers or devotions, spanning the year.

Mitchell, William J. In 1822 in Birmingham, England, he began the first mass production of steel NIBS. However, because they were handmade, he was temporarily overshadowed that same year by Joseph GILLOTT who made them by machine. Mitchell went on to prosper in his nib business, which still bears his name.

mnemonic device Written sign, knotted cord or other device which prompts the memory. Associated with primitive cultures which do not have a developed written language.

Moabite Stone STELE from *c.* 9th c. BC, discovered in the 19th c., 25 miles east of the Dead Sea. Its inscription describes the triumph of Mesha, King of Moab, in battle with Israel. The oldest known example of true ALPHABETIC writing.

model 1) Writing which is copied during practice. 2) To give a painted object a three-dimensional aspect by shading.

model book Contained ICONOGRAPHIC and decorative motifs for copying and adaptation. Some contained letters. The two earliest European model books containing letters have been edited by Michael Gullick: *A Working Alphabet of Initial Letters from Twelfth Century Italy* (1979) and *A Working Alphabet . . . from Twelfth Century Spain* (1987). *See* GOTTINGDEN MODEL BOOK.

modern Since the late 18th c., describes those typefaces derived from the refined engraved letters rather than the more organic pen-written forms (known as OLD STYLE). Modern types are characterized by thick strokes contrasted with hairline thins, unbracketed SERIFS and a very refined appearance. Examples are DIDOT and BODONI.

mold Also mould. Tray used in papermaking to scoop up and form pulp. *See* HANDMADE PAPER.

mold-made paper Machine-made, DECKLE EDGE paper that imitates HANDMADE. *See* HANDMADE PAPER.

monogram Configuration of two or more letters, often a person's initials, in which letters are connected by sharing common strokes. *Compare* CIPHER.

monoline Characteristic of letters whose strokes are all the same width, instead of the thick/thin of BROAD PEN calligraphy. Called SKELETON LETTERS when used to represent forms that will later be fleshed out with variations in stroke width.

Monotype Invented by Tolbert Lanston in 1893. Along with LINOTYPE, replaced HAND-SET TYPE in mass printing. As the operator typed on a keyboard the copy to be printed, each letter would be CAST in a fraction of a second and set in place for printing.

monumental Lettering or decoration carved in stone or cast in metal. The most common use of the term describes the majestic INSCRIPTIONAL ROMAN CAPITALS carved in stone.

mordant From the Latin *mordere* (to bite). In fabric-dyeing, a mordant is a compound that combines with the dye to fix the color or "bite" it into the cloth. In GILDING the term refers to the GUM or GESSO serving as a ground enabling the gold or other LEAF to stick permanently to the writing surface. In scribal gilding, mordant is synonymous with SIZE or ground, but mordant is more specific, as size has several other meanings. In the area of gilding furniture and picture frames, "mordant gilding" is a different process using oil-base size, which is useless on paper and parchment.

Morison, Stanley British (1889–1967) Distinguished typographer, designer, scholar, and champion of the traditional book arts employed in a way appropriate to our own time. Designer of Times New Roman typeface, among many others. Author of *Politics and Script* (1972).

Morris, William British (1834–96) Social reformer, philosopher, writer, craftsman, type designer, printer, calligrapher. Leading figure of the British ARTS AND CRAFTS MOVEMENT in the late 19th c., which was the foundation of today's fine crafts. All fine crafts interested Morris for their ability to express the humanity of the maker and the truth of the materials. This included letters directly written with a BROAD PEN accompanied by appropriate and harmonious decoration, a rare practice in a time that favored pointed-pen ROUNDHAND with its tortuously overwrought flourishes. Morris's example greatly inspired Edward JOHNSTON.

Morocco Fine goatskin leather used in BINDING books.

motto Words sometimes incorporated in a HERALDIC design, often written on a painted ribbon.

mould Synonym of MOLD.

mound Flat or hill-shaped base on which SUPPORTERS and the SHIELD stand in some HERALDIC designs.

movable type Separate metal letters, a line of which is capable of being placed (set) in any combination. The lines (cast on shanks) are tied together, inked, and printed on a platen press. Apparently used in Korea *c.* 1200, although the type was not metal, but clay or wood. In the West this method of printing was developed *c.* 1450 by Johann GUTENBERG of Mainz, Germany.

MS *pl.* MSS Abbreviation of ''manuscript.''

muller Formerly made of stone, the type used most by illuminators today is of solid glass, 3–4″ (7.6–10 cm) in diameter, and is dragged circularly on a surface of frosted glass to mix homemade GESSO or PAINT.

Munsell color system First published in 1905 by Albert H. Munsell, and frequently revised since, it scientifically defines all colors and their relations by measured scales of HUE, VALUE and CHROMA. Although it is impossible to describe color and color relationships objectively, this is the foremost system in providing a key to communication in this elusive field.

museum board Synonym of RAG board.

musk Serves no practical purpose, but is sometimes used as a perfuming agent in INK.

muller

N From the Semitic *nun* (snake) it has been written in a similar fashion to 𐤍 or N since the beginning. Its modern form developed during CLASSICAL Greek times.

nap Describes the smooth and silky surface of well-prepared PARCHMENT. Depending on the quality and size of the surface, to achieve this nap requires rubbing with fine grade (320–600; the larger the number, the finer are the abrasive particles in the sandpaper) wet-or-dry SANDPAPER (used dry) for up to 30 minutes, sometimes longer. If the parchment is to be used for fine painting, a nap is usually not desirable.

Naples yellow Subtle earthy yellow PIGMENT, once a combination of lead and antimony oxides. Today it is synthetic, so contains no lead, but may contain poisonous CADMIUM SULFIDE.

national script Among the regional versions of LATIN MINUSCULE which developed after the decay of Roman rule (*c.* 500), several major scripts emerged (each with variations): BENEVENTAN (Southern Italy), MEROVINGIAN (modern France and Germany), VISIGOTHIC (modern Spain) and INSULAR (British Isles). They in

turn influenced the one which was eventually to overshadow them all, CAROLINGIAN MINUSCULE.

native Synonym of NATURAL.

natural Material such as PIGMENT or DYE derived from plant, animal or mineral sources, as opposed to having been produced synthetically.

neck Also link. The part of the LOOPED "g" that connects the upper and lower COUNTERS.

needle burnisher Pointed piece of agate set in a handle for BURNISHING or drawing designs in SHELL GOLD or GILDED areas. Especially useful in getting leaf to stick around the edges of gilded areas. *See* BURNISHER *for illustration.*

negative space In calligraphy, the space between strokes, letters and lines of writing. Generally, any space within the area of writing or drawing, but can include MARGINS.

Nemoy, Maury American (1912–84) Student of Lloyd REYNOLDS. Calligrapher, designer of record sleeves and book jackets, teacher, author of *Calligraphy: The Study of Letterforms* (1985).

neo-Punic *See* PUNIC.

Nesbitt, Alexander (b. 1901) American designer, typographer, calligrapher, teacher who lives in New York. Among his books is *The History and Technique of Lettering* (1950, 1957).

Neudörffer, Johann the Elder (1497–1563) German calligrapher who lived and worked in Nuremberg. His *Ein Gute Ordnung . . .* (1538) is one of the earliest writing books to be engraved rather than WOODBLOCK printed. It also helped to establish a definitive FRAKTUR script.

Neudörffer, Johann the Younger German (1543–81) Prominent calligrapher from Nuremberg, whose work was based on that of his father, JOHANN NEUDÖRFFER THE ELDER.

detail of Neudörffer the Elder's writing book

Neugebauer, Friedrich Austrian (b. 1911) Influential calligrapher, designer and teacher, whose work and philosophy have been widely admired. Author of *The Mystic Art of Written Forms* (1980).

neutral color One which tends neither to red nor to blue (is neither WARM nor COOL). Neutral colors are usually browns or grays.

Newberry Library, Chicago, U.S. *See* Appendix, LIBRARIES.

new gamboge *See* GAMBOGE.

newsprint Paper from which newspapers are made. ACIDIC, and will turn brown, thus not recommended for fine work.

nib The end of the pen which meets the writing surface. May be detachable or cut from the BARREL of the pen. The first detachable nib for use in a holder, made *c.* 1800, was actually a semi-cylinder of quill cut for the purpose. Today detachable nibs are of steel. *See* CANT.

nib width Width of any given BROAD EDGE nib, used as a unit to measure letter height when determining WEIGHT. Thus, a letter three nib widths high will be heavier than a letter six nib widths high. ITALIC is often written at about five nib widths. *See* PEN SCALE.

Niccoli, Niccolo Italian (*c.* 1364–1437) When CAROLINGIAN forms are written with speed, they naturally become CONDENSED and CURSIVE. Niccoli was the first known scribe to use this writing, later called ITALIC. He collected hundreds of classical MSS, now part of the collection at the LAURENTIAN LIBRARY, Florence.

nick Slight notch out of what could otherwise be a continuous curved or straight line.

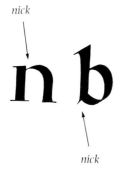

nick

nick

non-aligning numerals Also old style. Set of numerals where 1, 2 and 0 set the standard height while 3, 4, 5, 7 and 9 project below and 6 and 8 project above, thus: 1, 2, 3, 4, 5, 6, 7, 8, 9, 0.

non-repro blue Light blue, usually used in pencil form, which does not show up when ARTWORK is photographed for reproduction. Used for GUIDELINES, written notes to the printer, etc.

not Also "not press." British term for "not hot press," i.e. COLD PRESS paper.

notours Late MEDIEVAL term for SCRIBES who specialized in the writing of musical notation in medieval MSS.

numerals ARABIC: Our ten figures, 0–9, which first made their appearance *c.* 1000 AD, having come to Europe (most probably from India) via the Moorish occupation of Spain. It was more the idea they embodied than the form of the numerals that was revolutionary. Their form has changed completely in the last 1,000 years, but the concept of the zero and the base ten number system made for a more efficient system of notation than the one Europe had inherited from the Romans. Despite its efficiency, the system was not widely accepted until the mid-15th c. and in England two centuries later. ROMAN: figures 1–10 were based on hand signals, 1–4 being simply the number of fingers shown, 5 the whole hand held in a "V" shape with thumb extended, and

10, two hands crossed to form an "X." Figures for the larger numbers were "leftovers" from the ETRUSCAN alphabet: when the Romans adopted their alphabet, there were signs that could not be adapted to the Latin language, and were "Romanized" for use as numbers. Thus, chi () became ⊥ , L = 50; theta (⊙) became C = 100; and phi (Φ) became ⋒ , M = 1,000. Half phi became D = 500. In medieval MSS, a numeral is often denoted by a dot written before and after it.

O Has been written the same way since early Semitic times, but since there were no vowels in the written language, this form signified a guttural "C" sound, from the word *cayin* (eye). The Greeks assigned it the "O" sound.

oak gall Synonym of GALL NUT.

oblique Slanted. OBLIQUE STROKE: one which is at an angle to the writing line. OBLIQUE COPPERPLATE NIB: for writing COPPERPLATE. Inserted in a straight pen holder. OBLIQUE HOLDER: also for copperplate. Its nib attachment juts out at the angle required for this extremely slanted script, and is used with an ordinary DRAWING nib. OBLIQUE NIB: nib cut at an angle especially for right-hand or left-hand use. *See* CANT. OBLIQUE AXIS: *See* AXIS.

obsolete PIGMENTS or other materials become obsolete because they are more poisonous, impermanent, expensive or more difficult to use than their modern replacements.

ochre NATURAL EARTH PIGMENTS of clay and silica. Though they are found in many colors ranging from light yellow through green, to red, orange and brown, the term is usually used only for the red ochre (maroon in color) and yellow ochre (mustard color) pigment.

octavo Abbreviated 8vo. 1) QUIRE consisting of 8 PAGES. 2) Book of four folded sheets; yielding eight LEAVES, or 16 pages. 3) The size of a small book whose page size is $\frac{1}{8}$ of a sheet.

off center Work (line of writing, illustration, etc.) that has unequal side margins, as measured or as perceived. Usually refers to horizontal centering. ABOVE CENTER and BELOW CENTER are used for vertical centering.

Offenbacher Schreiberwerkstatt Begun in Offenbach, West Germany, by Rudolf KOCH after the First World War. A famous and influential German workshop/school in which select artisans practiced calligraphy, graphic design and other overlapping and related arts and crafts such as printing, BOOKBINDING and type design. Continued today under Karlgeorg HOEFER.

offhand flourishing Intricate rendering, with a pointed pen, of birds, cherubs, etc. in and around a written text, or by itself. Popular in the late 19th c.

oblique holder with nib attachment

offhand flourishing

86

offset lithography Synonym of OFFSET PRINTING.

offset pen Synonym of OBLIQUE HOLDER.

offset printing PLANOGRAPHIC process in which thin metal, plastic or paper plates are treated to resist or attract the printing ink and transfer the image to rubber rollers which in turn transfer it to the paper. Invented by Ira Rubell in New York in 1904. *See* THERMOGRAPHY.

offsetting Accidental transferring of ink or paint from one page to its adjacent page due to insufficient BINDER in paint, or ink that is not yet dry.

ogams Celtic RUNE-like writing system, based on Roman forms. The letters are formed by carving 1–5 side strokes at various angles to a straight base which is often the edge of a piece of wood or stone. Used by peoples of Ireland, Wales, Scotland and south-western England, beginning around the 5th c. AD, primarily for marking gravestones. Seldom used after the 7th c. due to the spread of Christianity and the Latin alphabet.

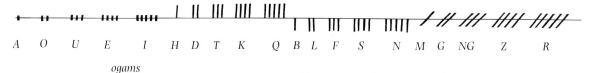

A O U E I H D T K Q B L F S N M G NG Z R

ogams

ogee

ogee Also compound curve. One which curves opposite ways at each end.

Ogg, Oscar American (1908–71) Student (and cousin) of Warren CHAPPELL. Typographer, calligrapher, teacher, author of *The 26 Letters* (1948, 1971), and *Three Classics of Italian Calligraphy* (1953).

oil of lavender Also oil of spike lavender. Preservative (not derived from the herbaceous plant, however). Similar to turpentine, it is not desirable for use in calligraphic work, as oil can ruin paper and parchment.

oil stone Synonym of SHARPENING STONE. Despite its name, scribes use water or DETERGENT instead of oil.

Old English Commonly used misnomer for GOTHIC. As the Italian RENAISSANCE HUMANIST scripts were gaining popularity in Europe in the 15th c., the northern countries such as England, whose disdain of Italian (papal) influence was pervasive, still hung on to the GOTHIC scripts, hence the name.

old face Synonym of OLD STYLE.

old style Pre-1640 typefaces of, for example, JENSON, GARAMOND and CASLON. Characterized by COUNTERS with an oblique AXIS, FILLETS, BEAK SERIFS and other qualities associated with pen-made letters. Old style (NON-ALIGNING) numerals are often used with them.

Oliver, M. C. British (1886–1958) Student of Edward JOHNSTON at the Royal College of Art, London. Influential teacher whose students included Ann CAMP, Heather CHILD and Donald JACKSON. Contributed essays to early editions of *The Calligrapher's Handbook*.

one stroke brush BROAD EDGE flat sable brush. *See* BRUSH.

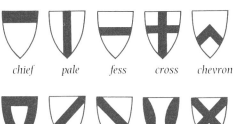

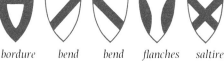

chief pale fess cross chevron

bordure bend bend flanches saltire
 sinister

ordinaries

ostrakon

outline letters

opaque Describes paint or ink that completely covers over what is underneath it, or any material that allows no light to pass through.

opening 1) Two facing pages of a book. 2) MS on one FOLIO with all text on the inside PAGES. 3) Window of a MAT.

oracle bones The earliest extant examples of Chinese writing, dating from *c.* 1500 BC, they are bones or tortoise shells carved with records of births and deaths, prayers and priests' responses to prayers.

ordinaries Bands or marks on a HERALDIC SHIELD.

organic pigments Pigments derived from animals, plants or petroleum. *Compare* INORGANIC PIGMENTS.

orihon ACCORDION book in which the reverse folds are glued together. When bound, it resembles a sewn binding.

ornament Decoration that is not essential to the structure of a piece of work.

ornamental handwriting Pointed pen writing popular in the late 19th c., in which pressure was used to make occasional strokes very thick.

orpiment From the Latin *auripigmentum* (the color of gold). Obsolete. Natural arsenic trisulfide. Found as a mineral in Asia Minor, this bright yellow pigment was used by the Egyptians, *c.* 4000 BC, and continued to be popular until the 15th c., when it fell out of favor with European MSS painters due to its incompatibility with the then-indispensable white lead. Today, CADMIUM and other yellows are used.

Osley, A. S. British (1914–87) Edited and translated important RENAISSANCE writing manuals, such as that of CRESCI and MERCATOR. Author of *Scribes and Sources: handbook of the chancery hand in the sixteenth century* (1980). Edited *Calligraphy and palaeography* (1965) for presentation to Alfred FAIRBANK on his 70th birthday. Long-time editor of the *Journal of the Society for Italic Handwriting*.

ostrakon *pl.* ostraca, ostraka Broken pieces of clay pots were used for informal notation, written on with a REED BRUSH and ink by ancient peoples of the Mediterranean and Asia Minor.

ostrum Latin for TYRIAN PURPLE DYE, used for ink.

outline Letters drawn in outline and left blank in the middle.

overlay 1) One of a series of acetate (plastic) sheets laid on top of each other, each with black artwork on it, and each representing a separate color in a project which will be printed in more than one color. 2) Sheet of translucent paper, laid on top of a MECHANICAL for reproduction, that contains instructions to the printer.

ox gall Powdered WETTING AGENT taken from the gall bladder of a cow. Includes bile, salts, acids, cholesterol, etc. Today largely replaced by synthetic wetting agents.

oxide of chromium Permanent, opaque, subtly elegant green paint that flows smoothly from the pen. Made from chromium sesquioxide. First introduced at the beginning of the 19th c.

P From the Semitic *pe* (mouth). Its early forms included ⬭ (Sinai *c.* 1400 BC) and �7 (PHOENICIAN). Written ⊓ in classical Greek. It attained its present form in classical Roman times.

p. Abbreviation of "page." pp. stands for "pages."

page Either side of a LEAF.

pagination Sequentially numbering pages in a MS, a practice which became common in the 16th c. It is usually omitted in small MSS.

paint Mixture of powdered PIGMENT and VEHICLE that makes the pigment fluid enough to work with and sticky enough to stay put. For scribes, paint has meant a pigment with an AQUEOUS vehicle (WATERCOLOR), containing such ingredients as soluble GUM, GLYCERINE and PRESERVATIVE. Considering the unlimited media being used to produce calligraphic work today, other types of paint are worth examining. ACRYLIC: minute globules of ACRYLIC resin dispersed in mineral spirits. Soluble in spirits or turpentine when wet or dry. Rarely if ever used in pens. OIL: since linseed or other oil is its vehicle, it does not usually adapt itself to use on paper, nor does its buttery consistency make it suitable to use in a pen. POLYMER: often mistakenly called acrylic paint. Minute globules of acrylic resin dispersed in water. Thinned with water, but completely waterproof when dry. Rarely, if ever, used in a pen. Because it dries quickly to an impervious plastic, wash brushes immediately after use.

Palatino, Giovanbattista Prominent Italian intellectual. In 1540 published *Libro nuovo d'imparare a scrivere*, a writing manual employing pointed ITALIC letters which were beautiful but somewhat difficult to write.

pale Band down the center of a HERALDIC SHIELD. *See* ORDINARIES.

pale gold leaf Metal LEAF containing about 8k. of silver mixed with about 16k. of gold. *See* LEAF, GOLD LEAF, SILVER LEAF.

paleography Study of the history of written or painted letter-forms, as distinct from those carved or incised. *Compare* EPIGRAPHY.

paleolithic Early Stone Age, ending *c.* 8500 BC. The LASCAUX cave paintings are from this era, as well as Native American narrative paintings.

palette knife Common term for what is technically named a painting knife. A plastic palette knife is used to scrape and collect from the grinding surface freshly mixed homemade paint. A steel palette knife can be used for large calligraphic strokes on canvas or paper.

palimpsest From the Greek *palimpsestos* (scraped again). A VELLUM, PARCHMENT or PAPYRUS page from which the original written text has been eradicated, and another text has been

detail from Palatino's writing manual

palette knife

palimpsest

written. This practice illustrates how short the supply of writing surfaces has always been. The main methods of erasure were firstly, wiping with water; and secondly, scraping with a knife or PUMICE stone. Frequently both were used. Often a trace of the erased text is evident even after the new text is written over it; it can be seen more clearly under ultraviolet light.

palindrome Sentence which reads the same forward as backward; for example, "Able was I ere I saw Elba."

palladium leaf Used in GILDING, a silvery metal of the platinum family which is costlier than gold. Darker than SILVER LEAF; slightly brownish.

Palmer method Developed by the American Austin N. Palmer (1860–1927). A variety of COMMERCIAL CURSIVE which is called "business script." Characterized by rapidly written, unSHADED letters. Palmer championed it in schools, claiming that it was a "tireless" method, using wrist and arm movement rather than finger movement, and that it did away with the impossibly refined examples in most contemporary COPYBOOKS. Palmer himself learned handwriting from a student of P. R. Spencer. *See* SPENCERIAN.

palm leaf book Palm leaves or long strips of any other suitable material fastened together at one end to be fanned out for reading. Another type is strung together like Venetian blinds.

Pantone The Pantone Matching System (PMS) is represented in a book of over 500 printing ink colors, each with its own "recipe," allowing precise matching and duplications of ink colors.

pan watercolor *See* WATERCOLOR.

paper The history of papermaking usually notes that *c.* 100 AD, the Chinese developed a way to pound fibers, such as hemp cloth and the inner bark of trees, to pulp. It was then floated in water, flour paste added and ladled into a mesh, letting the water drain off. This left a layer of pulp which, when dried under pressure, became a sheet of paper. The process was taken up by Arabs around 800 and carried to Morocco by 1100, thence to Spain *c.* 1150 and the rest of Europe. The Europeans proceeded to use pulp of cotton and linen. To this greatly simplified history it should be added that paper from plant pulp was not unknown around the Mediterranean and even in Europe in the early centuries AD, but it was so crude that it was far inferior to the smooth PARCHMENT and PAPYRUS, and nothing much was made of it. And even though relatively fine paper was available by the 12th c., it was not widely popular in Europe until the advent of MOVABLE TYPE printing in the 15th c. The QUILL pen (which snags on rough paper) was predominant in Europe: reeds were not readily available, and adequate steel nibs would not be widely obtainable for many centuries to come. Parchment remained the only practical writing surface. *See* BOND, BOARD, BRISTOL, CALENDER, CHINESE –, COLD PRESS, HANDMADE –, HOT PRESS, JAPANESE –, LAYOUT –, NEWSPRINT, MACHINE-MADE –, MOLD MADE –, RAG, TRACING –, WATERCOLOR –, WOODPULP –.

paper stretching Suggested when WASHES are used. Marie ANGEL's technique involves laying paper face up on a wooden board, dampening the paper surface with a wet sponge,

smoothing it down onto the board, taping the edges with paper TAPE and letting it dry. This will prevent it from COCKLING when wetted with paint.

papyri Plural of PAPYRUS. MSS written on papyrus.

papyrus Writing surface, common in the ancient Mediterranean countries from *c.* 3000 BC. Its use started to drop around 200 AD as PARCHMENT became popular, but continued even in Europe until the 12th c. when it was almost completely replaced by parchment and PAPER. It is made by pounding together two layers of strips cut lengthwise from the rush called *Cyperus papyrus*, the second layer at right angles to the first. The sticky, juicy strips, now fused together, are dried in the sun. The dried sheets, measuring about 12″ (30·5 cm) square, are glued together to form scrolls, the inside (writing) surface of which may be smoothed with PUMICE stone or ivory.

parallel glider Small, portable straightedge with a wheel at each end; for ruling parallel lines. Not always perfectly accurate.

parallel ruler Mechanism permanently attached to the drawing table for ruling parallel horizontal lines.

parallel rules Two STRAIGHTEDGES attached to each other for making parallel lines. Space between them is adjustable.

paraph FLOURISH added to a signature, originally to prevent forgery.

parchment Named for Pergamum (modern Bergama, Turkey), an early center for the production of this writing surface made of animal skin. The word "parchment" usually refers to any mammalian skin which has been soaked in lime for about two weeks to loosen the hair, and then scraped of hair and flesh with a curved blade, and dried under tension. Depending on the skin, any of these steps may be repeated and the skin may also be rubbed with chalk or other grease-absorbing agent. What distinguishes it from LEATHER is its tanning agent – lime leaves the skin almost white. What follows here is an abridged version of Somerville's parchment subgroups, as set out in *The Calligrapher's Handbook*. VELLUM: parchment made from calfskin. MANUSCRIPT PARCHMENT: prepared for writing on both sides, not just the HAIR SIDE. MANUSCRIPT CALFSKIN VELLUM: most popular scribal skin, prepared for writing on both sides, white to light cream in color. SLUNK MANUSCRIPT VELLUM: made from still-born or newborn calves, prepared for writing on both sides. Very thin and translucent. Often has less TOOTH than other vellum. CLASSIC VELLUM: prepared for writing on hair side only, often thick and is creamier in color than MS vellum. KELMSCOTT VELLUM: calfskin for printers' use, often too smooth for writing. BOOKBINDING VELLUM: called "natural grained calf vellum" and "natural veiny calf vellum," their surfaces are not as refined as "MS" and "classic," but are often pleasant to write on. NATURAL GOATSKIN PARCHMENT: finished on hair side only, varies from cream to light brown in color. The surface usually has a shiny appearance, but still has a pleasant tooth in writing. Also known as "natural goat vellum." A whiter version is "white goatskin parchment," which is sometimes erroneously called vellum. The surface of goatskin can vary abruptly in texture, thus consistent results require (as

with all materials) sensitivity through experience. SPLIT SHEEPSKIN PARCHMENT: sheepskin has a layer of fat between the two layers comprising the skin, making it possible to separate the two layers; the inner layer is used by scribes. The uniform greasy-smoothness of surface and white or gray-white color which both sides possess makes this a less responsive surface for writing than most other parchment. Also called "white sheepskin parchment." PREPARATION OF PARCHMENT FOR WRITING: the preparation procedure is necessary to remove grease (with PUMICE and/or FLOUR PAPER) and to raise the NAP. Every skin requires slightly different treatment, and detailed descriptions on how to prepare the surfaces can be found in many practical guides to calligraphy. A dusting with finely ground SANDARAC is always needed just before writing. Because it repels ink slightly, it ensures crisper strokes. The excess of both sandarac and pumice should be thoroughly dusted off with a soft brush before writing. *See* LEATHER.

parchment paper Made from wood fibers rather than skin, paper which supposedly resembles PARCHMENT.

parchment size Stiff gelatin made by boiling PARCHMENT scraps in water in a DOUBLE BOILER. When it is allowed to rot it becomes liquid without heating ("stale parchment size"). Some find this quality favorable. Either way, it is used as a BINDER in PAINT, GESSO, and as a SIZE for paper.

particle size The size and shape of the PIGMENT particles in paint and ink greatly affect the pigment's COVERING POWER, TINTING STRENGTH, brilliance of color and handling properties, as do the size and shape of the particles used in EXTENDERS. Normally, scribes have nothing to do with the manufacture of their pigments, but some such awareness is helpful when materials are hand-ground.

paste ink CARBON INK available in a tube to be diluted with water before use.

paste paper Paper decorated with colored rice paste. Used for ENDPAPERS or covers of books. First used *c.* 1600.

patent gold Synonym of TRANSFER GOLD LEAF.

Payne's gray LAMPBLACK with other colors added to produce a dark blue-gray PIGMENT.

pearl script Late 13th-c. French GOTHIC characterized by low BODY HEIGHT and tiny INTERLETTER SPACING.

peasant ruler *See* RULER.

pecia System by which books were hired out (measured by the QUIRE) for copying, usually by students in university centers in Italy, France and England, *c.* 13th–15th c.

pen From the Latin *penna* (feather). Any of hundreds of writing instruments which deposit ink on a writing surface by way of a hard, but sometimes flexible nib. *See* BALLPOINT −, DIP −, FIBERTIP −, FOUNTAIN −, METAL NIB, REED −, QUILL.

pen angle In BROAD PEN writing, the angle at which the nib's edge meets the paper in relation to the WRITING LINE. A "steep" angle is approx. 46°–90°, a "natural" angle is 30°–45°, and a "flat angle" an angle of 0° to 29°.

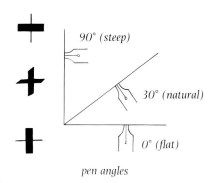

pearl script

pen angles

pen holders

measuring in nib widths

pencil Until the late 18th c., this was a small pointed brush (literally, "little tail") used by painters to draft outlines or do very fine work. The pencil as we know it goes back to perhaps 1100 when it was made of lead alloy. Since 1604 the writing material has been graphite. In the late 18th c., the Conté company patented the process used today: graphite powder and clay are mixed, in whatever proportion will yield the desired hardness. This is kneaded with water, reground and the water pressed out. The mixture is squeezed through a small hole to a worm-like shape, dried and fired in a kiln. After impregnation with wax to remove porousness, it is glued into a hollowed-out wooden shell, which will be cut to form a pencil.

Artists' pencils come in various grades, from the hardest, 10H, to the softest, 8B. HB stands for "hard black" which is medium hard. The neighborhood of 2H is usually satisfactory for scribes' use; 8H is often useful for lining on PARCHMENT because the NAP can widen and blacken an ordinary pencil line. *See* AUTOMATIC, CARPENTER'S –, DOUBLE –, NON-REPRO BLUE.

pen holder Shaft into which is placed a detachable NIB.

pen knife Originally a knife for cutting QUILL pens for everyday writing. Scribes nowadays, cutting pens from various materials including bamboo and wood as well as feathers, should note that a quill knife should be kept for quills only, as other materials can damage it. *See* QUILL KNIFE.

penman Name used from the early 17th c. to the early 20th c. for a SCRIBE who hires himself out to write documents.

pen manipulation The varying of the PEN ANGLE or PRESSURE while making a stroke or letter. This can also include using only a corner or one half of the NIB.

penmanship Name for HANDWRITING common from the 17th c. to the mid-20th c.

penner Pen container used by medieval traveling scribes.

pen scale Height of a letter as measured in the NIB WIDTHS of the pen being used. Used to plan or describe the WEIGHT of the letters being written.

pen stick Archaic for PEN HOLDER.

pen twisting The changing of the PEN ANGLE during a stroke. A form of PEN MANIPULATION.

pen width Synonym of NIB WIDTH.

pen wiper Small piece of cloth, chamois leather or absorbent paper used to clean the NIB, or to wipe off excess ink before writing.

Pergamum Also Pergamon. City in what is now Turkey from which PARCHMENT is named, having been a major center for its production in classical times. Now known as Bergama.

period *See* PUNCTUATION.

permanence The capacity of a material (paper, ink, paint, etc.) to resist change in color and consistency when exposed to light, heat, damp and acidic gases in the air. A slightly vague term, because so many factors are involved. Permanence can be

enhanced by considering how and where a work will be displayed and the properties of the materials being used.

permanent green Non-specific mixture of various greens and yellows. LIGHTFAST.

permanent white Non-specific term for various whites, including titanium dioxide and BLANC FIXE. LIGHTFAST.

permanent yellow Non-specific term for various yellows including barium yellow. LIGHTFAST.

Perspex British term for PLEXIGLAS.

Petrarch (Francesco Petrarca) Italian (1304–74) Through their interest in and collection of CAROLINGIAN manuscripts, Petrarch and his circle of HUMANIST colleagues are regarded as embodying the beginnings of the RENAISSANCE. He used the clean, straightforward letters of 9th–12th-c. Europe for his own writing, eschewing the GOTHIC pervasive at that time.

petroglyph Prehistoric record carved in stone.

petrogram Prehistoric drawing or painting on stone.

pH Acidity or alkalinity of a substance measured on a scale from 1 to 14. pH7 is neutral and desirable for lasting art materials. Below 7 is ACIDIC and above is ALKALINE.

phenol Carbolic acid. PRESERVATIVE. White crystalline germicide produced from coal tar. Available in drug stores as a 10% solution. Two drops per each tsp. of GLUE, SIZE or GUM ARABIC will prevent decomposition. Has a very strong smell, so it may be preferable to use other, more pleasant preservatives.

Phiastos Disk Dating from 1700 BC, a 6–7″ (15–18 cm) clay disk, as yet undeciphered, which was unearthed in 1908 at Phiastos on the Mediterranean island of Crete. Remarkable in that its 241 signs (including 45 different signs) are stamped with punches rather than written.

Philip the Good, Duke of Burgundy (1396–1467) One of the greatest collectors of fine MSS of his time. Employed some of the best scribes and illuminators to produce works for his library of over 3,000 books, many of which are now housed in the great libraries of Europe, including the Royal Library, Brussels, and the BIBLIOTHÈQUE NATIONALE in Paris.

philology The study of human speech and linguistics in relation to literature and culture.

Phoenicia A land in what is now Lebanon and coastal Syria, whose people flourished c. 1100–800 BC. They were aggressive traders and seafarers, colonizing areas of Greece, Italy, France, northern Africa and even Spain. With them came the earlier Canaanite idea of alphabetic writing, using consonants only; strange to speakers of English, but natural to the Semitic languages whose vowel sounds are predictable. Earliest known Phoenician alphabetic carving is on a bronze cup called the Baal of Lebanon, c. 800 BC. See ALPHABET.

phonetic System of writing in which a sign links up with a certain sound or sounds in speech, as compared with systems which include only literal or abstract word pictures.

Phoenician alphabet

phonetic complement Auxiliary sign to aid comprehension and pronunciation in the writing of SUMERIA, Egypt and Crete, c. 3000 BC. *See* POLYPHONE.

phonogram Sign which designates a particular vocal sound; a whole word or part of a word.

photocomposition Synonym of PHOTOTYPESETTING.

photographic print Reproduction (of LINE WORK, etc.) from a film negative.

photostat Reproduction (of LINE WORK, etc.) on paper. Less crisp than a photographic print, but also less expensive. Both are used for documentation of finished work, as CAMERA-READY artwork, or as a copy of the artwork on which to RETOUCH.

phototypesetting The projection of images onto photosensitive film or paper for use in printing. This process replaced LINOTYPE and MONOTYPE for mass printing in the late 1950s.

Phragmites communis Hollow reed from swampy areas of the north-eastern U.S. Suitable for making REED PENS.

phthalocyanine Also thalo blue and green. LAKE PIGMENTS developed in 1935. Phthalocyanine blue was the first SYNTHETIC ORGANIC PIGMENT to be PERMANENT enough for artists' general use. These pigments have good TINTING STRENGTH, and work well in a pen.

} one pica

pica Typographic measurement that equals 12 POINTS, or approx. $\frac{1}{6}$ inch.

pictogram Picture sign having no association with the sound or look of the word it represents. One of the oldest forms of written communication. *Compare* PHONOGRAM.

pictograph Literally, picture writing; before the development of writing systems. Each sign represents a word, either concrete (LOGOGRAM) or abstract (IDEOGRAM).

pictographic A and B Two scripts from the BRONZE AGE MINOAN culture on the Mediterranean island of Crete. Class A (*c.* 2000 BC) was a system of PICTOGRAMS carved into CYLINDER SEALS. The later Class B, a TRANSITIONAL script, was more CURSIVE and was inscribed in soft clay as well as in stone. Pictographic B included about 135 signs and was written both left to right and BOUSTROPHEDON fashion. These two scripts developed into MINOAN LINEAR A and B.

picture writing The drawing or carving of a scene or event. Practiced primarily before alphabetic systems were developed.

Pierpont Morgan Library New York, U.S. *See* Appendix, LIBRARIES.

pigment Finely powdered, insoluble coloring matter from plant, animal or petroleum (organic), or metal or mineral (inorganic) sources. Mixed with BINDER so it will stick to the surface, and VEHICLE so it will flow, to make PAINT. Pigment made from DYE is called a LAKE.

pinion feather Synonym of PRIMARY FLIGHT FEATHER; any of the first five in from the wing tip.

pipette

pipette Tiny, flexible plastic tube with a bladder at one end, made as a scientific instrument. It can be used to store small amounts of ink or paint, as the pipette prevents them from drying out.

pixel Smallest visual unit on computer screen. With a capable computer, subtle and complex letters and designs can be made by arranging the pixels and printing out the results.

planography A printing process, such as lithography and offset, that uses a smooth surface, the non-inked areas resisting the ink with oil or wax. *Compare* INTAGLIO, RELIEF.

plaster of Paris Calcium sulfate. Heating powdered GYPSUM at 145°C causes it to lose some, but not all, of its water content. This produces plaster of Paris, which, when mixed with water equaling 18–35% of its weight, will result in a moderately hard solid. The kind scribes use in GILDING is SLAKED PLASTER OF PARIS. The purpose of slaking (returning the crystalline water content to a substance) is to modify the crystalline structure of the plaster so as to attain the balance between flexibility and strength necessary in GESSO. The crystals' shape is affected by the way the slaking is done and by how much and in what way the plaster is ground during the mixing of the gesso.

The following instructions on slaking are given by Irene Base, the well-known British illuminator: sift a pound of powdered fine dental plaster into a gallon and a half of distilled water, stirring constantly with a wooden spoon. Continue to stir for an hour. Leave for a day, pour off and then replace water, and stir for ten minutes. Pour off water, replace and stir every day for a week, and every other day for another three or four weeks. Pour off water, put wet plaster into linen or muslin cloth, and squeeze it dry. Take out of cloth, and allow to dry gradually for a few days free from dirt. Cut into pieces while still soft and store in rust-free container.

plasticizer Ingredient in PAINT and GESSO, such as honey, sugar or GLYCERINE, which is hygroscopic (attracts moisture), and therefore keeps the mixture flexible to resist eventual cracking. Too much renders a mixture sticky and too little makes it brittle.

plate finish Paper surface that is COATED and lightly CALENDERED, making it smooth and slightly glossy. Formerly achieved with metal plates, now with rollers. *See* PAPER.

platinum leaf Non-tarnishing silvery metal LEAF that is slightly thicker and stiffer than gold leaf.

Plexiglas Also Perspex. Hard plastic, sometimes used in place of glass for framing artwork. Should only be used when necessary (as when shipping large framed artwork) because it scratches so easily, eventually clouding the image of the work. Must be cleaned with Plexiglas cleaner and a soft cloth (a paper towel will scratch it).

Pliny Pliny the Elder (23–79 AD) Roman scholar who documented scientific, artistic and political processes of his time, including some information about the scribal arts. Although some of his observations are not correct by the standards of modern science, they are nevertheless interesting and informative. Pliny the Younger (62–113), nephew of Pliny the Elder, was an author.

ply From the French *plier* (to fold). One of several layers of paper. Thus 3-ply BOARD is the equivalent of three thicknesses of 1-ply.

Poggio Poggio Bracciolini (1380–1459) was a Florentine man of letters, interested in their form as well as in the literature itself. His important contributions to calligraphy (and type) include his handwriting based on CAROLINGIAN forms (instead of GOTHIC) and his introduction of MAJUSCULES directly written (not drawn and filled in) with the same pen used for MINUSCULES. Thus, for the first time in history, a "family" of letters was developed within a script that included the capital letters.

point 1) Synonym of period or full stop in PUNCTUATION. 2) Unit of measurement in TYPOGRAPHY, approx. $\frac{1}{72}''$ (·35 mm). Typefaces are sized in points, measured vertically from the ASCENDER line to the DESCENDER line. Rarely used in calligraphy. Twelve points equal one PICA. This text is set in 10 point type. 3) Unit of $\frac{1}{1000}''$, used in measuring the thickness of paper.

polymer paint Minute globules of ACRYLIC paint dispersed in water; thinned with water. *See* ACRYLIC, PAINT.

polyphone Symbol found, for example, in SUMERIAN script of *c.* 3000 BC, which has more than one phonetic value. Auxiliary signs were used to indicate to the reader which sound, and therefore which meaning, was intended. The signs that the Sumerians devised did not take the place of, but were an addition to, the word signs. These auxiliary signs are called PHONETIC COMPLEMENTS.

polytych Many-leaved Roman wax TABLET, bound at one side as a CODEX.

ponce wheel Synonym of POUNCE WHEEL.

post 1) Paper size measuring $19\frac{1}{4} \times 15\frac{1}{4}''$ (48·9 × 38·7 cm). 2) Archaic term for a quantity of paper sheets, equaling 6 quires of 24 sheets each.

poster pen DIP PEN, of a width greater than about $\frac{1}{4}''$ (·6 cm). Of the many varieties, Powell and Coit brands seem to be the most popular because they glide easily on most paper. For some purposes, Automatic, Speedball and Steel Brush or Pendance felt pens will work best. Homemade poster pens can be cut from veneer, felt, plastic tubing and other materials.

postil Marginal note or comment, found in some Biblical scripture.

pot Paper size measuring $12\frac{1}{2} \times 15\frac{1}{2}''$ (31·8 × 39·4 cm).

potsherd Fragment of broken pottery, often used for informal notation in ancient Middle Eastern and Mediterranean cultures. *See* OSTRAKON.

pounce Granular or powdered substance sprinkled onto and/or rubbed into a writing surface to improve it. Materials such as ash, powdered CUTTLEFISH bone, crumbs from bread (sometimes baked with ground glass), chalk and PUMICE have throughout history been used to de-grease PARCHMENT and raise the NAP. SANDARAC, which repels water, is used to prevent BLEEDING or spreading of INK. In the days when a dip pen was used for everyday handwriting, pounce was sprinkled onto a freshly

written page to dry the ink quickly. This type included sand, powdered charcoal and biotite (powdered magnesium mica).

pounce box Also pounce pot. Small vessel with a perforated lid, used like a saltshaker to sprinkle POUNCE on a freshly written page. Was used more in handwriting than in calligraphy.

pounce wheel A small wheel with a handle and spikes, for pricking holes along the outline of a design. The pricked-through paper is then set on top of the surface to be lettered, and is dusted with fine powder (chalk, charcoal, etc.) which settles through the holes to outline the design on the final surface. A pricker, also called a runner, was a similar device run up the MARGINS of a page against a STRAIGHTEDGE by 19th-c. SCRIVENERS to prick markings for GUIDELINES into the PARCHMENT writing surface.

Praeneste gold brooch Also Praeneste fibula. Earliest known Latin inscription, *c.* 7th c. BC, which reads *Manios:med:fhefhaked: numasioi* (Manius made me for Numasis). The archaic spelling also points to the derivation of the Latin language from the ETRUSCAN.

precipitated chalk Synonym of BLANC FIXE.

prelims Pages in a book preliminary to the text. These include the TITLE PAGE and contents page, dedication, introduction, etc.

preservative Additive to PAINT, SIZE or other material to prevent decay. In the past such substances as OIL OF LAVENDER, FORMALIN and VINEGAR have been used. An ideal preservative should act against mold, bacteria and fermentation, should be non-ACIDIC and should not be detrimental to the texture or color of the material to be preserved. Tried-and-true BETA NAPHTHOL and the newer DOWICIDE A and B are three types that meet these criteria.

pressure The amount of pressure used in any given stroke, or part of a stroke, will affect the way it looks. With a flexible pen, greater pressure results in a wider line, as the pen SPLAYS. It is a factor, along with speed, pen type, surface, INK, SCRIPT, SLANT of writing surface, slant of letter, etc., that must be considered when planning any project.

pricked guidelines As modern SCRIBES usually use pencil dots as guides for lining up text, MEDIEVAL scribes often pricked tiny holes through several sheets of PARCHMENT at once with a pointed STYLUS or sharp knife. This has the advantage, when carefully done, of allowing the scribe to mark several pages identically, both front and back in relatively little time. Today a compass point can be used to prick the holes. *See* BLIND RULING, RUNNER.

pricker Also runner. *See* POUNCE WHEEL.

primary color Red, yellow or blue. *See* COLOR WHEEL.

primary flight feather Also PINION FLIGHT FEATHER. Any of the largest five feathers of each wing of a large bird. Used to make QUILLS.

print 1) An ART PRINT usually means a work done in INTAGLIO, RELIEF or LITHOGRAPHY – methods which are created, or "pulled," one by one, but produce multiple copies. In these processes, the original stone or plate deteriorates after a certain number of

pounce wheel

copies are made, resulting in a "limited edition." A work reproduced by offset printing or ordinary photographic means – those which can produce an unlimited number of almost identical copies – are not properly signed and numbered as an edition. A SILKSCREEN PRINT can fall somewhere in between, being made by hand in unlimited numbers. 2) To reproduce text by mechanical means. Methods of printing include RELIEF, INTAGLIO, and PLANOGRAPHIC processes. The earliest known example of printing was the PHIASTOS DISK, *c.* 1700 BC, but as far as we know printing did not become popular in the West until the advent of MOVABLE TYPE. There were books dating from the early 15th c. whose pages were printed from incised WOODBLOCKS, but these were very small in number compared with handwritten volumes. In China and Korea, woodblock printing had been practiced at least as early as the 13th c. After GUTENBERG, printing was fully launched as a way to reproduce literature. This ended the era of the scribe as the primary transmitter of Western culture through books, although a market remains to this day for MSS written by hand. 3) To write in non-CURSIVE handwriting.

print script "Ball-and-stick" writing taught to young children, begun in England in 1916. It is now considered by devotees of ITALIC HANDWRITING to be inferior because it does not naturally lend itself to CURSIVE, and has to be abandoned when "real" handwriting is learned. Ironically, it was Edward JOHNSTON's SKELETAL italic forms (intended to help understanding of letters) that spawned this system developed by others.

projector Synonym of ASCENDER and DESCENDER.

proper Indication in a BLAZON that a HERALDIC device is to be painted in lifelike colors rather than using only the traditional TINCTURES.

proportional scale Synonym of REDUCTION WHEEL.

provenance Source or origin of a work of art. An account of a work's provenance often includes not only where it was made, but also a list of its owners throughout the years.

Prussian blue An alkaline ferric-ferrocyanide pigment developed accidentally in 1704 by a colormaker who was experimenting with a red pigment. It thus became the first SYNTHETIC pigment. The dark, slightly greenish-blue had a variable reputation, depending on who manufactured it. Today, it is considered a PERMANENT pigment, although it may fade in strong light, recovering its color in darkness. Translucent when thinly applied.

psalter Christian book for private worship.

psilomelanite Mineral used for BURNISHERS. Some companies sell this as HEMATITE, so check before buying.

pulp Fibrous mush made by beating plant fibers in PAPER-making.

pumice Grayish-white volcanic glass available in powder or lump form. PUMICE POWDER: widely used as POUNCE on PARCHMENT where it draws out grease and helps to raise a desirable NAP. It is important to brush all of it off the surface before writing. PUMICE STONE: spongy stone-like substance

used since MEDIEVAL times for smoothing a rough parchment surface or for scraping off text to re-use the parchment. *See* PALIMPSEST.

punch Also counterpunch. Originally a goldsmith's tool for imprinting his trademark or other design into metal. In the manufacture of type, it is a steel letter, cut in relief on the end of a steel plug. The letter is stamped into brass, making a MATRIX for CASTING metal type.

punch cutter One who cuts each letter of a FONT, in reverse, onto one end of the PUNCH, to be used in casting metal type.

punctuation Graphic devices marking stops or pauses in a text were used occasionally in Greek and Egyptian PAPYRI and Roman monuments in the form of dots between words and paragraphs. In the 8th c., ALCUIN was concerned that sacred texts be "properly pointed," to facilitate reading aloud. MEDIEVAL punctuation included the medial stop (comma) written variously as ✔ and ╱ , and the full stop or point (period) written as a dot on or above the line. However, the dot also accompanied ABBREVIATIONS and numbers, and sometimes merely showed where the scribe rested his pen. An interrogation mark, similar to the modern one, the first surviving example of which dates from the 9th c., was used rarely in medieval times. The hyphen at line end was first used at about the same time. The modern, double quotation mark first appeared in the 6th c. Punctuation did not achieve widespread standardization until after printing was developed.

Punic Also Carthaginian. From Carthage, a Mediterranean empire centered in what is now Tunisia. Punic writing is a subdivision of PHOENICIAN ALPHABETIC writing, which died out *c.* 200 BC. Its two forms, MONUMENTAL and CURSIVE, spawned a more cursive third type known today as neo-Punic, which lasted until *c.* 300 AD. These scripts are "cousins" of Greek in that they all came from North Semitic sources, but Punic, unlike Greek, is not an ancestor of our alphabet.

PVA Polyvinyl acetate, an ACRYLIC polymer which can be used as a GILDING ground.

Q From the Semitic *qoph* (monkey); originally an emphatic "K" sound. Written ━O *c.* 1500 BC in the SINAI, and ♀ in PHOENICIA *c.* 1000 BC.

The once-popular long tail of the modern "Q" came from the sample sheets of 18th-c. printers who tried to outdo one another in showing off the opening words of a speech by Cicero, "Quo usque tandem. . . ."

quadrata See SQUARE CAPITALS, TEXTUS QUADRATUS.

quarter bound Style of BINDING books in which the back is of different material from the sides.

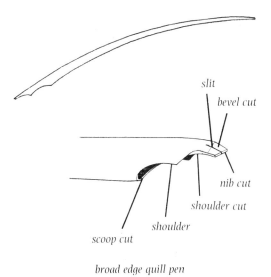

slit

bevel cut

nib cut

shoulder cut

shoulder

scoop cut

broad edge quill pen

quill knife

quarter uncial Non-specific term for very small HALF UNCIAL, sometimes based on length of PROJECTORS and the degree of formality in the writing.

quarto Abbreviated 4to. 1) QUIRE consisting of four PAGES. 2) The size of a book whose pages are a quarter of a full sheet of paper. The size would vary with sheet size.

quatrefoil Medieval four-lobed ornamental device.

question mark First appeared *c.* 9th c. *See* PUNCTUATION.

quill Pen made from a PRIMARY FLIGHT FEATHER of any large bird, usually a goose or turkey, but also a swan, crow, peacock, etc. The feather is soaked in water, CURED (hardened) in hot sand, a small slit is made for the middle of the nib, and the quill is cut to form a pen. Some scribes prefer to omit curing and store the cut quills in water always. *See* CURE.

The direct ancestor of the quill was the REED PEN cut to a BROAD EDGE. Reeds wrote beautifully on PAPYRUS, but as this began to be replaced by PARCHMENT *c.* 6th c. AD, the sharp, crisp quality of a quill better suited the silky smooth surface of the skin. Also, feathers were more plentiful in Europe than were the reeds used by Mediterranean scribes. As paper largely replaced parchment in Europe in the late 15th c., the quill remained. It was not until the flexible steel NIB was developed in the 1830s that the quill began to die out as the Western World's writing tool. Nonetheless, many scribes today favor the quill for its incomparably crisp strokes and hairlines as well as its sensitive balance of strength and flexibility in writing, especially on parchment.

quill knife Has three distinctive characteristics. 1) The handle is much larger than the blade (a common proportion is a $5\frac{1}{2}''$ handle with a $1\frac{1}{2}''$ blade). 2) The cutting edge itself is straight. 3) One surface of the blade is ground in a convex shape, to enable SCOOP CUTS to be made, while the other is flat to enable straight cuts. This knife should be used only for quills, as cutting anything else may damage it. (It may, however, be used to scrape written mistakes from parchment.)

quinacridone Type of SYNTHETIC ORGANIC PIGMENT first mass produced in the 1950s. Known under various trade names, such as "Acra" reds. Translucent, extremely PERMANENT.

quipus Also *quipos, quipu,* from the Quichuan *quipu* (knot). Ancient method of recording information through a system of knots tied in woolen cords of various lengths, suspended from a top band. Used, for example, by the Incas.

quire 1) Gathering, or collection, of 4 sheets folded once. This yields 8 LEAVES, or 16 PAGES. A quire is sewn together as a book or as one of many component sections of a larger book. 2) Any size grouping of sheets folded and sewn together. 3) 24 unfolded sheets of the same size and stock of paper. 4) $\frac{1}{20}$ of a REAM.

quotation mark *See* PUNCTUATION.

R From the Semitic *res* (head). The sign looked like our letter "P" (or a backwards "P") for most of its development. It was not until early Latin that a tiny leg appeared, becoming a fully fledged leg in classical Latin. HALF "R": first appeared in CAROLINGIAN minuscule, and remained popular throughout the GOTHIC period. It relied on the previous letter (usually an "o") to provide its spine, adding strokes that mimic the capital "R." When an "r" followed a letter it could not easily join, a regular "r" was used.

r. Abbreviation for RECTO, thus "fol.10r." means "folio 10 recto."

rabbit skin glue Made from boiling rabbit skin, it is a tough glue used in GESSO when very large areas are to be GILDED – in panels, for example. Rarely used in the scribal arts.

rag board MAT BOARD that has 100% RAG CONTENT; the finest kind available.

rag content The percentage of non-ACIDIC cloth PULP (as opposed to wood pulp, which is often acidic) in any given paper product. 100% rag means that the material is non-acidic, thus desirable for use in lasting work.

ragged "Ragged right" means that, although the left MARGIN on a page of writing or type is straight, the right margin is slightly uneven. This will be because each line has been allowed to finish naturally at the end of a word or hyphenation, without adjusting the spacing to force lines to be of even length. *See* JUSTIFY, FLUSH.

raised printing Synonym of THERMOGRAPHY.

rampant HERALDIC term for a beast standing on its hind legs.

Ramsey Psalter Late 10th-c. MS housed in the BRITISH LIBRARY and written in a late CAROLINGIAN hand. Used by Edward JOHNSTON to develop FOUNDATIONAL script. Named for the monastery where it was thought to have been made, although modern scholarship suggests Winchester. *See* CAROLINGIAN *for illustration.*

rattle The sound made when "snapping" or crumpling paper to test its hardness; associated with good handmade paper. Hard, durable papers have a relatively loud, crisp rattle.

Rawlinson, Maj. Gen. Sir Henry C. While a British soldier stationed in Persia (modern Iran), he deciphered and translated the complete CUNEIFORM text of a stone recording the achievements of Darius the Great (521–486 BC). This marked the first time any of the cuneiform scripts had been deciphered. After his results were published in 1846, he went on to decipher Babylonian cuneiform.

raw sienna *See* SIENNA.

raw umber *See* UMBER.

realgar Arsenic disulfide, a red orange NATURAL PIGMENT used as early as 4000 BC in Egypt. Poisonous, replaced in the 19th c. by

ⓞⓡ

half "R"

CADMIUM RED. Other ancient names are red orpiment and sandaraca (which chemically has nothing to do with SANDARAC).

ream 500 sheets of fine paper. For other papers, the number varies from 480 to 516.

rebus A picture representing a syllable or a word. For example, this illustration can be read as "dogma." In HERALDRY a rebus is a pictorial representation of, or pun on, the name of the bearer.

rebus principle Also phonetic transfer. The idea that a sign can represent two or more words that sound alike, with the context providing the specific meaning. In ancient times, this principle reduced the number of signs needed in a written language, making it less cumbersome.

recto Upper side of a LEAF, or right-hand page. *Compare* VERSO.

red iron oxide Red EARTH PIGMENT that is CALCINATED (roasted) yellow earth. Sold as "light red," "VENETIAN RED," and "INDIAN RED."

red lead Now obsolete bright scarlet PIGMENT made by roasting white lead. Used all over the world from ancient times into the 20th c. Tends to turn brown with time.

Pigment names in general were loosely applied until recently, thus the word "minium," which has been synonymous with red lead since MEDIEVAL times, meant in the ancient world the similarly colored CINNABAR and VERMILION.

red ochre The only RED IRON OXIDE EARTH PIGMENT that is naturally dark red, and not made by roasting yellow iron oxide. One of the very first pigments used, it was painted on the head and chest of corpses by Neanderthal and Cro-Magnon peoples (possibly as early as 50,000 BC), who perhaps associated the color with life-giving blood. It is extremely PERMANENT and OPAQUE.

redondilla Script of early 16th-c. Spanish WRITING MASTERS. Unadorned and FORMAL with both HUMANIST and GOTHIC influences.

reduction wheel Device for computing percentages of reduction and enlargement. By lining up any two measurements on discs that are attached at the center, the proportion of one to the other will be shown on a dial near the center of the wheel.

reed brush Used for writing by ancient Egyptians. A slender reed is chewed or hammered until its end becomes frayed.

reed pen Also split reed pen. This pen is made from hollow-stemmed marsh plant, and has a slit in its NIB which draws ink down to the writing surface. Medieval Islamic scribes, masters of the *qalam* (reed pen) cut their reeds in March, covering them in fermenting manure for at least six months to dry the pith and harden the reed, so that the nibs would stay sharp. For normally sized bookhands, the diameter of these pens ranged from $\frac{3}{16}''$ (\cdot5 cm) to $\frac{3}{8}''$ (1 cm). According to Mohamed Zakariya, author of *The Calligraphy of Islam* (1979), the best reed, cane or bamboo is only available overseas in the Middle East and Asia. In America, plants picked below the 35th parallel (South Carolina) are recommended; northern reeds and bamboo are too soft. To make the traditional Arabic pen, the first joint from the ground will

"dogma" rebus

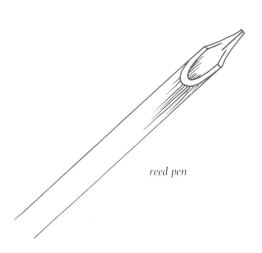

reed pen

provide the hardness necessary. He then CURES the plant with a blow torch, turning it a dark brown (bamboo needs no curing). For Western calligraphy, various reeds such as *Phragmitis communis*, found in the north-eastern U.S., or those sold in hardware stores for supporting plant stems, give various desirable results. For example, if the text is very short, a soft spongy reed can be used – one that would become too dull after many lines of writing, and that may give very interesting visual quality to the letters.

Rees, Ieuan (b. 1941) British calligrapher, designer, lettercarver who lives and works in Wales. Influential teacher in Britain and the U.S. Co-editor of *Modern Scribes and Lettering Artists* (1981). President of the SOCIETY OF SCRIBES AND ILLUMINATORS, 1977–79.

registration marks Marks placed on a page of material to be printed in more than one color, but outside the image area, and so eventually cut off. The marks will indicate whether the image is placed (registered) precisely on top of the first color during printing. If not, registration is adjusted on the printing press.

Reiner, Imre Hungarian (1900–87) Lived and worked in Switzerland. Studied with F. H. Ernst SCHNEIDLER. Graphic artist, type designer, illustrator and painter of great originality. Author of *Alphabets* (1947).

relief Printing, such as LETTERPRESS, RUBBERSTAMP, etc., in which the surface that inks the paper is raised, while the background is recessed. *Compare* INTAGLIO, PLANOGRAPHY.

Renaissance Literally "rebirth." The ITALIAN RENAISSANCE, *c.* 14th–15th c., was concerned with HUMANIST scholarship and art, especially the literature, sculpture, painting and science of CLASSICAL Greece and Rome. Crowded GOTHIC letters were replaced by a rounder MINUSCULE. PETRARCH and his colleagues, associated with the beginning of the Italian renaissance, collected and studied old MSS which they believed could have been from ancient Rome, but which were more often from the 9th to the 12th c. The GOTHIC RENAISSANCE (12th c.) is associated with the establishment of UNIVERSITIES. CAROLINGIAN RENAISSANCE: during the reign of CHARLEMAGNE, a great emphasis was placed on scholarship and thus MSS. This period (*c.* 800) was the first major European "learning explosion" since the fall of the Roman Empire in the 5th c.

reservoir Small piece of metal attached to the upper or under side of a NIB. It holds a supply of ink and regulates ink flow by conducting the ink to the slit of the nib, which in turn draws it to the page. It is important that the extreme tip of a detachable reservoir should lightly touch the underside of the nib, near enough to the tip to help ink flow, but not so near as to make ink flood out. This usually means a distance of about $\frac{1}{16}''$ (·16 cm). An "S"-shaped reservoir for use with a REED PEN or QUILL may be made by cutting a thin strip from a soft drink can. The "U"-shaped "spring" section of this reservoir prevents it from falling out of the pen's BARREL.

resin Organic resins are exudations of trees or shrubs that are soluble in volatile solvents (turpentine, etc.) but not in water, as is GUM. Neither organic nor synthetic resins are used much in our

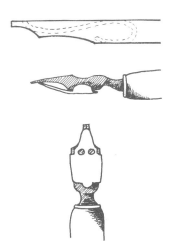

reservoir

water-based craft. However, SANDARAC and DRAGON'S BLOOD are two which have been used in powdered form.

resist Substance which, when applied to a surface, will prevent that surface from being affected by subsequent washes, sprays, etc. For example, a liquid latex resist (masking fluid) can be used to write letters on white paper and then be left to dry in the same way as ink (it remains slightly tacky, but not wet). The entire sheet then receives a coat of blue watercolor WASH. When that is dry, the latex resist is rubbed off, leaving the letters underneath white, but the surrounding area blue. Another type of resist is frisket (paper cut to cover certain areas, then stuck on with frisket glue or rubber cement).

retouch To add to, or to take away from, a stroke already written or drawn, in order to improve its appearance.

Reynolds, Lloyd American (1902–78) Master teacher, author, philosopher, champion of ITALIC HANDWRITING in schools. He taught himself calligraphy and then went on to teach for forty years at Reed College in Portland, Oregon. Educated a generation of west-coast American scribes in whose teaching and work his inspiration is still alive and well. Produced 20 half-hour television programs entitled *Italic Calligraphy and Handwriting*. Organized an important exhibition, "Calligraphy, the Golden Age and its Modern Revival" (1958) at Portland. *See The Calligraphy of Lloyd Reynolds* (1988).

rhune Synonym of RUNE.

rhythm The tempo of the writing movement as determined by the size of writing, the nature of materials being used, PRESSURE, SLANT, SPACING, and the confidence and focus of the scribe.

rice paper Misnomer for any of the thin, UNSIZED, translucent JAPANESE PAPERS.

right-handed nib *See* NIB, CANT.

river Irregular line of blank space down the page, caused by gaps between words created by JUSTIFYING the MARGINS, or by any spacing which is too loose.

Rodríguez-Benitez, Guillermo Puerto Rican (1914–1989) Businessman whose collection of calligraphy includes major works by Donald JACKSON. Was also a calligrapher and designer of great skill and sensitivity.

roll Synonym of SCROLL; an equally acceptable term, preferred by some.

rolled serif *See* SERIF.

roller press Provides the high pressure required in INTAGLIO printing.

Roman 1) Pertaining to CLASSICAL Rome, for example, when describing INSCRIPTIONAL CAPITAL letters. 2) HUMANIST minuscule scripts and the typefaces that were and are fashioned after that style. A slight misnomer, because the humanist letters were inspired by late CAROLINGIAN models, not Roman, but the name has been used in this way for more than 600 years. 3) Sometimes used in TYPE to describe any FACE that is not slanted.

Roman cursive script

rotunda script

Roman capitals MAJUSCULE letters, in CALLIGRAPHY, LETTERING, or TYPE, that are modeled after INSCRIPTIONAL capitals from CLASSICAL Rome.

Roman cursive Roman handwriting. Quickly written, UNSERIFED everyday version of ROMAN MAJUSCULE, executed with a STYLUS in wax or with a reed brush and ink on PAPYRUS. In the first centuries BC the letters were rarely joined, but during the later centuries of the Roman Empire they were often connected, and began to show characteristics of MINUSCULE.

Romanesque Term describing architecture and decoration of western Europe *c.* 11th–13th c. Characterized by high, rounded arches and profuse decoration, as seen in the letterforms and illumination of the period.

Roman numerals *See* NUMERALS.

Roman uncial *See* UNCIAL.

ronde Mid-17th-c. French COMMERCIAL CURSIVE with BATARDE influences. Written with a QUILL cut to a very thin BROAD EDGE.

rose madder Light pink form of MADDER LAKE pigment.

Rosetta Stone Carved in 197 BC in honor of the Egyptian king Ptolemy V. Discovered in Egypt in 1799 by Napoleon's army. Executed in three scripts, GREEK, HIEROGLYPHIC (formal Egyptian) and DEMOTIC (cursive Egyptian). It was the existence of three different versions of the same text that provided the key for the deciphering of hieroglyphics by French Egyptologist Jean Francois Champollion in 1822.

rosin sized Synonym of BEATER SIZED.

rotunda Subgroup of formal GOTHIC scripts; those practiced in Italy, Spain and southern France *c.* 13th–16th c. Far rounder than its angular contemporaries in northern Europe and Britain, the compressed rotunda had short PROJECTORS, small INTERLINEAR SPACE, many FUSIONS between letters and heavy, UNSERIFED strokes.

rough draft Freely drawn first sketch for a project, often smaller than the finished product.

round Synonym of BOWL.

roundhand 1) Name derived from RONDE, which in 17th-c. England was called roundhand; a CURSIVE, rapidly written with a quill cut almost to a point. COMMERCIAL CURSIVE and many of today's handwriting systems derive from it. *See* COPPERPLATE, the modern name for this script. 2) British term for script with round arches, such as HUMANIST and FOUNDATIONAL script.

roundscript BROAD PEN CURSIVE with a BATARDE flavor. Nineteenth-century version of the French RONDE.

royal Paper size measuring $20 \times 25''$ ($51 \times 63{\cdot}5$ cm).

rubber British term for ERASER.

rubber cement Gum rubber dissolved in benzol for temporarily gluing surfaces such as paper. Papers of moderate strength can be pulled apart and repositioned. Excess can be rubbed off with an ERASER or finger. Usually for CAMERA-READY or temporary

work; never for lasting work as it will bleed through the paper and discolor it within a year or two. Prolonged exposure to the fumes is harmful. *See* HEALTH HAZARDS.

rubber stamp RELIEF letter design cut in rubber to be stamped by hand, usually as decoration on envelopes or for some other temporary use (normal stamp pad ink, made of DYE and GLYCERINE is FUGITIVE). Homemade stamps can be cut with a blade from hard white plastic or other erasers.

rubbing An image taken from an incised inscription, such as a tombstone, by placing a sheet of soft paper over the inscriptions and rubbing with a waxy crayon.

rubric From Latin *ruber* (red). Prominent letters or headings in red. These were first used in the PAPYRI of ancient Egypt, in which rubrics have been found in a copy of *The Book of the Dead c.* 1500 BC. In late MEDIEVAL book production the rubricator was often one of several specialists involved.

ruled space Measured from the BASELINE of the top line of writing to the baseline of the bottom line on a page. *See* WRITING SPACE.

ruler Flat strip, of any material, whose edge contains measurement markings. If sufficiently hard, it can be used as a STRAIGHTEDGE. PEASANT RULER: a strip of paper containing "tick marks" made by a scribe to measure off writing lines for a specific project, as standard ruler marks are rarely useful in laying out writing. ROUND RULER: a cylinder, in use some centuries ago, rolled down a page to make speedy, if imprecise, parallel lines. BEVELED RULER: for making ink lines. The BEVEL prevents the ink from spreading underneath the ruler.

ruling pen Metal pincer-like device for drawing straight lines of consistent (adjustable) width. May also be used as a writing tool.

rune Also rhune. Any one of numerous angular systems of writing, usually cut in wood, stone or bone. They contain no curves and few horizontals. Associated with Germanic, Scandinavian and Celtic cultures (although it has its roots in CLASSICAL ROMAN). The first extant examples date from *c.* 3rd c. AD, and they continued to be used until after the 13th c. From the Old Norse *run* (secret). Church clerics despised runes because of their association with magic and pagan ritual. *See* FUTHARK, OGAMS.

runner *See* POUNCE WHEEL.

running script Synonym of CURSIVE.

rush In calligraphy, it is synonymous with REED.

rustic Script written with a BROAD EDGE pen or brush, in which ROMAN capitals are laterally CONDENSED and horizontal strokes are generally heavier than the vertical. Rustic was the most popular Roman BOOKHAND from the 1st to the 5th c., and continued to be used extensively as a script for titles until the 11th c. It remains, at its best, one of the most elegant and graceful scripts ever developed.

ruling pen

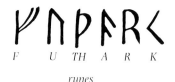

F U TH A R K

runes

rustic script

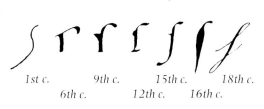

1st c. *9th c.* *15th c.* *18th c.*
 6th c. *12th c.* *16th c.*

varieties of the long S

S Derived from $\}$ and similar letters in early Greek and Latin inscriptions. The Phoenician **W** , and Hebrew $\}$ are relatives of "s" with the phonetic value of "sh." The LONG S can be seen in early Roman graffiti and hastily written documents on wax and papyrus. It made its way into formal writing *c.* 6th c. and was used, often along with the "s" in many scripts and printing types, until the 19th c. It was phased out after 1795 when John Bell, a British printer and type designer, discarded it in his own work, and the change became universally accepted.

sable Finest type of pointed BRUSH, made from the tail hairs of the kolinsky, a Siberian mink.

sabox Type of BRUSH made of a mixture of sable and ox hair.

saddle stitch To bind a book of one GATHERING by opening it out flat and stapling through the center fold.

saffron Dried orange-yellow stigmas of the autumnal crocus flower, *Crocus sativus*, a flower that originated in Persia and was later cultivated in Europe. To obtain one ounce of saffron, 4,320 flowers are required. It has been used since antiquity to DYE cloth, and to lend an orange color and pungent aromatic flavor to food. Medieval scribes and painters of MSS put in a dish a pinch of the dried stigmas and covered them with GLAIR, letting the coloring matter infuse the glair with a brilliant yellow. This mixture was used primarily in MS production to give a warmer tone to green and VERMILION paint, and as a glaze to spread over dry layers of paint. Occasionally it was used by itself to decorate initial capital letters or to write with. The saffron/glair mixture was even used to paint over tin foil to make it resemble gold. In some medieval MSS, the color has remained unchanged, but the dye has long since become obsolete as it usually fades easily.

As a colorant for GUM AMMONIAC or other MORDANT, it serves the triple function of making the mordant stand out in color from the writing surface (making application and gilding easier), of providing an aesthetically pleasing yellow base for the gold leaf, and of acting as a preservative for the liquid mordant.

Saint Columba One of the greatest of the zealous and energetic Irish missionaries. Born in Ireland in the 6th c., he established monasteries in Britain and Europe, including those at Iona (an island off Scotland), LUXEUIL (Gaul, now part of France), SAINT GALL (Switzerland) and BOBBIO (Italy); all of which influenced the development of BOOKHANDS.

Saint Gall Swiss monastery, which produced some of the earliest GOTHIC script, *c.* 10th c.

sal ammoniac (ammonium chloride) Occasionally used since MEDIEVAL times as a hygroscopic (moisture attractive) agent in GESSO, thus helping the gold to stick in GILDING. Centuries ago it was used to cause a chemical reaction in copper-green PIGMENTS, turning them blue.

salient Springing or leaping beast in HERALDRY.

salt (sodium chloride) Component in grinding GOLD LEAF to gold powder. *See* GOLD POWDER *for process.*

Salter, George (1897–1967) German book designer and letterer who lived and worked in New York. Known for his many book jacket designs for Knopf publishers, and his lettering arts class at Cooper Union in New York City. There he taught many who were to become prominent lettering artists and designers.

saltire Two intersecting diagonal bands on a HERALDIC SHIELD. *See* ORDINARIES.

sandarac The first was probably juniper RESIN. Today, a resin produced by the coniferous tree *Callitris quadrivalvis*, which grows in Mediterranean Africa and in Australia. The product comes in elongated yellow lumps approximately $\frac{1}{4}''$ (\cdot64 cm) long. These must be ground with a mortar and pestle to an off-white powder, or POUNCE. The powder is used to rub onto writing surfaces which would otherwise be too slick for drawing thin hairlines, or too absorbent (and thereby liable to bleed). To avoid scratching the writing surface with the larger granules of powder, a sieve/sandarac bag may be made from 5″ (13 cm) square of old T-shirt fabric, bound at the top. The bag is rubbed on the writing surface or shaken above it. Excess sandarac should be brushed off. If too much powder has been deposited, a white line appears down the center of written strokes where the ink has been repelled.

sandaraca 1) MEDIEVAL word for SANDARAC. 2) Can mean the pigment REALGAR (red arsenic sulfide) in ancient Greek and Roman texts.

sandbox Synonym of POUNCE BOX.

sander Synonym of POUNCE BOX.

sandpaper Generic name for several abrasive papers used to remove tiny bumps from dry GESSO before GILDING, or to improve the NAP of parchment. The finer grades (320–600) are recommended (the larger the number, the smaller the abrasive particles, and the smoother the sandpaper). Among the types for scribal use are silicon carbide, also known as "wet-or-dry" (used dry). It is used wet only to remove the coating from a new hematite or psilomelanite BURNISHER. Jeweler's polishing compound should be rubbed on the burnisher afterwards.

Sans Serif

sans serif typeface

sans serif *Sans* in French means "without." "Sans serif" describes a script or typeface in which the stroke endings are without SERIFS, or "feet."

Sanvito, Bartolomeo Italian (1435– after 1518) One of the leading SCRIBES of his time. Wrote distinctive pen-written capitals, often in bright pinks and greens. He was possibly also an ILLUMINATOR. At least 35 of his MSS have been identified.

scale sketch LAYOUT in which MARGINS and lines of text are accurately ruled, but letters are freely drawn.

scarlet From *suqlat* (broadcloth, which was often dyed red), probably Persian or Indian in origin. The color took on the fabric's name. Centuries ago scarlet could mean any color from

Schwabacher typeface

scribe at work, depicted on a medieval illuminated MS

bluish TYRIAN PURPLE through red to orangish-red or even pink. It was the color, sometimes exclusively, of royalty. Today "scarlet" denotes a vivid red, tending toward orange, available in various COAL TAR LAKES and CADMIUM PIGMENTS.

schlag metal Type of imitation GOLD LEAF made from zinc and copper. Bright gold in color which it retains reasonably well if not exposed to air pollution.

Schneidler, F. H. Ernst German (1882–1956) Very influential graphic artist whose talents included calligraphy. Taught at the Stuttgart Akademie. Author of *Der Wassermann*, a four-volume portfolio of graphic art and typographic problems.

Schwabacher GOTHIC CURSIVE typeface widely used after 1480, especially in southern Germany. Replaced by FRAKTUR in the early 16th c.

scoop cut The first cut in making a quill, as well as subsequent cuts from the SHOULDER to the NIB. *See* QUILL *for illustration.*

score To draw a BLIND RULE as a GUIDELINE in writing or to ensure a straight and clean fold.

scribe One who practices the craft of writing.

scrinium Latin word for a large case in which MSS were kept.

script 1) Any distinct generic style of written letters; for example, "the CAROLINGIAN script." 2) CURSIVE or SEMI-CURSIVE writing in which the letters tend to connect with each other due to speedy and, usually, slanted writing.

scriptliner Pointed sable brush, with longer hairs than the watercolor brush. *See* BRUSH.

scriptorium Room or cell for transcribing books and documents, especially in MEDIEVAL monasteries.

scriptura lapidaria Latin for pen-written letters that copy stone-carved letters. Synonym of SQUARE CAPITALS.

scriptura quadrata Synonym of SQUARE CAPITALS.

scrivener Before the advent of the typewriter, photocopy machine or tape recorder, the scrivener copied law court transcriptions, ENGROSSED wills and deeds, wrote letters for the illiterate and did book-keeping. The phrase "money scrivener" came to mean money lender only in 18th-c. England. "Scribe," "clerk," "copyist," and "scrivener" are essentially synonymous, but the latter specifically connotes Victorian England. The word has been in use since the 14th c.

scroll Also roll. Long piece of PAPER, PAPYRUS, fabric, PARCHMENT etc. (usually made of connected pieces) sometimes fastened at one or both ends to rods around which the writing surface rolls and unrolls to be read. The writing may be laid out in several ways, but is often in COLUMNS. The scroll predated the CODEX (book of pages) by perhaps 2,000 years, and was usually made of papyrus in ancient times. They were rarely used for book texts after the first centuries AD. The Jewish Torah has always remained in scroll form. The scroll has once again become a mainstay of our culture with the use of magnetic tapes for sound and video.

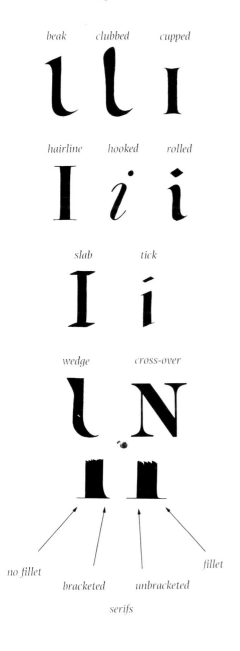

secretary hand script

beak clubbed cupped

hairline hooked rolled

slab tick

wedge cross-over

no fillet fillet

bracketed unbracketed

serifs

scroll pen BROAD EDGE pen with gaps in its NIB to produce stripes rather than a solid line. Mostly used for BORDERS and decorative letters.

seal Design, or the instrument that impresses the design, on wax, stone, clay, or paper, as a mark of ownership. It can also denote the wax, wafer or similar token affixed to a document. *See* CYLINDER SEAL.

secondary colors Orange, violet and green. *See* COLOR.

secretary hand 1) Specifically an English BATARDE, in use 15th–17th c.; everyday business script. 2) Generally refers to many CURSIVE GOTHIC scripts used for business at this time in Britain and northern Europe.

self-cover Book whose cover is of the same material as the text pages.

semi-alphabetic One of the most revolutionary advances in the history of communication systems, in which each consonant in the spoken language is represented by a unique written sign. This concept replaced the SYLLABIC system which used too many signs to be really efficient. This system was eventually refined by the addition of vowel signs to culminate in the ALPHABETIC system in use for the past 3,500 years.

semi-angular script Synonym of SPENCERIAN.

semicolon Form of PUNCTUATION which appeared *c.* mid-8th c.

semi-cursive Writing speedily executed, resulting in occasional joins between letters which are often slightly sloping. Examples are HALF UNCIAL or brush-written RUSTIC. *Compare* FORMAL, CURSIVE.

semi-formal SEMI-CURSIVE, but recent rather than ancient writing.

semi-uncial Synonym of HALF UNCIAL.

separation of words *See* WORD SEPARATION.

sepia Today, sepia and warm sepia PIGMENTS are mixtures of BURNT SIENNA and LAMP BLACK, permanent colors that are chemically unrelated to the original sepia ink. The ancient sepia dye comes from a glandular organ known as the ''ink-sac'' of a cuttlefish. This foot-long, primarily Mediterranean creature looks like a squid, but differs due to a calcified internal shell, which calligraphers can grind to powder and use as POUNCE. In one ink recipe, the ink-sac was removed, dried, pulverized and boiled with lye solution. The extract was precipitated out with hydrochloric acid, was washed and dried at low temperature, then ground and mixed with GUM ARABIC. When first applied, sepia was warm black, gradually becoming reddish brown.

serif 19th-c. word for a small stroke to finish off the stroke of a letter. Seems to have first appeared in carved Greek letters *c.* 4th c. BC. Among the many kinds are: beak, bracketed, unbracketed, clubbed, cupped, hairline, hook, rolled, slab, tick and wedge. *See* TERMINAL.

serigraphy SILKSCREEN process of printing, sometimes the best method for lettering on cloth surfaces.

service book Book of prayers, chorales, etc. used in church services. In late MEDIEVAL times, some were written in large letters on huge pages so that one book could be seen by many people at once.

set hand SEMI-FORMAL handwriting used in the administration offices of MEDIEVAL and RENAISSANCE England. *See* FREE HAND.

set out To mark in pencil, chalk, etc. a finished design on the surface to be written or painted upon, in preparation for the final work.

set square Piece of flat plastic or metal in the shape of a right-angled triangle, for drawing perpendicular lines along a BASELINE.

sewing One of the steps in BOOKBINDING. Connects the LEAVES to each other and to the binding.

sgraffito Any method of writing that involves incising a top layer of paint to reveal an undercoating, usually of another color.

shade 1) To increase greatly the width of a stroke or part of a stroke by applying pressure on a pointed flexible NIB, or by RETOUCHING. 2) The wide, often gray outline on two adjacent sides of each stroke of a letter. Intended to suggest a shadow cast by the letters to emphasize them visually. 3) The addition of black to a pure hue (a paint which has no white or black in it) creates a shade of that hue, as maroon is a shade of red. *Compare* TINT.

shaft 1) Section of a FEATHER on which the BARBS are found. 2) Any PEN or PEN HOLDER above the NIB. 3) STEM of a letter. 4) Section of the nib which fits inside a penholder.

shank Type term for a letter's STEM.

sheepskin *See* PARCHMENT.

shellac Resin exuded from trees with the sting of the LAC insect. Most comes from India. May be dissolved in ALCOHOL or water. Used in making waterproof INK, as it is almost impervious to water when dry.

shell gold Tablet of GOLD POWDER mixed with GLUE or GUM. Applied as WATERCOLOR in a pen or brush. So named because it was formerly sold in half a mussel shell.

shield Primary feature of a HERALDIC design. In late MEDIEVAL times a shield emblazoned with the family's coat of arms identified a soldier during battle. Today, a shield is a design around which may be drawn animal, human or other figures, words, etc.

short fold *See* FOLD.

short "R" *See* R.

shoulder 1) Curved portion of the MINUSCULE "h," "m," and "n." 2) Place where the central SCOOP CUT meets the under cuts on a QUILL pen.

showcard Sign quickly hand-lettered on paperboard for promotional display in shop windows, movie theaters, etc. Flourished in America especially between the 1880s and the 1930s.

sienna RAW SIENNA: very PERMANENT yellow-brown EARTH PIGMENT of hydrated iron oxide, alumina and silica. The best

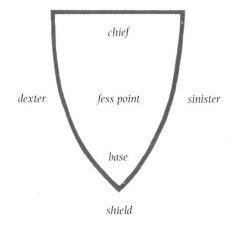

chief

dexter *fess point* *sinister*

base

shield

quality deposits are found in Italy near the Tuscan city of Siena. BURNT SIENNA: made by roasting raw sienna, which changes it from brownish yellow to dark reddish brown. The textures of both are largely unsuitable for use in a pen.

sigla 1) Word reduced to a single letter by abbreviation. Common in MEDIEVAL MSS and on ancient coins and medals. 2) A list of symbols used in a book, usually printed in the preliminary pages.

signature 1) Visual device (letters, numbers, or both, arranged sequentially) enabling the QUIRES of a book to be bound together in the right order. *See* CATCHWORDS. 2) Often erroneously used as a synonym of quire.

signwriter One whose skill with a brush and knowledge of letterforms allows him or her to letter a sign directly, as a calligrapher letters a page.

silk Silk has three main uses in calligraphy: 1) Soft clean silk is used to wipe grease off GILDING instruments before use, as residual hand grease causes metal LEAF to stick where it is not wanted. 2) Raw silk thread can be used to fill the cavity of an inkwell before pouring in the liquid ink. Dipping the pen in the ink-soaked thread can deposit the right amount of ink on a reservoir-free nib (a method practiced by many Arab calligraphers using reeds). 3) Silk fabric can be a substrate for ink or paint, especially with a brush.

silkscreen Method of printing wherein a special ink is forced with a squeegee through a silk cloth made especially for the purpose, leaving a layer of color on the surface below. Often the best method for printing on cloth, but widely used on paper as well.

silver leaf Sheets of genuine silver, $3\frac{3}{8}''$ (8·7 cm) square and one ten-thousandth of an inch thick (about three times as thick as GOLD LEAF), used in GILDING. Silver leaf oxidizes upon exposure to air, turning black within anything from hours to years, depending on the pollution level. With White Gold leaf, which is approximately half silver and half gold, some oxidizing can be expected. Lemon Gold leaf contains about 6k. of silver, and Pale Gold leaf about 8k. Oxidation is minimized by coating leaf with GLAIR after application and by keeping the finished work in a sealed frame.

Simons, Anna (1871–1951) German calligrapher. Student of Edward JOHNSTON in London. By translating Johnston's *Writing & Illuminating, & Lettering* into German (1910) and later *Manuscript and Inscription Letters*, she gave impetus to the growing German calligraphic movement.

single gold leaf *See* GOLD LEAF.

sinister Left side as worn, right side as viewed, of a HERALDIC SHIELD.

size From the Latin *assidere* (to sit near). It has two main uses in calligraphy. 1) Size is any sticky medium that keeps PIGMENT or metal LEAF seated permanently where it is put. Without size (made of GESSO, GLAIR, GUM, GARLIC JUICE, ACRYLIC MEDIUM, GELATIN, starch or other sticky substance mixed with pigment or as a size for leaf) the pigment or leaf would not adhere to the writing surface. 2) Applied as a film on PAPER (tub- or surface sizing) or mixed with paper PULP during manufacture (internal

skeleton letters

final design

sizing), it makes the writing surface less absorbent of ink and paint.

skeleton MONOLINE draft of letters to be written, painted or carved illustrating the path along which the pen, brush or chisel will later travel. A skeleton sketch is usually used to analyze the structure and spacing of a layout.

skewing The gentle rubbing of a GILDED letter in a circular motion with a soft brush or cloth to remove surplus gold from its edges. The process, through this slight pressure, also puts the gold in better contact with the SIZE.

skewings Tiny pieces of GOLD LEAF left over from GILDING.

skin Synonym of PARCHMENT, or sometimes of LEATHER.

slab serif *See* SERIF.

slaked Term describing PLASTER OF PARIS which has had crystalline water content added to it; the kind used as an ingredient in GESSO.

slant Slope of the letters from the vertical. Although any script may be slanted, slant is a characteristic of letters written with speed.

slant lines Lines, later erased, to help the scribe keep letters at the intended slope.

slip Small lath of wood. A number of these tied together like bamboo blinds makes a type of Chinese BOOK, dating from before the 1st c. AD.

slip pen Archaic word for a pen which has a detachable NIB.

slip sheet Synonym of GUARD SHEET.

slope Synonym of SLANT.

slunk Calf born prematurely, thus "slunk MS calfskin vellum" is made from the hide of a still-born or very young calf. *See* PARCHMENT.

small capitals Also small caps. Typographical term for CAPITAL LETTERS that are just a little taller than the BODY HEIGHT. When a word or line is entirely capitalized, it is generally more pleasing in small capitals, for this helps keep the COLOR of the page consistent.

small letters Synonym of MINUSCULE.

smalt Obsolete PIGMENT made of ground cobalt blue glass used in Europe from the early 15th to the 19th c. The glass had to be ground coarsely to keep its COVERING POWER and color, and thus was too grainy to work with easily. It was replaced by COBALT BLUE.

snap A CHALK LINE is "snapped" to mark GUIDELINES on large lettering projects such as signs.

societies for calligraphers *See* Appendix, SOCIETIES.

Society of Scribes and Illuminators *See* Appendix, SOCIETIES.

spacing Distance between strokes, between letters (INTERLETTER SPACE) and between words (INTERWORD SPACE). INTERLINEAR SPACE is the space between lines of writing. To a student, "good

spacing'' means that spaces between these entities have a regular, pleasing rhythm as opposed to areas of clogged density or of sparseness. As the student advances in skill, spacing can be used to enhance emotionally and visually a piece of writing.

spectrum Light waves between ultraviolet and infrared, visible as a range of colors from violet through blue, blue-green, yellow-green, yellow and orange, to red.

Spemann, Rudo (1905–47) Famous German calligrapher who was a student of Anna SIMONS and F. H. Ernst SCHNEIDLER.

Spencerian method Also semi-angular script. Developed in 19th-c. America by Platt Rogers Spencer (1800–64), it was the first system of its kind to teach handwriting, rather than merely to provide examples for slavish and often incorrect copying. The system emphasized hand and arm movement, rather than finger movement only, and blended the time-consuming formal ROUNDHAND with the quick, but almost illegible ANGULAR HAND to produce a legible everyday handwriting which was quickly and easily written, as compared with its antecedents. Began to lose popularity in the late 19th c. and was replaced by the even speedier PALMER and ZANERIAN methods.

spine 1) First stroke of an ''S''; its serpentine stem. 2) The part of a CODEX at which its pages are sewn together. 3) The spine of an animal's skin should lie in the direction of the spine of the book when PARCHMENT is cut, for it can help the pages to lie flatter.

splay A splayed NIB is one whose two halves are separated when pressure is applied during writing, or, in the case of a broken nib, permanently separated.

split reed pen Synonym of REED PEN.

split-skin parchment PARCHMENT made from sheepskin.

spur Small projection off a main stroke, as in the BEARD of a ''G.''

square capitals Also *capitalis quadrata*. Pen-made version of the ROMAN MONUMENTAL capitals. Employed for luxury books *c.* 1st c. BC–5th c. AD. Only two early MSS written in this script survive (both are texts of Virgil); the earliest dates from the late 4th c.

square cut nib *See* CANT.

S.S.I. Abbreviation of SOCIETY OF SCRIBES AND ILLUMINATORS. *See* Appendix, SOCIETIES.

Stadtische Bibliotheken, Munich. *See* Appendix, LIBRARIES.

stamp pad *See* RUBBER STAMP.

Standard, Paul (b. 1896) American calligrapher, teacher, translator (of some works of Hermann ZAPF). Helped pioneer the use of ITALIC HANDWRITING in the eastern U.S. Author of *Calligraphy's Flowering, Decay and Restauration* (1947), and *Arrighi's Running Hand: A Study of Chancery Cursive* (1979).

standish Synonym of INKSTAND.

stat Synonym of PHOTOSTAT.

stave Groups of horizontal lines for musical notation, found in SERVICE BOOKS.

writing in the Spencerian mode

splayed nib

square capitals

steel nib *See* METAL NIB.

stele Commemorative slab or pillar carved with letters, pictures or designs; common in ancient Greece, Rome and the Middle East.

stem Main "weight bearing" stroke of a letter; usually vertical, or at an angle if the script is at a slant. Occasionally the stem is diagonal, as in the capital "N" or "Z."

D. Stempel AG Type foundry in Frankfurt. Founded in 1890 by David Stempel, closed in 1980.

stencil Sheet with letters or other designs cut out. When the stencil is laid over the writing surface, its design can be outlined or painted onto that surface, and then, if desired, re-used.

stichometry Ancient Greek and Roman system of measurement of a MS by lines (of 34–38 letters each) to determine how much the scribe should be paid. *See* PECIA.

stick ink BLACK STICK INK has been made in China since *c*. 3rd c. BC. The highest quality carbon is produced by slowly burning materials such as oil, bones or hemp in a row of large chambers, connected by narrow channels. The airborne carbon drifts from chamber to chamber collecting on the walls. Only the finest particles travel as far as the last chamber and are used to make the finest ink. A paste of this carbon, GLUE (of animal or fish bones and skin) or GUM is formed into sticks and dried in often changed cold ashes for 3 to 10 days. When buying ink sticks, choose those with finely stamped designs. Crude designs indicate crude, grainy ink. Some scribes prefer MATTE sticks to shiny, as shininess indicates the presence of SHELLAC, which can clog the pen.

Stick ink is used by rubbing one end back and forth on the slant of an INKSTONE in a pool of, say, 5–10 drops of distilled water. More drops are added if necessary. Wipe the stick's end dry after rubbing and always rinse the stone clean with cool water after each batch of ink is used. Apply ink to the NIB with a bristle BRUSH. The very tip of the brush may be dipped in water before dipping in ink as the ink starts to dry and to become thicker on the stone. No RESERVOIR is needed with this ink. COLOR STICK INK: made by forming a paste of pigment and binder into a stick which is then left to dry. Should be ground on an unglazed porcelain GAKEN DISH whose white color will keep the ink from turning gray, as it would on slate.

stilus *See* STYLUS.

stoichedon Arrangement of letters aligned vertically as well as horizontally. Common in Athenian inscriptions *c*. 400 BC.

Stone, Reynolds British (1909–79) Began professional life as a typographer at the Cambridge University Press. After a short time as a student of Eric GILL, he decided to pursue engraving, which included trademarks and other work in metal, stone and wood. Known especially for his impeccably designed bookplates which feature a name, often in formal italic, surrounded by SWASHES which remain dignified in their abundant flourish. A catalog of an exhibition of his work in the Victoria and Albert Museum was published in 1981, entitled *Reynolds Stone 1909–1979*.

stoichedon inscribed in stone

Stonyhurst Gospel St. John's Gospel written at the scriptorium of WEARMOUTH-JARROW in the late 7th c. Earliest known European BINDING. Text is in a very fine late UNCIAL.

straightedge Generally a flat piece of plastic, wood or metal, such as a RULER. Drawing or cutting against it carefully will produce a straight line or cut. Metal edges are best for cutting against.

stress Synonym of AXIS.

striper Thin BROAD EDGE long-haired BRUSH.

stroke 1) Any written line in any direction, curved or straight. 2) Any component of a letter written between pen lifts.

strontium yellow Strontium chromate PIGMENT, sold as LEMON YELLOW. LIGHTFAST.

stylus Also stilus. Pointed instrument for scratching characters into soft materials such as wax or clay. In ancient Rome styli were made mostly of bronze, bone, wood or silver. The non-pointed end was rounded or flattened to be rubbed on the wax, erasing the previous writing. Styli have also been used since MEDIEVAL times for BLIND RULES, to PRICK GUIDELINES or to trace designs on paper or vellum in preparation of the final writing or illuminating.

substrate 1) Also GROUND. The PAPER, PARCHMENT, fabric or other material which serves as the writing surface. 2) Base for LAKE PIGMENTS.

sugar White crystallizable material consisting essentially of sucrose, made from sugar cane or sugar beet. Because it is hygroscopic (attracts moisture) rock sugar is used as a PLASTI-CIZER in watercolor, and in GILDING GROUNDS to aid the adhesion of GOLD LEAF. Too much sugar makes PAINT or GESSO undesirably sticky.

sulfur Non-metallic element. PIGMENTS containing sulfur (VER-MILION, CADMIUM, ULTRAMARINE, for example) discolor or blacken when exposed to acid.

Sumeria Located in what is now Iraq, the site of the first known adequate system of PHONETIC writing, c. 2000 BC. The Sumerians, involved in foreign commerce, were able through this phonetic, SYLLABIC system to absorb new and foreign words easily into the language. Their writing, a version of CUNEIFORM, made record-keeping relatively easy, as compared with previous systems which used too much detail in each sign to be efficient.

Sumi ink *Sumi* means "ink" in Japanese, especially STICK INK. In our usage, however, it has come to mean Japanese liquid (bottled) CARBON INK.

super-calendered paper Usually machine-made paper which has a very smooth surface. The equivalent term for handmade paper is HOT PRESS. *See* CALENDER.

supporters Animal, human or fantastic forms that sometimes flank a HERALDIC SHIELD on either side.

surface gold SIGNWRITER'S term for grades of GOLD LEAF that are not pure gold. *See* KARAT.

surface sizing Process of coating a paper sheet with a film of SIZE to decrease its absorbency. More often called "tub sizing" when referring to handmade paper.

surface tension Tendency of a liquid to contract into small spherical droplets. Water has high surface tension, which can be detrimental to WASHES, especially on certain papers. The addition of a drop or two of ox gall or other WETTING AGENT can reduce the surface tension of ink or paint.

suspension Type of ABBREVIATION, common in medieval MSS, in which an entire word is represented by its first letter or letters.

swash FLOURISH, replacing a STROKE'S TERMINAL or SERIF.

swash capitals Capital letters that contain an unusual number of FLOURISHES. Used primarily as decorative INITIALS, because they can be illegible when used to spell a word.

syllabic System of writing in which there is a unique written sign for each syllable in the spoken language. First developed *c.* 2000 BC, probably in Sumeria (modern Iraq). A major step on the way from picture writing to alphabetic writing, the syllabic system allowed for flexibility in absorbing new and foreign words into the language; important in trade.

symbol Sign that stands for or refers to something else.

sympathetic ink Ink that is invisible until the writing is subjected to a subsequent process, such as heating or dipping in chemicals.

synthetic organic pigments DYES, LAKES, and PIGMENTS made of complex mixtures of carbon compounds from the distillation of coal tar by-products. The name COAL-TAR COLOR, although synonymous, was used for these dyes in the pre-1930s when they were notoriously IMPERMANENT. Since the development of permanent pigments such as THALO BLUE and GREEN, ALIZARIN CRIMSON, and CHINESE ORANGE, they have become universally accepted.

syllabic writing inscribed in clay

T From the Semitic *taw* (sign), it has been written as an " ✗ " or " ✚ " shape since its inception, appearing as we know it today in the early Greek.

tablet From Latin *tabula* (board, list). 1) Various writing surfaces in slab form including clay, into which were impressed CUNEIFORM characters. The dried clay was used to impress a copy of the original document. The copy would then be used as an envelope for the original, to discourage and detect forgery while in transit to the recipient (otherwise, the text could simply be moistened and changed). WAX TABLETS: writing surfaces developed in ancient Greek and Roman times because PAPYRUS and PARCHMENT were too costly for everyday notes. One, two or more portable wooden panels were shallowly scooped out on one or both sides, leaving raised wooden margins and an indented

wax tablet

surface on which a thin layer of blackened wax was poured. The cool wax served as the writing surface for a STYLUS. The wax surfaces, being indented, did not touch each other when the tablets were closed together for protection and bound together with hinges or rings. Today, a tablet is a slab made of paper sheets glued together at one edge. 2) Pill-sized compressed portion of SHELL GOLD or other PIGMENT to be dissolved with a wet brush as needed for paint.

tachygraphy From Greek *tachy* (rapid), and *graphein* (to write). Greek and Roman shorthand in which thousands of words were known by their abbreviations and contractions.

Tagliente, Giovanniantonio Writing master to the Venetian chancery from 1492. Published influential COPYBOOK *Lo presente libro insegna* (printed in 1524 with incised WOODBLOCKS), which contains lovely ITALIC, some very creatively embellished. The facsimile edition is edited by James Wells (1952). Other reproductions of Tagliente's writing are published in *Three Masters of Italian Calligraphy*, edited by Oscar OGG (1953).

tail Diagonal stroke connected to the letter at one end only. Found, for example, in "Q," and "y."

tail edge Bottom edge of a CODEX.

tailpiece 1) Synonym of COLOPHON. 2) Ornament used to fill up space at the bottom of a short page or text, or at the end of a chapter.

talc Also called French chalk. Natural magnesium silicate. Used as a de-greaser for GILDING tools, and sometimes as an EXTENDER in paint.

tannic acid Obtained from GALL NUTS, tree bark and many other plants. Lends stability to IRON SALTS in production of IRON GALL INK.

tanno gallate of iron ink Synonym of IRON GALL INK.

tape Only those that will remain unchanged over the years, such as LINEN TAPE, should be used in lasting work. For temporary uses: DRAFTING TAPE sticks, but is removable without damaging the surface, and can be reused; MASKING TAPE, off-white with a slightly rough surface, and SCOTCH TAPE, the normal transparent kind, should never be used in artwork, as they become dry and change color over the months and years; PAPER TAPE has dry glue which is moistened before use.

tap water Slightly ACIDIC, therefore inferior to distilled water for fine work.

teaspoon Abbreviated tsp. Equals 140 drops.

temper Synonym of CURE, as with a QUILL. Metal NIBS are also tempered with heat in manufacture. This tempering will not change unless the nib is heated hotter than the original tempering. A flame used to burn the oil off a new nib will not ruin its temper.

tempera From the Latin *temperare* (to mix). Any EMULSION with properties midway between watercolor and oil PAINT. The original emulsion paint is EGG tempera, popular in RENAISSANCE

detail from Tagliente's copybook

Italy. (Although a small amount of egg in paint will not harm the flow, egg tempera is too thick to use in a pen.)

Commercial tempera is always sold in tubes. "Tempera" paint sold in jars is misnamed, because it is AQUEOUS, not emulsion.

template Piece of plastic, metal or stiff BOARD with shapes cut out. Used for tracing designs, penciling identically positioned writing lines (for the name and date) on certificates, or to protect the area around the cut-out from erasure, spray or other processes.

terminal End of a non-SERIFed stroke. *See* BALL −, DISHED −, and FLAT −.

terra verte Synonym of GREEN EARTH PIGMENT.

text Bulk of the copy in a written or printed work. Does not include headings.

text face TYPEFACE whose simplicity and legibility suit it for text, as compared with a DISPLAY FACE, which may be more eccentric.

text hand Synonym of TEXT SCRIPT.

text script Also text hand. Script whose clarity and legibility make it suitable for pages of text, as compared with more decorative or CURSIVE writing.

textura Latin for "woven." Synonym of BLACKLETTER.

textus prescissus GOTHIC script in which the pen is turned to a 0° PEN ANGLE during some downstrokes to produce FLAT TERMINALS.

textus quadratus GOTHIC script written without extreme PEN MANIPULATION, resulting in a diamond-shaped FOOT at the base of each letter.

textura rotunda Synonym of ROTUNDA.

text weight PAPER suitably thin for use in books, as compared with the thicker COVER WEIGHT. *See* BASIS WEIGHT.

thalo pigments Synonym of PHTHALOCYANINE.

thermography Also called raised printing. The printed matter is dusted with a powder and heated, melting the powder granules into the ink to yield raised letters. This process bears no relation to ENGRAVING, although the product is similar.

thioindigo SYNTHETIC ORGANIC PIGMENT. The red-violet "B" variety is the only one of this type reliably LIGHTFAST.

thorn Anglo-Saxon letter developed from "d," having the phonetic value "th," so named because it was the first letter of the word "thorn." After the Norman conquest (11th c.), it came to be represented by the letter "y," thus "ye" became the precursor of "the." It did not disappear completely until printing became widespread. An example can be found in the third character of the RUNE illustration, p. 107.

Thoth Ancient Egyptian god of writing.

thumbnail sketch Very small, quickly executed ROUGH DRAFT.

thymol Distilled from the thyme plant, or made synthetically. Can be added to homemade INK to prevent fermentation.

tick 1) Synonym of FINIAL. 2) Type of serif. *See* SERIF.

textus prescissus *(top) and* textus quadratus

tilde
piñata

tilde In Spanish, a mark placed over an "n" when it is pronounced "ny," as in "piñata" (pronounced "pinyata").

tilted axis *See* AXIS.

tinctures The traditional colors used in HERALDRY. There are three catagories. METALS: or (gold) and argent (silver); COLORS: gules (red), azure (blue), sable (black), vert (green) and purpure (purple); FURS: ermine, ermines and vair. *See* HATCHINGS.

tint Any color produced by the mixture of white PIGMENT with a pigment that contains no white. Thus, a tint of dark red would be light red or pink. *Compare* SHADE.

tinting strength Capacity of a PIGMENT or DYE added to paint to change the paint's color. The mixture must be supplemented with additional quantities to compensate for the low tinting strength of a pigment.

titanium white Very opaque PIGMENT used in oil and acrylic PAINT, but not in WATERCOLOR. Sometimes used to replace WHITE LEAD in GESSO.

Titivillus Patron demon of calligraphers. Origin unknown. He first appears in the 13th c. as a collector of sin and error for the devil in the form of words omitted and misspelled while copying sacred texts.

title page Page containing a book's title; usually on the RECTO side of the second or third LEAF.

tittle Synonym of DETERMINATIVE.

toner SYNTHETIC ORGANIC PIGMENT dye, made from coal tar, in its most concentrated form, having been precipitated onto little or no LAKE base. Used in PAINT manufacture.

tooling Stamped impressions on the BINDINGS of some books.

tooth 1) Quality of paper, PARCHMENT, or other writing surface that causes drag or resistance to the pen. A smooth, slick surface with no tooth can result in thick HAIRLINES and lack of control in writing. Medium tooth causes just enough drag on the pen to facilitate control, produce fine hairlines and allow the writing process to be enjoyable and rhythmical. Too much tooth impedes ink flow and progress of the pen. The term is relative. By varying the ink, writing tool, size of letters, speed, pressure, etc., surfaces of all types can be used effectively for an appropriate purpose. 2) A DOG TOOTH was commonly used in MEDIEVAL times as a BURNISHER for GOLD LEAF.

toothpick A flat toothpick is good for mixing PAINT or GESSO.

torse Synonym of WREATH.

Tours Monastery, Indre-et-Loire, France. Important center of MEDIEVAL MS production, where CAROLINGIAN minuscule was perfected. *See* ALCUIN OF YORK.

Trajan inscription The Trajan Column was erected in 133 AD by the Romans to commemorate military victories by the Emperor Trajan. At the base of the ornately carved column is an inscription, measuring $4\frac{1}{2} \times 10'$ ($1\cdot37 \times 3\cdot05$ m) and containing letters between $3\frac{1}{2}$ (9 cm) and $5\frac{1}{4}''$ (13·2 cm) in height. These ROMAN CAPITAL letters, incised in marble, are outstanding

examples of their kind. Trajan Roman capitals have been a model for strong, graceful and well-proportioned letters ever since. The R. R. Donnelley and Sons Co. in Chicago has perhaps the best cast of the inscription in existence, made by Father CATICH. Another cast, not quite as good, is in the British Museum. The Rochester Institute of Technology (Rochester, New York) has on view a RUBBING of the inscription, made by Father Catich.

Trajan inscription

transfer gold GOLD LEAF that adheres by pressure to a sheet of tissue paper. Because gold leaf is almost weightless and very fragile, transfer gold can be easier to handle, as both tissue and gold are put face down on the SIZE. However, it is considered to give an inferior surface to loose leaf gold.

transfer letters Adhesive-backed letters sold on sheets of plastic or paper. Applied by BURNISHING (rubbing) one by one onto the desired surface.

transfer paper For transferring a design from one surface to another by using a similar principle to that of carbon paper in typing. The original design to be traced is placed on top, the transfer paper next, face down, followed by the blank surface to receive the design. As the design is traced with a sharp pencil or ballpoint pen, the transfer paper will imprint the design on the lower layer.

If the design to be traced is drawn on the other side of the transfer paper, only two layers are involved. Homemade transfer paper is made by covering one side of tracing paper or typing paper with pigment (soft-colored chalk or pencil). Rub the layer of pigment with a cotton ball or tissue to remove excess. Brands of ready-made transfer paper are available, but the homemade variety can give the greatest flexibility in working with surfaces of varying color and texture.

transitional 1) Scripts which are a mixture of IDEOGRAMS, PHONOGRAMS and PICTOGRAMS. Examples include those from MESOPOTAMIA, Egypt and Crete *c.* 3000 BC. 2) Typefaces such as BASKERVILLE that have characteristics of both OLD STYLE and MODERN type.

transliteration Modifying the writing system of language A to serve language B. This process allowed CUNEIFORM to serve many languages and cultures for thousands of years, as it allows us to use an alphabet almost identical to the ancient Romans'.

transparent paints Translucent paints which must be mixed with another paint, such as white, to make them OPAQUE. Examples are PRUSSIAN BLUE, ALIZARIN LAKE, COBALT BLUE and VIRIDIAN.

Traube, Ludwig (1865–1907) Distinguished German teacher and scholar. Nearly all modern PALEOGRAPHIC work on pre-CAROLINGIAN or early MEDIEVAL writing was inspired by him. E. A. LOWE was a pupil. Author of *Nomina Sacra*, published posthumously.

trefoil Medieval design that has three lobes, or "leaves."

Très Riches Heures Famous MS illuminated by the LIMBOURG BROTHERS, made *c.* 1413 for Jean, Duc de BERRY. Currently housed, but not on view, at the Musée Condé in Chantilly, France.

triple gold Relatively thick GOLD LEAF, commonly used for GILDING outdoors, and seldom on MSS.

triptych 1) Roman wax TABLET consisting of three boards hinged together. 2) Today, the term can be applied to any work in three parts that are presented together.

T-square

T-square Composed of a blade fastened to a head, for drawing lines perpendicular to the head by placing it against an edge (usually the left edge of a drawing table). Can be used as a guide for a SET SQUARE in drawing vertical or slanting lines.

tube The squeezable metal tube for keeping paint moist was introduced in the 1840s. Prior to that, WATERCOLOR was homemade in small batches, or purchased in cakes or pans.

tub sizing To coat a sheet of paper with SIZE to decrease its absorbency.

turnour In MEDIEVAL times the production of an illuminated MS involved many specialists. Among these, the turnours were responsible for outlining INITIAL letters and borders.

tusche Term for fluids to be used on LITHOGRAPHIC stones. They look like ink, but contain the greasy components of a lithographic crayon.

tweezers Can be used to pick up pieces of GOLD LEAF during GILDING. Wipe with a clean silk scarf or talc before each use to keep hand grease off.

type Originally, individual letters CAST from a MATRIX to be arranged to form a page of text, inked and printed on paper or PARCHMENT. This is metal type, but the term also refers to the many modern forms of MOVABLE TYPE including PHOTOTYPESETTING (on film) and those programmed into computer software to be printed out on a laser printer.

typeface Also face. A FONT in type. Named for the "face" (printing surface) of a metal type letter.

typewriter Machine which imitates typeset letters. The first practical model was developed in 1873.

typography The art of choosing appropriate type for a project and arranging it in a way that communicates efficiently and is pleasing to the eye.

Tyrian purple Obsolete ancient DYE. First made synthetically in 1904 as a LAKE and since superseded by more PERMANENT dyes. The original dye was made as early as 1500 BC in PHOENICIA in colors ranging from pink/red to blue/purple. It was the color of kings' robes (royal purple) and was later used to dye PARCHMENT for making the sumptuous MSS written in gold and silver which St. Jerome found ostentatious. According to PLINY the Elder, the instructions for making the dye (for wool or silk; presumably also for parchment) are as follows: salt a great number of whelks (various Mediterranean mollusks, such as *Murex brandaris*) for 3 days, then boil them in water for 10 days, after which the material to be dyed is immersed for 5 hours. The material is then exposed to light, in which it turns from deep yellow, to green, to blue to purple. Various species of mollusk yield various colors of purple. Pliny adds that 12,000 sea creatures are needed for one meter of cloth.

U Cursive form of "V." "V" represented both vowel and consonant sounds since Roman times, until mid- to late MEDIEVAL times, when the "u" developed, to represent the vowel. The two were used interchangeably for many centuries. It first appeared as a separate entity in English dictionaries in 1800.

Ugarit CUNEIFORM script *c.* 1400 BC. Hundreds of clay TABLETS found in 1928 in modern coastal Syria constitute the earliest known examples of true ALPHABETIC writing – that which incorporates signs for vowels that are equally weighted visually to consonants. The other prevailing systems at that time were sophisticated consonant-only systems often called alphabetic. Although Ugaritic is an important find, no similar specimens have been uncovered, making it a sort of historical orphan. The next true alphabetic writing we know about is Greek, *c.* 800 BC.

U & lc 1) Short for upper and lower case: writing or printing that uses capitals and small letters in the normal way, compared with, for example, all capitals. 2) Journal of the International Typeface Corporation, New York. *See* Appendix, PUBLICATIONS.

Ullman, Berthold Louis British (1882–1965) Author of a standard reference book, *Ancient Writing and Its Influence* (1932, 1969) among other books.

ultramarine ash Pale blue PIGMENT; a by-product of ULTRAMARINE genuine. Contains mostly the grayish impurities that are found in LAPIS LAZULI, mixed with some of the bright ultramarine blue. PERMANENT, but bleaches in contact with ACIDS.

ultramarine blue GENUINE: made since ancient times by grinding and washing (LEVIGATING) the semi-precious stone

LAPIS LAZULI. In very short supply and prized above all other blues during late MEDIEVAL and RENAISSANCE times, especially for painting the Virgin's robes in MS paintings. Widely used in the golden age of Persian MSS, *c.* 16th–18th c. Still available today, although very expensive. SYNTHETIC (French ultramarine): in tube paints, a dark, slightly purplish blue which yields brilliant TINTS. More NEUTRAL blues are possible from the powdered pigments. PERMANENT, but will bleach if exposed to ACIDS. Discovered in 1787 while a Mr. LeBlanc was making soda – a stage in this process involves heating sodium sulfate with coal and limestone, and on one occasion a blue encrustation was observed on the walls of the furnace. Following extensive research, a method of manufacturing this blue substance was developed. It turned out to be almost identical in chemical composition to lapis lazuli, except that it contained no impurities. It soon became the standard blue pigment for artists.

ultraviolet Light waves from 10 to 380 nm., just below the visible SPECTRUM. These are the waves that do the most damage to works of art.

umber RAW UMBER: EARTH PIGMENT of great PERMANENCE. OPAQUE, dull brown or yellowish-brown. The best quality umber comes from the Mediterranean island of Cyprus. BURNT UMBER: dark reddish-brown pigment made from roasted raw umber.

unbracketed serif See SERIF.

uncial Sturdy, round, MAJUSCULE BOOKHAND used from the 3rd to the 9th c. May have originated in North Africa. Blends Latin and Greek influences. Associated with Christianity. Its literal meaning, "inch high," is an exaggerated description of the large letters of any style used for many DELUXE books and scrolls in the first centuries AD. The term "ROMAN UNCIAL" refers to SQUARE CAPITAL or RUSTIC scripts. LATE UNCIAL (*c.* 7th-9th c.) is more refined and characterized by PEN MANIPULATION. Today uncial refers to a single family of scripts, characterized by rounded, Greek-looking "A," "D," "E," "H," and "M." The name "uncial" for this script was not widely used until the mid-1800s.

university Developed in late 12th-c. Europe (Oxford, Paris, Bologna, etc.), universities became centers of MS production because of the growing need for books. *See* PECIA.

union Synonym of FUSION.

unjustified Synonym of RAGGED.

Updike, Daniel Berkeley (1860–1941) Distinguished American printer. Author of *Printing Types – Their History, Forms and Use* (1922), a primary reference on the subject.

upper case Typographical term for capital letters. They were kept in a case above the "LOWER CASE," or MINUSCULE, letters.

upstroke Written line directed toward the top edge of the page.

Urbino, Duke of, Federigo da Montefeltro (1422–82) Italian art patron who commissioned works from the best scribes of his time. His library, in which he allowed no printed books, was acquired by Pope Alexander VII and is now part of the VATICAN LIBRARY.

qUAEFACTASUN
lecTAASpICIUN
TERNAqUOG-EJ
TUSETDJUJNJTA
UJUSJTAq-DJUIN

uncial

pECCATORISSED
UTCONUERTA
TURETUJUAT·
CUMERÇOJNTer
ROGASSEMUS

late uncial

uterine vellum Also SLUNK manuscript calfskin vellum. PARCH-MENT made from the skin of stillborn or very young calves. Thin, translucent, pliable and small.

Utrecht Psalter Made at Rheims in the 8th c., considered by some to be the finest example of CAROLINGIAN ILLUMINATION. Now housed in the Utrecht University Library.

V Had been, in early ROMAN times, both vowel and consonant. Its vowel value was eventually supplanted by "U" and "W." As a Roman numeral it stands for 5, variously explained as half of "X" (10) or five fingers of the hand held in a "V" shape.

v. Abbreviation of VERSO; thus "fol.10.v." means folio 10 verso.

"V"-cut Also "vee cut." Term describing the shape of the incision made for most letters hand-cut with a chisel in stone.

value Lightness or darkness of a given color. For example, if a color contains a lot of white, it has a light value. Conversely, with a lot of black, it has a dark value.

Vandyke brown NATURAL bituminous EARTH PIGMENT that contains ferric oxide. PERMANENT in GOUACHE, IMPERMANENT in WATERCOLOR.

van Krimpen, Jan *See* KRIMPEN.

variegated leaf Metal LEAF made of a copper alloy that has been given an oxidizing treatment in manufacture, resulting in random swirls and blotches of color from red-orange through blues, greens and purples. It will continue to oxidize after GILDING, so is not PERMANENT.

Vatican Library Rome, Italy. *See* Appendix, LIBRARIES.

vegetable black PIGMENTS made with the soot from burning vegetable oil, twigs, hemp, wine lees, etc. *See* BLACK.

vegetable colorants Colors obtained from the leaves, berries, petals, etc. of plants are usually extremely IMPERMANENT, although they have been used in paint from earliest times until well into the 19th c. Genuine MADDER is one of the few still being used.

vegetable parchment WOODPULP PAPER that is thought to resemble PARCHMENT.

vehicle The liquid portion of paint or ink: for scribes this means water (as compared with turpentine, etc.). Anything dissolved in the water, such as GLYCERINE or GUM, becomes part of the vehicle. The PIGMENT particles are not part of the vehicle.

vellum PARCHMENT made from calfskin.

Venetian Pertaining to, or in the style of, the first Venetian printers (late 15th c.), whose typefaces were based on the

"V"-cut "I"

contemporary HUMANIST writing style. These faces remain standards of legibility and elegance.

Venetian red Rust-colored PIGMENT of NATURAL and SYNTHETIC ferric oxides. Extremely PERMANENT.

verdigris Also copper acetate; cupric acetate; bice. From the French *verte grez* (Greek green). Obsolete light bluish-green PIGMENT. Used from ancient Greece to the end of the 19th c. Made by corroding copper by exposing it to the fumes of acetic acid, or other vegetable acids such as vinegar. LIGHTFAST, but often turns brown or black on contact with other pigments.

vermilion Brilliant red-orange of synthetic mercuric sulfide, a SULFUR pigment. Began replacing the NATURAL (and less pure) CINNABAR *c.* 12th c. Tends to blacken with too much direct sunlight. Widely replaced today by CADMIUM REDS.

versal Late 19th-c. word, popularized among calligraphers by Edward JOHNSTON. Any variety of CONSTRUCTED or drawn capital letter having exaggerated thicks and thins, and usually oversize SERIFS. In MEDIEVAL times they were used as boldly decorative INITIAL letters at the beginning of verses and paragraphs, as the name suggests, or by themselves for short stretches of important text. Term is little used among PALEOGRAPHERS and other scholars, as it is too general.

verso Side of a LEAF to the left of the spine of a book. *Compare* RECTO.

vertex Synonym of APEX.

vertical axis *See* AXIS.

Vicentino *See* ARRIGHI, Ludovico degli.

Victoria and Albert Museum London, England. *See* Appendix, LIBRARIES.

vinegar, white wine Ingredient in MEDIEVAL recipes for making IRON GALL INK and paint. All but obsolete today, as non-ACIDIC PRESERVATIVES are available.

viridian Dark bluish green translucent PIGMENT of hydrous oxide of chromium. Made since 1860. PERMANENT.

Visible Language A quarterly journal concerned with all aspects of literacy, that sometimes publishes articles on type design and calligraphy. Established 1966. *See* Appendix, PUBLICATIONS.

Visigothic NATIONAL SCRIPT of Spain *c.* 500–900. So called, even though it flourished after the Visigoths had fallen from power in 531.

visually centered *See* CENTERED.

vitriol, green Also sulfate of iron; copperas. When mixed with GALL NUT liquor, it forms the sole base of all IRON GALL INK.

volumen Latin for "a thing rolled up," thus an early name for SCROLL.

von Larisch, Rudolf Edler *See* LARISCH.

versals

Visigothic script

the waist of an "I"

W Mid- to late MEDIEVAL European development, an offshoot of the Roman letter "V." At one time it was actually written as two "U"s or "V"s.

waist Slight thinning in the middle of a straight stroke. *See* ENTASIS.

waistline Upper boundary of the BODY HEIGHT in writing or TYPE.

Walker, Emery British (1851–1933) A former associate of William MORRIS, he co-founded the Doves Press in 1900 with T. J. COBDEN-SANDERSON. Their Doves Roman type and straightforward design give their books a different beauty to Morris's more ornate productions.

Walters Art Gallery Baltimore, U.S. *See* Appendix, LIBRARIES.

warm color A color on the red-orange side of the COLOR WHEEL. *See* COLOR.

warm sepia *See* SEPIA.

wash Application of watery paint or ink over large areas. Usually done with a brush or sponge and involves enough water to render the paint or ink TRANSLUCENT, showing the paper through. Some are so light as to color the paper only softly, while others may be almost OPAQUE.

water Distilled water is preferred for fine work because tap water contains ACIDS and other ingredients which may in time damage the work.

waterbottle Squeezable plastic container that dispenses drop by drop.

watercolor AQUEOUS PAINT, available in several forms. CAKE: Contains PIGMENT, GUM and varnish. Cakes are dried, to be reconstituted with a wet brush as needed. HOMEMADE: the procedure for making one's own paint from powdered pigment and BINDER is explained in detail in *The Calligrapher's Handbook*. Some scribes prefer this method, in order to control its texture and quality. PAN: called semi-soft, contains pigment, gum and GLYCERINE. STICK: hard sticks of pigment and glue to be ground like STICK INK in a GAKEN dish. TUBE: containing pigment, gum, glycerine and water, the paint remains soft in storage for many months or sometimes even years. The translucent variety is called "AQUARELLE," the opaque "GOUACHE." The word "watercolor" on its own indicates aquarelle.

water dropper Tube with rubber bladder for dispensing drop by drop.

water gilding *See* GILDING.

waterleaf Paper which is UNSIZED, and therefore very absorbent.

watermark Wet paper PULP lies on a screen which forms it into a thin layer. The screen may have the paper company's (or other)

trademark in wire relief, resulting in thinner paper where the trademark is. This "watermark" is thus visible when held up to light. The first known watermark was a design of a tower on a sheet of paper from 1293.

waterproof ink *See* INK.

Waters, Sheila British (b. 1929) Student of Dorothy MAHONEY. Lives and works near Washington, D.C. Greatly encouraged the calligraphic arts by conducting frequent workshops in her studio, and traveling around the U.S., Canada, and Australia to teach and lecture since the 1970s. Author of *Foundations of Calligraphy* (scheduled to be published in 1991).

waxer Electric machine that rolls warm wax onto the back of artwork for MECHANICALS. This wax-coated paper may be repositioned.

wax tablet *See* TABLET.

Wearmouth-Jarrow Twin monasteries in Northumbria, England, which produced a fine and distinctive UNCIAL script, *c.* late 7th–mid-8th c. Famous examples are the STONYHURST GOSPELS and the CODEX AMIATINUS.

web press Printing press using paper fed from a roll, or web, of paper, which is cut into sheets after printing.

wedge serif Developed in IRISH MAJUSCULE, it continued in IRISH MINUSCULE and ANGLO-SAXON MINUSCULE. *See* SERIF.

weight 1) Refers to the relationship of a letter's stroke width to its height. Strokes, or letters made of strokes which are relatively wide, are "heavyweight" or "bold," while those which are relatively thin are "lightweight." 2) *Concerning paper, see* BASIS WEIGHT.

Wellington, Irene British (1904–84) Student and later assistant of Edward JOHNSTON at the Royal College of Art. Influential teacher. Her work is known, as one anthology put it, for its "strength, freedom, grace and delicacy." *More Than Fine Writing*, a book on her life and work by Heather CHILD, Heather Collins, Ann HECHLE and Donald JACKSON, was published in 1986.

wetting agent Substance that decreases the SURFACE TENSION of any liquid, but specifically the water in paint or ink, allowing the solution to spread more easily, or "take" better, on a surface. Traditionally, this has meant OX GALL, which has now largely been replaced by synthetic detergent-like compounds. Used in WASHES, or other cases when too much SIZE makes the paper resist ink or paint.

Whalley, Joyce Irene British. Former assistant librarian at the VICTORIA AND ALBERT MUSEUM. Among her publications are *Writing Implements and Accessories* (1975) and *The Pen's Excellencie* (1980).

wheat paste Homemade GLUE, which may be used in BOOKBINDING. Robert Williams, the calligrapher, teacher and writer from Chicago, suggests this recipe: 1 part (by volume) flour, 3 parts water, a few drops of PRESERVATIVE. Mix the flour with $\frac{1}{3}$ of the water until lump-free. Mix in the remaining water, and heat very slowly in a glass or enamel pan until the mixture is the

consistency of sour cream. Remove from heat, cover with thin film of water. Let cool. Pour off water and stir in a few drops of preservative. Store in plastic or glass container. Refrigerated it will keep for up to a week before mold forms, at which point it should be discarded.

wheelie Synonym of PARALLEL GLIDER.

whelk Mollusk from which TYRIAN PURPLE DYE was made.

white glue Available under many brand names, white glues are polyvinyl acetate emulsions and other synthetic resins. They are INERT, so will not turn surfaces brown or otherwise damage them over time, but applications must be carefully chosen, because they can COCKLE paper if improperly used, and cannot be removed after drying.

white gold leaf LEAF made half of silver and half of gold. The silver content will tarnish. *See* GOLD LEAF, SILVER LEAF, LEAF.

white space Synonym of NEGATIVE SPACE.

white vine Type of ornate MEDIEVAL decoration in which the background of a vine pattern is drawn in, leaving the white paper or PARCHMENT revealed in the form of the vine itself.

whiting Also chalk. Natural calcium carbonate, composed mainly of the remains of microscopic sea organisms. Thus, even when purified through LEVIGATION, it cannot approach the purity of its artificial counterpart (BLANC FIXE) for use as a paint additive and base for LAKE pigments. It is, however, sometimes used as a POUNCE to remove grease from PARCHMENT.

whole bound Book whose cover is entirely of one material.

widow Line of type or calligraphy that is undesirably short, as when a paragraph ends on a line with just one word, or the last part of a hyphenated word. In fine work, this is to be avoided by redesigning or respacing the text.

Winchester Important center of book production in England in the late 10th and 11th c. It was probably on a Winchester MS that Edward JOHNSTON based his FOUNDATIONAL script. *See* RAMSEY PSALTER.

wmk Abbreviation of WATERMARK.

woad *Isatis tinctoria*, a European herb of the mustard family whose leaves yield a dark blue dye produced in a similar way to INDIGO. At the time of the Roman invasion, it was used by the British as a ceremonial body dye. For dying cloth and making paint it was replaced by the more PERMANENT indigo in the 17th c., and became obsolete in the 1930s. Because woad and indigo are chemically so similar, it is difficult to tell which one may have been used in a given MS.

woodblock printing This RELIEF process, which involves cutting a letter in reverse on a block of wood, was used in the 8th c. in China and spread to Europe by the 14th c. The first writing manuals in the early 16th c. were done this way. When letters written with a quill are copied by carving into wood, they tend to become more spiky than the original. This can be seen by comparing the illustrations of the writing of TAGLIENTE that has been copied in wood by another artist, in *Lo Presente* (p. 119),

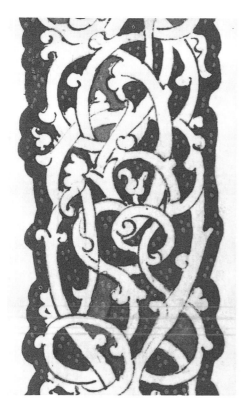

medieval white-vine work

and the actual writing of CATANEO (p. 27). It is good to keep this in mind when studying any writing manual that has been printed from woodblocks. Woodblock printing was largely replaced by INTAGLIO engraving during the 17th c. for printing books containing writing or drawing.

woodpulp paper In the mid-19th c. it replaced paper made of cloth pulp. Unfortunately, the ALUM used as SIZE eventually causes the paper to crumble, resulting in millions of ruined books. Woodpulp paper without alum is available today, although it is still not widely used.

workable fixative *See* FIXATIVE.

word separation Most early writing placed words next to each other without any kind of visual pause. The use of dots between words or sentences developed in ancient Greece, Egypt and Rome (*see* TRAJAN INSCRIPTION *for illustration*), but the custom of making actual space between words was not firmly established until the 10th c. in Europe.

wove PAPER made on a MOLD with no LAID pattern; a smooth, even surface. The first was made by John BASKERVILLE in 1755, to enhance the fineness of his printing.

wreath Band of twisted cloth painted at the base of the CREST in some HERALDIC designs. Originally an actual band worn on the helmet to keep MANTLING in place.

writer's hand Localized or generalized disorder characterized by aching or stiffness of the hand. Often mistaken for arthritis, it is actually a soft tissue rheumatism.

writing System of commonly understood marks that visually represent perceptions, thoughts, feelings and beliefs. Such systems arose in various cultures almost simultaneously *c.* 4000–3000 BC. Reasons for its development can be observed by noting the earliest extant examples in various ancient cultures: accounting (Sumeria), agricultural records and incantations for the dead (Egypt), trade (Phoenicia), prayer (China), scripture (Palestine), poetry (Greece). *See* EMBRYO WRITING.

writing field Inscribed area of a surface, as opposed to areas without writing. Measured from the WAISTLINE of the first line to the BASELINE of the last. *See* RULED SPACE.

writing ink Outdated term for IRON GALL INK.

writing line Synonym of BASELINE, but may be preferred when speaking of a whole page of writing, as opposed to a student's practice sheet.

writing manual Book containing instruction for fine writing, usually with illustrations to be copied.

writing master COPYIST, usually post-printing, who taught writing and arithmetic. Some were flamboyant promoters of their fancy ROUNDHAND or ITALIC writing systems, and of the accompanying COPYBOOKS offered for sale.

writing space Synonym of WRITING FIELD.

X The ETRUSCANS had used the signs and , but it appeared in classical Greek and Latin in the form familiar to us.

X-ACTO knife Metal scalpel-like knife with detachable blades of various shapes, curved and straight.

x-height Synonym of BODY HEIGHT.

Y In about 100 BC, after their conquest of Greece, the Romans adopted this Greek symbol as the letter "Y" to better suit the Greek alphabet to Latin sounds.

Yciar, Juan de Author of the first Spanish writing manual *Arte Subtilissima* (1548). The 1550 edition was published in facsimile in 1958, edited by Evelyn Schuckburg.

yellow bole Often considered a good colorant for GESSO to be gilded with SILVER LEAF, as the red ARMENIAN BOLE is preferred for GOLD LEAF.

yolk *See* EGG.

Z After their conquest of Greece *c*. 100 BC, the Romans adopted this Greek symbol as a letter, adding it to better suit the Greek alphabet to Latin sounds.

Zanerian school Predominant American school of ENGROSSING, especially fine instruction in COPPERPLATE, business writing (a form of COMMERCIAL CURSIVE) and ORNAMENTAL PENMANSHIP. Flourished in the late 19th c. The school closed in the 1970s, although their writing books are still published. Their *Zanerian Manual of Alphabets and Engrossing* was reprinted in 1981. *See* ENGROSSING.

Zapf, Hermann German (b. 1918) Distinguished type designer (Optima, Palatine series, Melior and scores of other popular faces), calligrapher, author of *About Alphabets* (1960, 1970), *Creative Calligraphy* (1985), designer of *Manuale Typographicum* (1954, 1970), *H. Z. & His Design Philosophy* (1987), among other books, teacher (at the Werkkunstschule Offenbach, Rochester Institute of Technology, among others), typographer, lecturer, artist. His work, teaching and philosophy have proba-

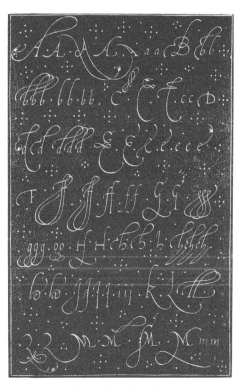

calligraphy of Juan de Yciar

bly had more influence on letter design than those of anyone else in the second half of the 20th c.

zed British spoken form of the letter "Z."

zinc white Synonym of CHINESE WHITE.

zoomorphic Type of decoration involving realistic or fantastic animal forms, especially popular in MEDIEVAL times.

APPENDIX

Parts of the Letter

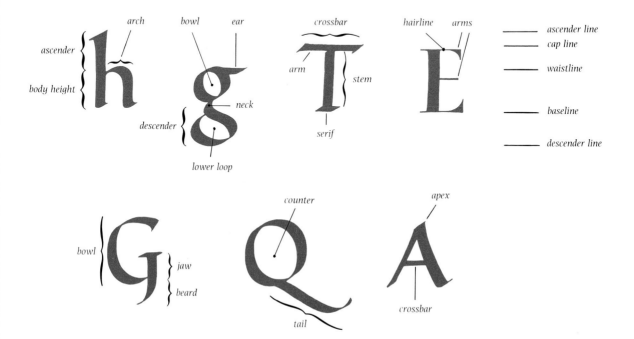

Timeline

(Scripts are listed at approximate time of first development. Many continued in use for centuries. See listings in text.)

	30,000–15,000 BC	cave paintings
agriculture	7000	
	3000	Sumerian cuneiform script
Egyptian pyramids		
	2000	
Abraham		
	1500	
		alphabetic script
Tutankhamun		(Semitic)
Phoenicians		
King David	1000	
Etruscans		alphabetic script
Homer		(Greek)
	500	
Socrates		
Julius Caesar		
Jesus	+	Roman inscriptional capitals
		square capitals and rustic
Constantine		uncial
St Patrick		
	AD 500	half uncial
Mohammed		late uncial
Charlemagne		Carolingian
	1000	
William the Conqueror		early Gothic
Marco Polo		Gothic
Chaucer		batarde, secretary hands
Michelangelo		humanist, italic
		movable type
Columbus	1500	
Martin Luther		copperplate engraving
Shakespeare		roundhand scripts
Napoleon		commercial cursive
Queen Victoria		Spencerian
		calligraphic revival
Martin Luther King		computerized typesetting
	2000	

Prominent Places in the Development of the Calligraphic Arts

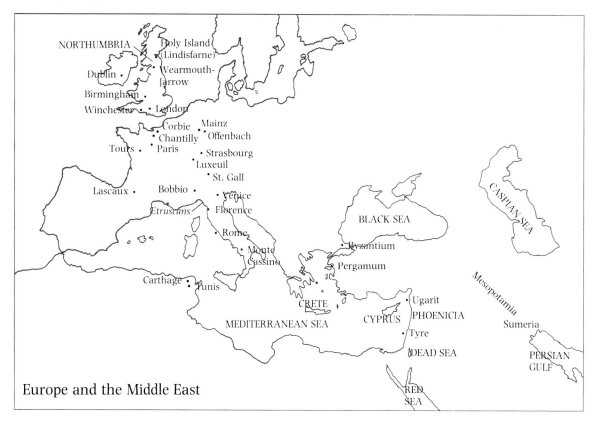

NORTHUMBRIA
Holy Island (Lindisfarne)
Dublin
Wearmouth-Jarrow
Birmingham
Winchester • London
Corbie Mainz
Chantilly Offenbach
Tours Paris
• Strasbourg
Luxeuil
• St. Gall
Lascaux Bobbio
Venice
Etruscans Florence
BLACK SEA
• Rome
Byzantium
Monte Cassino
Pergamum
Carthage • Tunis
CRETE
Ugarit
CYPRUS PHOENICIA
MEDITERRANEAN SEA
Tyre
DEAD SEA
RED SEA
CASPIAN SEA
Mesopotamia
Sumeria
PERSIAN GULF

Europe and the Middle East

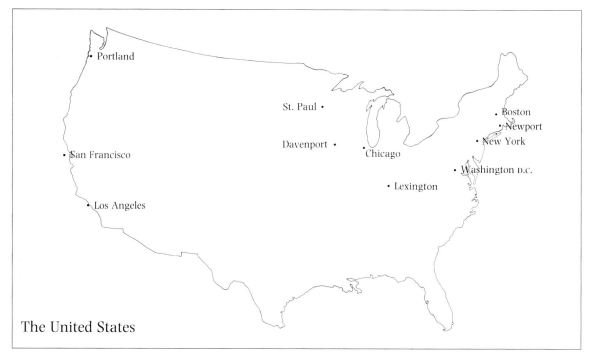

• Portland
St. Paul •
• Boston
• Newport
Davenport •
• New York
• San Francisco
• Chicago
• Washington D.C.
• Lexington
• Los Angeles

The United States

GUIDE TO FURTHER INFORMATION

Libraries with Important Manuscript Collections

This list is not meant to be inclusive; rather, it is a short, geographically diverse list of useful collections; a starting point. Be sure to write or call any institution well in advance if you plan to visit. Often a letter of recommendation and some scholarly affiliation is required to study the MSS themselves. If you are not working on a scholarly project, you may want to examine photographs instead. Two libraries which specialize in photographs of MSS are the Hill Monastic Manuscript Library and the Central Lettering Record, listed below.

Bibliothèque Nationale
58 rue de Richelieu
Paris 75084 France
Tel: 4703 8126
Extensive collection of Western MSS.

Bodleian Library
Department of Western Manuscripts
Oxford University
Oxford OX1 3BG England
Tel: 0865 244675
Extensive collection of Western MSS.

British Library
Department of Manuscripts
Great Russell Street
London WC1B 3DG England
Tel: 071-636 1544
Extensive collection of Western MSS.

Melbert B. Cary, Jr. Library
Rochester Institute of Technology
One Lomb Memorial Drive
Rochester, NY 14623
Tel: 716-475-2411
Fine printing and calligraphy, both old and contemporary, including a rubbing of the Trajan inscription by Father Catich.

Central Lettering Record
Central School of Art and Design
Southampton Row
London WC1 England
Tel: 071-405 1825
Large collection of photographs of lettering. Founded by Nicolete Gray.

Craft Study Centre
Holburne Museum
Bath, England
Tel: 0225 466669
Important collection of 20th-c. calligraphy, including that of Edward Johnston and Irene Wellington.

J. Paul Getty Museum
17985 Pacific Coast Highway
Malibu, California 90265
Tel: 213-459-7611
Collection of European illuminated MSS from the 9th to the 16th c., including a model book of calligraphy by Georg Bocskay and other notable scribes.

Hill Monastic Manuscript Library
Bush Center
Saint John's University
Collegeville, MN 56321
Tel: 612-363-3514
Over 50,000 manuscripts and 100,000 papyri are available on microfilm.

Houghton Library
Harvard University
Cambridge, MA 02138
Tel: 617-495-2440
Philip Hofer collection of medieval, Renaissance and contemporary calligraphy, as well as a good collection of fine printing.

Klingspor Museum
Herrnstrasse 80
D-6050 Offenbach-am-Main
West Germany
Tel: 80 65 29 54
Excellent collection of 20th-c. book arts, including calligraphy. Founded 1953 by Karl and Wilhelm Klingspor.

Laurentian Library (Biblioteca Medicea-Lauranziana)
Piazza S. Lorenzo 9
50123 Firenze, Italy
Tel: 055 210760

Minnesota Manuscript Initiative
Post Office Box 4024
St. Paul, MN 55104
Housed in the Wilson Library at the University of Minnesota, includes work by Irene Wellington, James Hayes and other 20th-c. masters. Established in 1981.

National Archaeological Museum
1 Tositsa Street
Athens, Greece
Tel: 301 821 7717
Houses more than 13,000 inscriptions from the 6th c. BC to AD 300.

Newberry Library

60 West Walton Street

Chicago, IL 60610

Tel: 312-943-9090

Although it has many fine examples of calligraphy, this collection specializes in printed books. Of interest to calligraphers are the numerous important writing manuals and copybooks from the 16th c. and later. Founded 1887.

Pierpont Morgan Library

33 East 36 Street

New York, NY 10016

Tel: 212-685-0008

Around the turn of the century, John Pierpont Morgan (1837–1913) acquired several important collections which ranged from medieval MSS to contemporary fine printing. In 1924 his library was opened to the public, as his son continued to expand what remains the finest and most extensive collection of MSS in the United States.

San Francisco Public Library

Special Collections, The Harrison Collection

Civic Center

San Francisco, CA 94101

Tel: 415-558-3940

Over 400 pieces of fine calligraphy, mostly contemporary.

Stadtische Bibliotheken

Handscriften-Abteilung

Maria-Theresia Str. 23

8000 Munchen 80, West Germany

Tel: 089 4702024

Collection includes 12,000 MSS.

Vatican Library (Biblioteca Apostolica Vaticana)

Porta St. Anna

Cortile Belvedere

1-00120 Città del Vaticano, Italy

Of the 65,000 MSS in this collection, a few are on view to the public. To obtain MS privileges, you may write to the Apostolic Delegate to your country. In the U.S., the address is 3339 Massachusetts Avenue NW, Washington, D.C. 20008; in the U.K., 54 Parkside, London SW19.

Victoria and Albert Museum

Cromwell Road, South Kensington

London SW7 2RL England

Tel: 071-938 8500

One of the world's most important museums of fine applied art and crafts. Houses a notable collection of Renaissance and 20th-c. calligraphy.

Walters Art Gallery

600 North Charles Street

Baltimore, MD 21201

Tel: 301-547-9000

Houses one of the finest manuscript collections in the United States, second only to the Pierpont Morgan. Its more than 800 MSS range from 9th to 19th c., with particular strength in the late medieval and Renaissance periods. Founded 1904.

Calligraphic Societies and Publications

* denotes major society

THE UNITED STATES

ALABAMA

Calligraphy Arts Guild of Huntsville

P.O. Box 2407, Huntsville, AL 35804

Columbus Calligraphy Guild

Box 771, Phenix City, AL 36867

ARIZONA

Calligraphic Society of Arizona

P.O. Box 27695, Tempe, AZ 85285

ARKANSAS

Ozark Society of Scribes

Box 451, Eureka Springs, AR 72632

CALIFORNIA

Calligraphic Arts Guild of Sacramento

Box 161976, Sacramento, CA 95816

Calligraphy Center

1323 Cole Street, San Francisco, CA 94117

* **Friends of Calligraphy**

Box 5194, San Francisco, CA 94101

Pacific Scribes

P.O. Box 3392, Santa Clara, CA 95055

San Diego Fellow Calligraphers

3626 Central Avenue, San Diego, CA 92105

* **Society for Calligraphy**

Box 64174, Los Angeles, CA 90064

The Calligrapher (Mensa)

P.O. Box 7000-305, Palos Verdes, CA 90274

The League of Handbinders

7513 Melrose Avenue, Los Angeles, CA 90046

Write On

P.O. Box 957, Boulevard, CA 92005

COLORADO
Colorado Calligraphers' Guild
P.O. Box 6746, Cherry Creek Station, Denver, CO 80206
CONNECTICUT
Calligraphers Guild of New Haven
P.O. Box 2099, Short Beach, CT 06405
Connecticut Calligraphy Society
Box 493, New Canaan, CT 06854
Connecticut Valley Calligraphers
Box 1122, Farmington, CT 06034
Mysticalligraphers
P.O. Box 267, Mystic, CT 06355
DELAWARE
Delaware Calligraphy Guild
P.O. Box 1660, Wilmington, DE 19899
DISTRICT OF COLUMBIA
* **Washington Calligraphers Guild**
P.O. Box 3688
Springfield, VA 22116
FLORIDA
Calligraphers Guild of Jacksonville
P.O. Box 5873, Jacksonville, FL 32247
Scribes of Central Florida
P.O. Box 1753, Winter Park, FL 32790
South Florida Calligraphy Guild
6950 SW 28th Street, Miramar, FL 33023
St. Petersburg Society of Scribes
2960 58th Avenue South, St. Petersburg, FL 33712
Tampa Calligraphy Guild
P.O. Box 2051, Tampa, FL 33601
GEORGIA
Friends of the Alphabet
P.O. Box 11764, Atlanta, GA 30355
ILLINOIS
American Academy of Calligraphy & Lettering Art
P.O. Box 10204, Chicago, IL 60610
* **Chicago Calligraphy Collective**
Box 11333, Chicago, IL 60611
INDIANA
Alcuin Society of the Book Arts
P.O. Box 222, Carmel, IN 46032
Indiana Calligraphers Association
P.O. Box 194, New Albany, IN 47150
KANSAS
Wichita Calligraphy Guild
P.O. Box 3453, Wichita, KS 67202
Center for the Calligraphic Arts
Box 8005, Wichita, KS 67208
KENTUCKY
Kentucky Calligraphers Guild
P.O. Box 32234, Louisville, KY 40232
LOUISIANA
New Orleans Lettering Arts Association
P.O. Box 4117, New Orleans, LA 70178

MAINE
Calligraphers of Maine
P.O. Box 2751, S. Portland, ME 04106
MARYLAND
Chesapeake Calligraphers
P.O. Box 1320, Columbia, MD 21044
The Southern Maryland Society of Scribes
c/o The Talent Shoppe, RT 235 & St Mary's Ind. Park, Hollywood, MD 20636
MASSACHUSETTS
Concord Scribes
Box 405, Concord, MA 01742
* **Lettering Arts Guild of Boston**
P.O. Box 461, Boston, MA 02102
The Quilligraphers Guild
23 Maple Street, Holden, MA 01520
MICHIGAN
Calligraphy Workshop
14940 Beech Daly Road, Redford, MI 48240
Friends in Calligraphy
1987 Hunters Ridge Drive, Bloomfield, MI 48013
Michigan Association of Calligraphers
P.O. Box 55, Royal Oak, MI 48068
Pen Dragons
1205 Harbrook, Ann Arbor, MI 48103
MINNESOTA
* **Colleagues of Calligraphy**
P.O. Box 4024, St. Paul, MN 55104
MISSOURI
Saint Louis Calligraphy Guild
P.O. Box 16563, St. Louis, MO 63105
MONTANA
Big Sky Scribes
1610 Boulder Avenue, Helena, MT 59601
Great Falls Scribes (Branch of Big Sky Scribes)
2005 Mountain View Drive, Great Falls, MT 59405
Missoula Calligraphers Guild (Branch of Big Sky Scribes)
314 University Avenue, Missoula, MT 59801
The Octavo Society
2815 Woody Drive, Billings, MT 59102
NEVADA
Society of Desert Scribes
P.O. Box 19524, Las Vegas, NV 89119
NEW JERSEY
Jersey Shore Calligraphers' Guild
24 Irving Place, Red Bank, NJ 07701
NEW MEXICO
* **Escribiente**
P.O. Drawer 26718, Albuquerque, NM 87125
Oppulent Order of Practicing Scribes
Route 1, Box 32, Roswell, NM 88201
NEW YORK
Chautauqua Calligraphers Guild
Rural Box 321, RFD 2, ST RT 380, Jamestown, NY 14701

Genesse Valley Calligraphers Guild
55 Monteroy Road, Rochester, NY 14618
Guild of Bookworkers
663 Fifth Avenue, New York, NY 10022
Island Scribes
P.O. Box 43, N. Baldwin Station, Baldwin, NY 11510
* **Society of Scribes, Ltd.**
Box 933, New York, NY 10150
Suffolk Scribes
P.O. Box 433, Bellport, NY 11713
NORTH CAROLINA
Carolina Lettering Arts Society
P.O. Box 20466, Raleigh, NC 27619
OHIO
Calligraphy Guild of Columbus
P.O. Box 14184, Columbus, OH 43214
Greater Cincinnati Calligraphers Guild
P.O. Box 429345, Cincinnati, OH 45242
Guild of the Golden Quill
Box 354, Mid City Station, Dayton, OH 45402
Western Reserve Calligraphers
P.O. Box 43579, Cleveland, OH 44143
OKLAHOMA
Calligraphy Guild of Oklahoma
Box 33098, Tulsa, OK 74135
Sooner Scribes
P.O. Box 312, Norman, OK 73070
OREGON
Allied Body of Calligraphers
P.O. Box 1381, Grants Pass, OR 97526
Capital Calligraphers
P.O. Box 17284, Salem, OR 97305
Creative Arts Community, Inc.
P.O. Box 4958, Portland, OR 97208
Goose Quill Guild
Oregon State University, Corvallis, OR 97330
* **Portland Society for Calligraphy**
P.O. Box 4621, Portland, OR 97208
The Calligraphers Guild
Box 304, Ashland, OR 97520
Valley Calligraphy Guild
2352 Van Ness, Eugene, OR 97403
PENNSYLVANIA
Calligraphers Guild of NE Pennsylvania
Box 297, RD 5, Edgewood Drive, Clarks Summit, PA 18411
Calligraphy Guild of Pittsburgh
P.O. Box 8167, Pittsburgh, PA 15217
Philadelphia Calligraphers' Society
Box 7174, Elkins Park, PA 19117
Village Calligraphers Guild
P.O. Box 194, Jamison, PA 18929
SOUTH CAROLINA
Carolina Calligraphers Guild of Scribes
P.O. Box 25416, Orchard Park Station, Greenville, SC 29601

TENNESSEE
Calligraphy Guild of Chattanooga
P.O. Box 15164, Chattanooga, TN 37415
Memphis Calligraphy Guild
1413 Hawkcrest Cove, North, Cordova, TN 38018
Nashville Calligraphers Guild
111 Harpeth Valley Road, Nashville, TN 37221
TEXAS
Capital City Scribes
P.O. Box 50455, Austin, TX 78763
Dallas Calligraphy Society
6660 Santa Anita Drive, Dallas, TX 75214
Fort Worth Calligraphers Guild
P.O. Box 11265, Ft. Worth, TX 76110
Houston Calligraphy Guild
c/o Art League of Houston, 1953 Montrose Boulevard, Houston, TX 77006
Pen Crafters Guild of El Paso
10508 Tomwood Avenue, El Paso, TX 79925
San Antonio Calligraphers' Guild
P.O. Box 6476, San Antonio, TX 78209
UTAH
Northern Utah Association of Calligraphers
P.O. Box 3587, Logan, UT 84321
Utah Calligraphic Artists
P.O. Box 8791, Salt Lake City, UT 84108
VIRGINIA
Calligraphers Guild of the Peninsula
P.O. Box 5031, Newport News, VA 23605
Tidewater Calligraphy Guild
P.O. Box 8871, Virginia Beach, VA 23450
WASHINGTON
Skagit Whatcom Calligraphers
1233 Field Road, Bow, WA 98232
Society for Calligraphy & Handwriting
Box 31963, Seattle, WA 98103
Tacoma Calligraphy Guild
P.O. Box 851, Tacoma, WA 98401
Write On Calligraphers
P.O. Box 277, Edmonds, WA 98020
WISCONSIN
Cream City Calligraphers
P.O. Box 1468, Milwaukee, WI 53201
Wisconsin Calligraphers Guild
P.O. Box 55120, Madison, WI 53705
AUSTRALIA
Australian Society of Calligraphy
P.O. Box 184, West Ryde, NSW 2114
CANADA
Bow Valley Calligraphy Guild
P.O. Box 1647, Station M, Calgary, Alberta T2P 2L7
Calligraphic Arts Guild of Toronto
Box 115, Willowdale, Station A, North York, Ontario M2N 5S7

Calligraphy Society of Ottawa
> P.O. Box 4265, Station E, Ottawa, Ontario K1S 5B3

Fairbank Calligraphy Society
> 80 Howe Street, Victoria, British Columbia V8V 4K3

International Association of Master Penmen and Teachers of Handwriting
> c/o Eileen Richardson, 34 Broadway Ave, Ottawa K1S 2V6

La Société des Calligraphes
> P.O. Box 704, Snowdon, Montreal, Quebec H3X 3X8

Northern Lights Calligraphers
> P.O. Box 6220, Fort McMurray, Alberta T9H 4W1

Northern Scribes Calligraphy Club
> Box 1922, Prince George, British Columbia V2L 5E3

Westcoast Calligraphy Society
> Box 48390, Bentall Centre, Vancouver, British Columbia V7X 1A2

ENGLAND

The Letter Exchange
> 54 Boileau Road, London SW13 9BL

North West Calligraphy Association
> 46 West Vale, Neston, South Wirral, Cheshire L64 9FF

Oxford Scribes
> Field Barn Farm, Hampton Poyle, Oxford OX5 2PY

* Society for Italic Handwriting
> 4 Knifton Court, Mimms Han Rd, Potters Bar EN6 3DA

* Society of Scribes & Illuminators
> *(formed in 1921 by students of Edward Johnston)*
> 54 Boileau Road, London SW13 9BL

HOLLAND

Mercator Society
> Gaasterland Str. 96, 2036 NJ, Haarlem

HONG KONG

Alpha Beta Club
> P.O. Box 73615, Cowloon Central Post Office

SOUTH AFRICA

Calligraphy and Italic Handwriting Society of South Africa
> Box 34481, Jeppestown, Johannesburg 2043

WEST GERMANY

Bund Deutscher Buchkunstler
> Klingspor Museum, D6050 Offenbach am Main, Hernstrasse 80

NOT PRIMARILY CALLIGRAPHIC:

American Institute of Graphic Art
> 1059 3rd Avenue
> New York, NY 10021

Graphic Arts Guild
> 11 West 20th St – 8th floor
> New York, NY 10011

PUBLICATIONS

Most societies have their own publications. Below are the addresses of international publications listed in the text.

Calligraphy Review
> Box 1511
> Norman, Oklahoma 73070
> Tel: 405-364-8794
> quarterly

Fine Print
> Post Office Box 193394
> San Francisco, California 94119
> Tel: 415-543-4455
> quarterly

Ink and Gall
> Post Office Box 1469
> Taos, New Mexico 87571
> Tel: 505-776-8659
> quarterly

U & lc
> International Typeface Corporation
> 2 Dag Hammarskjold Plaza
> New York, New York 10017
> Tel: 212-371-0699
> quarterly

Visible Language
> Rhode Island School of Design
> Graphic Design Department
> 2 College Street
> Providence, Rhode Island 02903
> quarterly

Bibliography

CALLIGRAPHY AND LETTERING

Pen Lettering, Ann Camp 1984
The Calligrapher's Handbook, Heather Child ed. 1986
Roman Lettering, L. C. Evetts 1979
Lettering as Drawing, Nicolete Gray 1971
Creative Lettering: Drawing and Design, Michael Harvey 1985
Kalligraphie, Gestaltete Handschrift, Karlgeorg Hoefer 1987 (sold with separate English translation)
Formal Penmanship, Edward Johnston (H. Child ed.) 1971
Writing & Illuminating, & Lettering, Edward Johnston 1979
The Little Writing Book, Rudolf Koch 1984
The Craft of Calligraphy, Dorothy Mahoney 1982
Complete Guide to Calligraphy Techniques and Materials, Judy Martin 1984
The Mystic Art of Written Forms, An Illustrated Handbook for Lettering, Friedrich Neugebauer 1979
The Anatomy of Letters: A Guide to the Art of Calligraphy, Charles Pearce 1987
The Practical Guide to Calligraphy, Rosemary Sassoon 1982
The Practical Guide to Lettering and Applied Calligraphy, Rosemary Sassoon 1986
Letterforms: An Introductory Manual of Calligraphy, Lettering and Type, Paul Shaw 1986
Written Letters, Jacqueline Swaren 1986
Creative Calligraphy, Hermann Zapf 1985

CONTEMPORARY CALLIGRAPHIC ART

Sixty Alphabets Gunnlaugur S. E. Briem intro. 1986
Lettering Today, John Brinkley ed. 1964
Calligraphy Today, Heather Child ed. 1979
More Than Fine Writing: The Life and Calligraphy of Irene Wellington, Child/Collins/Hechle/Jackson 1987
Words of Risk: The Art of Thomas Ingmire, Michael Gullick 1989
Florilège, Alain Mazeran ed. 1987
Modern Scribes and Lettering Artists, Rees and Gullick 1983
International Calligraphy Today, Hermann Zapf foreword 1982

COPPERPLATE

The Universal Penman, George Bickham 1954
Script Lettering for Artists, Tommy Thompson 1965
Zanerian Manual of Alphabets and Engrossing (Zaner Bloser) 1981

HANDWRITING

The Italic Way to Beautiful Handwriting, Fred Eager 1974
A Handwriting Manual, Alfred Fairbank 1975
Handwriting Made Easy, Tom Gourdie 1981
The Practical Guide to Children's Handwriting, Rosemary Sassoon 1983
Please Write, Wolf Von Eckardt 1988

HISTORICAL SURVEYS

The Decorated Letter, J. J. G. Alexander 1978
Masters of the Italic Letter: Twenty-two Examplars from the 16th Century, Kathryn Atkins 1988
The Illuminated Manuscript, Janet Backhouse 1979
A History of Illuminated Manuscripts, Christopher De Hamel 1986
A Book of Scripts, Alfred Fairbank 1979
Ornamental Alphabets and Initials, Alison Harding 1983
Historical Scripts, Stan Knight 1984
2000 Years of Calligraphy, Dorothy Miner *et al.* 1980
The Pen's Excellencie, Joyce Whalley 1980
Time Sanctified: The Book of Hours in Medieval Art and Life, Roger Wieck 1988

HISTORY OF WRITING AND WRITING MATERIALS

The Art of Written Forms, Donald Anderson 1969 (unfortunately out of print, but worth seeking in a library)
Sign, Symbol, Script: An Exhibition on the Origins of Writing and the Alphabet, Carter and Schoville 1984
The Book Before Printing, David Diringer 1982
Medieval Calligraphy, Marc Drogin 1980
A History of Lettering: Creative Experiment & Letter Identity, Nicolete Gray 1986
The Story of Writing, Donald Jackson 1981
The Art of Lettering: The History, Anatomy, and Aesthetics of the Roman Letter Forms, Albert Kapr 1983
Ancient Writing and Its Influence, B. L. Ullman 1969
The Pen's Excellencie, Joyce Whalley 1980

ILLUMINATION AND HERALDRY

Painting for Calligraphers, Marie Angel 1984
Il Libro dell' Arte (The Craftsman's Handbook), Cennino Cennini (trans. D. V. Thompson 1954)
The Calligrapher's Handbook, Heather Child ed. 1986
Heraldic Design, Heather Child 1979
Secreta: Three Methods of Laying Gold Leaf, Joyce Grafe 1986
The Art of Limming, Michael Gullick ed. and intro. 1976
The Story of Writing, Donald Jackson 1981
Materials and Techniques of Medieval Painting, D. V. Thompson 1956

RELATED TOPICS

Inks, their Composition and Manufacture, C. Ainsworth Mitchell 1937
Medieval Latin Paleography. A Bibliographical Introduction, L. E. Boyle 1984
Etching and Engraving, Walter Chamberlain 1973
Woodcut Printmaking and Related Techniques, Walter Chamberlain 1973

A Short History of the Printed Word, Warren Chappell 1986

Drawing on the Right Side of the Brain, Betty Edwards 1979

From Concept to Context: Approaches to Asian and Islamic Calligraphy, Fu/Lowry/Yonemura 1986

Painting Materials, A Short Encyclopedia, Gettens and Stout 1966

Pricing & Ethical Guidelines, Graphic Artists Guild 1987

Bookbinding, Arthur W. Johnson 1978

The Practical Guide to Book Repair and Conservation, Arthur W. Johnson 1989

The Practical Guide to Craft Bookbinding, Arthur W. Johnson 1985

The Practical Guide to Marbling Paper, Anne Chambers 1987

Letters Slate Cut, Kindersley and Cardoza 1981

A Dictionary of Color, A. Maerz 1930

An Introduction to Carrageen & Watercolor Marbling, Maurer and Maurer 1984

The Artist's Handbook, Ralph Mayer 1981

The Rubber Stamp Album, Miller and Thompson 1978

Bookbinding and the Conservation of Books, Roberts and Etherington, 1982

Handbook of Ornament, Franz Sales Mayer 1957

Hebrew Calligraphy: A Step-by-Step Guide, Jay Seth Greenspan 1980

Signwork: A Craftsman's Manual, Bill Stewart 1984

Hand Made Paper Today, Turner and Skiold 1983

Writing Implements and Accessories, Joyce Whalley 1975

Composition and Permanence of Artists' Colours (Winsor & Newton)

TYPE

Designing with Type, James Craig 1980

ABC of Lettering and Printing Types, Eric Lindegren 1982

Typography, Ruari McLean 1980

Encyclopedia of Typefaces, W. Pincus Jaspert *et al.* 1970

Main Suppliers of Calligraphic Materials and Books

John Neal, Bookseller

1833 Spring Garden Street
Greensboro, North Carolina 27403
Tel: 919-272-7604
Largest selection of calligraphic books; carries some supplies. Membership in its Lettering Arts Book Club gives discounts on purchases, a newsletter (catalog, book reviews) several times a year and a yearly calligraphic keepsake.

Paper & Ink Books

15309A Sixes Bridge Road
Emmitsburg, Maryland 21727
Tel: 301-447-6487
Large selection of books, supplies, greeting cards and items such as tote bags, coffee mugs, aprons and rubber stamps with calligraphic designs. Yearly catalog.

Pendragon

Post Office Box 25036
Woodbury, Minnesota 55125
Tel: 612-739-9093
Largest selection of supplies, also carries books. Regular customers receive newsletters (helpful-hint articles, listings of new supplies) and yearly catalog.

Utrecht

33 Thirty-fifth Street
Brooklyn, New York 11232
Tel: 718-768-2525
Does not specialize in calligraphy supplies, but sells brand name art supplies at discount prices, including paper, paint, brushes, etc. Also has outlets in New York City, Philadelphia, Washington DC, Boston and Chicago.

Twinrocker Handmade Paper

Post Office Box 413
Brookston, Indiana 47923
Tel: 317-563-3119
Many varieties of highest quality paper, including stationery, handmade by Howard and Kathryn Clark. Paper made to your specifications is available.

Name Brand Rubber Stamps

Post Office Box 34245
Bethesda, Maryland 20817
Catalog contains hundreds of calligraphic stamps done by Linda Abrams and Dini Chapnick, both fine calligraphers and designers. Custom stamps, stamps from your artwork and stamp pads available.

Leo F. White

Rear/10 Aylesbury Street
Botany, N.S.W.
Post Office Box 4
Botany 2019
Australia
Vellum and parchment. Kangaroo vellum available.

Wm. Cowley Parchment Works

Newport Pagnell

Bucks England

MK16 ODM

Tel: 0908 610038

Foremost producers of vellum and parchment.

Paperchase

213 Tottenham Court Road

London W1

Tel: 071 580 8496

Stocks papers

T. N. Lawrence & Son Ltd.

2 Bleeding Heart Yard

Greville Street

Hatton Garden

London EC1N 8SL

Stocks papers

Falkiner Fine Papers Ltd.

76 Southampton Row

London WC1B

Tel: 071 831 1151

Specializes in handmade and oriental paper, gilding materials, pens and nibs, parchment and vellum. Also stocks a very wide range of books on calligraphy.

Philip Poole & Co.

at L. Cornelissen & Son Ltd.

105 Great Russell Street

London WC1B 3RY

Tel: 071 636 1045

Wide range of pens, nibs and inks. L. Cornelissen & Son also stock most art materials, including material for gilding.

Benyon Ltd.

Unit 7

Morrison Yard

551A Tottenham High Road

London N17 6SB

Stocks vellum

Winsor & Newton Ltd

51 Rathbone Place

London W1

Tel: 071 636 4231

Sources of Illustrations

Line drawings by Marta Legeckis, except for *quill pen*, by George Yanagita. Calligraphic illustrations by Rose Folsom, except for the upper *copperplate*, by Kathleen McCann; *Arabic writing* (Ruq'ah, Naskh, Thuluth) by Mohamed Zakariya; *Hebrew writing* by Avraham Cohen. Photographic illustrations are reproduced by kind permission of the following:

Biblioteca Ambrosiana, Milan: *Irish minuscule* (from Bangor Antiphonary, late 7th c.). Bibliothèque Municipale, Amiens: *Corbie* (French, late 8th c.). Bibliothèque Nationale, Paris: *late uncial* (Italian, 5th or 6th c.). Bodleian Library, Oxford: *uncial* (English, 7th–8th c.) British Library, London: *Anglo-Saxon minuscule* (early 9th c.); *late Carolingian minuscule, early Gothic* (in text column; English breviary, late 12th century); *Lindisfarne Gospels* (also *Anglo-Saxon majuscule, knotwork*). The Freer Gallery of Art, Smithsonian Institution, Washington D.C.: *arabesque* (Persian, 6th c.); *Arabic Farsi* (poetical text, Persian, 1523); *Muhaqqaq* (14th-c. Persian Qur'an), Kufic (10th-century ceramic plate); *Chinese standard script* (Sui Dynasty, from "The Sutra of the Great Demise"), *small seal script* (Ming Dynasty, "Seven Scholars Going Through the Pass" inscription), *cursive script* (Yuan Dynasty, 1352); *Japanese writing* (Heian, early 12th c., from the "Ishiyama gike"). Houghton Library, Harvard: *Cataneo; coulée; Greek minuscule; gloss; formal humanist; humanist italic; Schwabacher; white vine.* Library of Congress, Washington D.C.: *Gutenberg Bible* (first page of Genesis). Melbert B. Cary, Jr. Library, Rochester Institute of Technology, New York: *Baskerville; Bodoni* (from *Manuale Tipografico*, 1818); *Caslon* (from specimen sheet, 1734); *civilité* (16th c.); *Garamond* (from specimen sheet, 1592); *Goudy Old Style* (from AFT specimen book); *Hammer* (uncial type from specimen sheet); *Manutius.* The Metropolitan Museum of Art, New York, Fletcher Fund: *Etruscan* (toy jug with alphabet, 7th–6th c. BC); *inscriptional Roman* (Roman gravestone, 41–54 AD); *stoichedon* (Greek, 425 BC); Bequest of Walter C. Baker: *cylinder seal and imprint* (Mesopotamian, *c.* 1800–1595 BC); Gift of Edward S. Harkness: *hieratic* (Egyptian, *c.* 332–30 BC); Rogers Fund: *hieroglyphs* (Egyptian stele, *c.* 2117–2069 BC), *syllabic writing* (clay tablet, with Mesopotamian cuneiform script, 2112–2004 BC); *tablet* (Coptic, wood covered with wax); Gift of Joseph V. Noble: *ostrakon* (Egyptian). The Newberry Library, Chicago: *Arrighi* (from *La Operina*); *Cresci* (from *Essemplare di piu sorti lettere*); *Koch; Neudörffer* (title page, *Ein Gute Ordnung. . .*); *Palatino; Tagliente* (title page, *Lo presente libro insegna*). Pierpont Morgan Library: *babery* (French, 13th c.); *batarde* (French, late 15th c.); *Beneventan* (Italian, 10th c.); *Carolingian* (French, 9th c.); *chancery cursive; Coptic* (5th c.); *early Gothic* (left of text); *palimpsest; rotunda* (Italian, late 19th c.); *secretary hand* (English, mid-15th c.). Trinity College Library, Dublin: *Book of Kells* (also *Irish majuscule*). Vatican Library: *rustic* (from the *Codex Palatinus*); Archivo della Basilica di S. Pietro: *half uncial* (Italian, before 510 AD). Victoria and Albert Museum, London: *Johnston* (from *A Book of Sample scripts*; also *foundational*). The Walters Art Gallery, Baltimore: *cadels* (from the French Berry Bible, late 14th c.); *corrections* (from English book of hours, 14th c.); *diaper pattern* (from French book of hours, early 14th c.); *drolleries* (French psalter, late 13th c.); *Greek late majuscule* (from Byzantine Lectionary of the Gospels, late 10th c.); *scribe* (from 13th-c. French Bible); *textus prescissus* (English, early 14th c.); *versals* (German, late 11th c.). *Italic handwriting* (detail of a letter by Alfred Fairbank) reproduced by kind permission of the Dowager Marchioness Cholmondeley, CBE, President of the Society for Italic Handwriting. *Engrossing* and *Lombardic* reproduced by permission of the publisher Zaner Bloser, Inc. *Lascaux cave paintings* courtesy of the French Government Tourist Office. *Offhand Flourishing* collection of Delbert Tysdal.

Initial letters by Rose Folsom; "u" from E. Johnston, "y" adapted from L. C. Evetts, *Roman Lettering*, 1979.